THE FLE
HUMANI

The Fletcher Jones Foundation has endowed this imprint to foster innovative and enduring scholarship in the humanities.

Ubiquitous Listening

Ubiquitous Listening
Affect, Attention, and Distributed Subjectivity

ANAHID KASSABIAN

University of California Press
BERKELEY LOS ANGELES LONDON

University of California Press, one of the most distinguished university presses in the United States, enriches lives around the world by advancing scholarship in the humanities, social sciences, and natural sciences. Its activities are supported by the UC Press Foundation and by philanthropic contributions from individuals and institutions. For more information, visit www.ucpress.edu.

University of California Press
Berkeley and Los Angeles, California

University of California Press, Ltd.
London, England

© 2013 by The Regents of the University of California

Library of Congress Cataloging-in-Publication Data

Kassabian, Anahid.
 Ubiquitous listening : affect, attention, and distributed subjectivity / Anahid Kassabian.
 p. cm.
 Includes bibliographical references and index.
 ISBN 978-0-520-27515-7 (cloth : alk. paper) – ISBN 978-0-520-27516-4 (pbk. : alk. paper)
 1. Music–Philosophy and aesthetics. 2. Listening. 3. Sound. I. Title.
 ML3800.K184 2013 781'.11–dc23
 2012039945

Manufactured in the United States of America

22 21 20 19 18 17 16 15 14 13
10 9 8 7 6 5 4 3 2 1

In keeping with a commitment to support environmentally responsible and sustainable printing practices, UC Press has printed this book on Rolland Enviro100, a 100% post-consumer fiber paper that is FSC certified, deinked, processed chlorine-free, and manufactured with renewable biogas energy. It is acid-free and EcoLogo certified.

Cover illustration: Hrayr Anmahouni Eulmessekian (with Anahid Kassabian), *Solemnity*. Wall sound sculpture with video projection, 2010. Installation loop 58 min.; poetry by Nancy Agabian, Najwan Darwish, Lola Koundakjian, Amir Parsa, Alan Semerdjian, Maral K. Svendsen, Alene Terzian.

Contents

	Acknowledgments	vii
	Introduction	xi
1.	UBIQUITOUS LISTENING	1
2.	LISTENING TO VIDEO ART AND THE PROBLEM OF TOO MANY HOMELANDS	20
3.	"BOOM!" IS THE NEXT BIG THING	33
4.	MUSICALS HIT THE SMALL SCREEN	51
5.	IMPROVISING DIASPORAN IDENTITIES: ARMENIAN JAZZ	73
6.	WOULD YOU LIKE SOME WORLD MUSIC WITH YOUR LATTE?	84
	Conclusion	109
	Notes	119
	Works Cited	135
	Index	149

Acknowledgements

These acknowledgments are too long for a reason. *Ubiquitous Music* has been a very long time in the making, and it appears in its current form because a huge range of really fun and smart people have talked to me, sometimes at great length, about the ideas that were driving me (crazy).

There are so many students and colleagues who should be named here that I'm sure to forget some of them. My fall 2001 Film Theory seminar at Fordham University (especially Brandi Fanning, Duane Loft, and Beatrice LaBarge) helped to work out some of the issues in the film chapter, and my first Reception Theory students at Liverpool helped me clarify some thoughts in the last days of revision; a number of Armenian artists and videomakers helped with the chapter on Armenian video art, especially Tina Bastajian, Diana Hakobyan, Hrayr Fulmessekian, and Thea Farhadian. The PhD reading group at Liverpool University that began in 2006 and is still going has been a source of genuine intellectual camaraderie and inspiration, as has its counterpart at the Institute for Musical Research in London. I am grateful to Tom Rea Smith for his eleventh-hour help with the one musical example in the book.

Among the close friends whose work I admire, and therefore whose input I rely on, even a brief list would include my colleagues at Fordham and Liverpool; individually, Hrayr Anmahouni, Ian Biddle, Shay Brawn, Norman Cowie, Thea Farhadian, Linda Garber, Freya Jarman, David Kazanjian, Marc Nichanian, Stephen Penfold, Amit Rai, Stephen Rubenstein, David Schwarz, David Shumway, Fionnghuala Sweeney, and Allan Zink have all made differences in my thoughts. Jonathan Sterne and Steve Waksman, who were the readers of both the proposal and the final draft for the press (and who graciously revealed themselves as such), significantly improved this book through their serious engagement with it, as

well as their comments on various papers along the way. They are two of the finest thinkers on sound and music I know, and I'm very grateful indeed for their time and energy. Over the years, a number of students worked on various bits of this project, and to them I owe an enormous debt of gratitude: Elena Boschi, Ross Edwards, Edwina Hay, Laura Hydak, Louis Johnson, Áine Mangaoang, Molly Mahon Marler, John McGrath, Missy Pinto, and Maral Svendsen. I'm truly grateful for the work you all did to make this book happen.

There are those friends whose contributions were to my sanity rather than my thinking, in particular Sandra Lock, Irene Higham, and Clare McCarthy (all of whom I met at the wonderful Pain Management Programme at the Walton Centre in Liverpool), my colleagues on the San Francisco Armenian Film Festival Committee and the Board of Trustees of the Liverpool Arabic Arts Festival, and Kathleen Sauchelli Gordon, who is the best next-door neighbor I could ever ask for.

Patricia Clough, whose fault my entire career has been, never has the grace and good sense to rest on her laurels, but is always pushing her ideas—and mine—into new arenas with increasingly challenging thoughts and shapes. To her I owe more thanks than I could begin to express.

The opportunity to give lectures and get feedback on my ideas helped their development enormously—many thanks to the students and staff at all the places that so graciously invited me, especially McGill University, Newcastle University, and Carnegie Mellon University. My own institutions, Fordham University (and the Ames Fund there), University of Liverpool, and my guest stay at Göteborgs Universitet in Sweden, all helped me develop my ideas. The Sound in Media Culture Project, the Nordic Research Network for Sound Studies, and the new European Sound Studies Association all contributed to my thinking; the International Association for the Study of Popular Music has been my intellectual home since my student days, and the Society for Cinema and Media Studies as well. Many thanks to all those who founded and run these groups, which are crucial to thought.

I've been lucky enough to have two mothers: my real mother, Iris Kassabian, who is herself an accomplished musician, and who astonishingly continues to read (and comment quite helpfully on) every word I write, and my great-aunt, Elizabeth Kazanjian, who was always like a second mother. I owe both of them a distinct and substantial debt. My father, who died in the very earliest stages of researching this book, nonetheless left such a stamp on me that he's everywhere in these pages.

For some scholars, families are a place of refuge outside of their scholarship, but my family is woven into the most foundational structures of my work. My partner, Leo G. Svendsen, has thought every thought in this book with me, and he has contributed not only by keeping us together all these years, but also through his own reading and thinking, as well as critiques of mine. This would be a very different, and less interesting, book without him. Maral Kassabian Svendsen has also contributed to this book in innumerable ways: ze provides me with a steady stream of Internet, gaming, and comic culture referents; insists that I watch, read, and think about things I would otherwise never know about; and then thinks them with me in incisive, insightful ways. The two of you make me sound a lot more knowledgeable than I would seem on my own, and for that I can only be grateful.

Parts of chapter 1 appeared in *Echo: A Music-Centered Journal* (vol. 3, no. 2) and in *Popular Music Studies*, edited by David Hesmondhalgh and Keith Negus (London: Hodder Education, 2002).

Parts of chapter 2 appeared in *Essays on Sound and Vision*, edited by John Richardson and Stan Hawkins, Helsinki University Press, 2007.

Parts of chapter 3 appeared in *Popular Music in Film*, edited by Ian Inglis, Wallflower Press, 2003; and in *Lowering the Boom*, edited by Jay Beck and Tony Grajeda, University of Illinois Press, 2008.

Parts of chapter 6 appeared in *Twentieth-Century Music*, volume 1, number 2, 2004.

Introduction

Whether we notice or not, our days are filled with listening. Of course, you will object: some people more than others, some countries more than others, some economies more than others, and this is true. But a colleague told me he heard music in a supermarket on a dirt road in South Africa, so let us not leap to conclusions about the lives of others.[1] Nonetheless, I will be happy here to think about England and the United States, the two countries where I've lived, and to a lesser extent, Canada and western Europe, where I have frequently traveled and have discussed these issues with colleagues and students.

Ubiquitous Listening is about the listening that fills our days, rather than any of the listenings we routinely presume in musicology, sociology, media studies, and elsewhere. The problem I am addressing is not a disciplinary one—it crosses fields and disciplines blithely. How do we listen to the music we hear everywhere, and how does that listening engage us and activate the world we move in?

My basic thesis is this, put bluntly: *Ubiquitous musics*, these musics that fill our days, are listened to without the kind of primary *attention* assumed by most scholarship to date. That *listening*, and more generally input of the *senses*, however, still produces *affect*ive responses, bodily events that ultimately lead in part to what we call emotion. And it is through this listening and these responses that a nonindividual, not simply human, *distributed subjectivity* takes place across a network of music media.

Since these six terms—*ubiquitous musics, affect, the senses, attention, listening,* and *distributed subjectivity*—are at the core of everything that follows, they bear some defining.

UBIQUITOUS MUSICS

What we listen to most is what I have termed "ubiquitous musics." I took the term *ubiquitous* from Mark Weiser's idea of ubiquitous computing, in which computing power would be embedded in everyday objects, including walls, clothing, and the like (Weiser 1991; see also chapter 1). Similarly, ubiquitous musics come out of the wall, our televisions, our video games, our computers, and even out of our clothing (see, for some examples, the range of clothing with pockets for MP3 players and sleeves for earphone cords, or Oakley-Thump, the world's first digital music eyewear, or temperature-regulating ski jackets).[2] Workplaces, shops, homes, cars, buses, trains, phones, restaurants, clubs . . . music is everywhere, some through our own choices, some without our sanction or control. Of course, ubiquitous music preceded Weiser's article by some sixty years—it is the first ubiquitous mediated experience after print. The point is not that ubiquitous computing is a metaphor for ubiquitous music, but rather that an idea (of embedding things in everyday life) that we think of as coming from computing long preceded it—though the significance of radio, Muzak, and phonographs was perhaps not obvious at first.

In his delightful book *Elevator Music* (2004), Joseph Lanza has argued that ubiquitous musics (though he doesn't use the term, of course) are a quintessentially twentieth-century technology. Like thermostats, he says, they allow us to control our environments (70). It is certainly true that the technologies of ubiquitous music—radio and Muzak and the phonograph, then hi-fis, transistor radios, tape decks, Walkmen, CD players, Internet radio, satellite radio, MP3 players, and so on—are produced and taken up steadily throughout the twentieth century. Moreover, at the turn of the nineteenth to the twentieth century, there was virtually no music without musicians present in the same room, whereas by the end of the century, music was everywhere, from the office to the shower, and many of us couldn't imagine life without it. My daughter, who is currently twenty-two, would prefer to have music on in the background always, or at least almost always, and most of my students seem to be roughly the same, according to what they say about their own listening habits. They say they're most often not paying attention to the music; they just want it as a background accompaniment to their routines and activities.

AFFECT

But what are all these ubiquitous musics doing, as we listen to them in so many different places and ways? Are they hailing us, in a process of

Althusserian subject formation? Are they purveyors of ideologies? Do they constitute us as subjects? While works that argue such things—most notably Susan McClary's *Feminine Endings*—came to the fore in the early 1990s in the field of musicology, analyzing the Western art music canon of modernity, such analysis didn't spread more widely into ethnomusicology and popular music studies, though critical musicology is still, from some perspectives, a growing tradition. But if pieces of music aren't hailing us as bourgeois subjects, what *are* they doing? Especially at these lower levels of attention? It seems clear that they are operating in a different modality altogether, and I am proposing that that modality is affect. *Affect* is the circuit of bodily responses to stimuli that take place before conscious apprehension. Once apprehended, the responses pass into thoughts and feelings, though they always leave behind a residue.[3] This residue accretes in our bodies, becoming the stuff of future affective responses.

To take a simple example, then, my eyes used to well up with tears at a particular phone company ad on television. When I could register my thoughts and feelings—that the ad was stupid and calculating, commodifying the feelings of people with distant family and lovers just to sell phone service—I was wholly repulsed by the ad. But it worked on me before that analysis slipped into place, which was very quickly. Nonetheless, my affective response was even faster, and the tears came before the dislike of the ad.

SENSES

Scholarship on affect is also closely connected to a renewed interest across the disciplines in the senses. There are many examples of such works, and the fascinating, wonderful outpouring of books on sound over the last couple of years is one subset among them—we are suddenly paying attention to sound with a new vigor. For just some examples of exciting work in sound studies, Jonathan Sterne's *The Audible Past: Cultural Origins of Sound Reproduction* (2003) treats the history of sound reproduction to consider our very notions of sound. Fred Moten's brilliant *In the Break: The Aesthetics of the Black Radical Tradition* (2003) takes improvisation, heard (not only) through sound and music, as the very structure of blackness, and uses what he helps us to hear as a specifically and strenuously black critique of Western philosophy to bring a black radical tradition into focus. Richard Cullen Rath's *How Early America Sounded* (2005) compares the soundways of European, First Nations, and Africans in early

America. John Picker's *Victorian Soundscapes* (2003) considers how sound is represented in the period by novelists, philosophers, and scientists. Emily Thompson's *The Soundscape of Modernity* (2002) discusses architecture and sound design and what they tell us about modernity. *Hearing Cultures* (2004), edited by Veit Erlmann, compellingly suggests that considerations of sound will irrevocably change our thinking about times, places, and cultures. His latest book, *Reason and Resonance: A History of Modern Aurality* (2010), is an intellectual history of listening, or perhaps more to the point thinking about listening, in western Europe. Mark Smith's *Listening to Nineteenth-Century America* (2001) contends that even the most fundamental identities in the period—northern versus southern, slave versus free—were constructed in sound, while Karin Bijsterveld's *Mechanical Sound: Technology, Culture, and the Public Problems of Mechanical Noise in the Twentieth Century* (2008) considers noise and its regulation in Europe and North America. And these, and many others, are all within the last ten years.

And this doesn't even include music therapy or the literature on listening in counseling and education. Relatedly, there is a growing body of work on film sound, including *The Sounds of Early Cinema* (2001), edited by Richard Abel and Rick Altman; James Lastra's *Sound Technology and the American Cinema: Perception, Representation, Modernity* (2000); Jay Beck and Tony Grajeda's *Lowering the Boom* (2008); Steve Wurtzel's *Electric Sounds: Technological Change and the Rise of Corporate Mass Media* (2007); and the journal *Music, Sound, and the Moving Image*.[4]

Throughout this book, I am connecting listening, sound, attention, and affect as a way to theorize the relationship between ubiquitous musics and distributed subjectivities, and one way to get at those relationships is to begin from specific physical memories of specific musical events.

AFFECT AND THE SENSES

In June 2006 I went to a memorial concert for an old family friend, renowned oud player George Mgrdichian. It was held in a relatively small club in Greenwich Village in New York, and it was *packed*. Musicians such as the Waverly Consort, the Gerard Edery Ensemble, and David Amram played, and it was extraordinary. What it was emphatically *not* was a rock concert or a club night, so it was neither especially loud nor especially bass-y in the sound mix.

Nonetheless, at several points the music flowed through the furniture into my thighs, back, and arms. This very immediate and contact experience in an unexpected context made me aware immediately of the many settings in which that experience is commonplace—for example, concerts, clubs, cars.[5]

The BBC did a segment in spring 2006 on what they represented as a new genre called dubstep. In it, Kode 9, a dubstep producer, says, "The thing that's consistent in the music is the sub-bass. You know, it's not too much mid-range bass frequencies that you get in drum and bass just now; it's got a solid sub-bass foundation, and as I said in an ideal world anything goes on top of that" (BBC 2006). His invocation of sub-bass made me think of many settings in which music (quite often what I would call ubiquitous music) is experienced through more than ears—not only those club nights where those in the know wear earplugs to protect their hearing while reveling in the music traveling through their feet and bodies, but also in cars, and in the homes of audiophiles, whose subwoofers on their high end Home Theater 5.1 surround-sound systems allow them to have similar body-vibrating aural experiences at will.

Dubstep DJ Joe Nice goes further: "It's a sound you can't really describe until you hear it, and it's not like you hear it in an iPod, you hear it in a CD player and you say 'OK, this sound is cool.' There's a physicality to the music, you know it's a physical listening experience. When you hear it on a big system, you hear it loud, you feel the bass move through your chest, you hear your ears get a little warm" (BBC 2006).

Feeling "the bass move through your chest" and hearing "your ears get a little warm" recasts any remaining notions of hearing as a distance sense, shifting it instead into coextension with touch. Certainly this idea evokes the image of Beethoven with his ear to the piano. In *It's All Gone Pete Tong*, made in 2004 by writer/director Michael Dowse, star deejay Frankie Wilde loses his hearing from the damage done in clubs pounding out dance music. He spirals downward into a continuous paranoid drug haze until he realizes one day that he can "hear" by placing his feet on the speakers and feeling the beat. Like profoundly deaf percussionist Evelyn Glennie, he conducts his career by feeling vibrations, primarily through his feet. As Glennie (1993) has said:

> Hearing is basically a specialized form of touch. Sound is simply vibrating air which the ear picks up and converts to electrical signals, which are then interpreted by the brain. The sense of hearing is not the only sense that can do this, touch can do this too. If you are standing by the road and a large truck goes by, do you hear or feel

the vibration? The answer is both. With very low frequency vibration the ear starts becoming inefficient and the rest of the body's sense of touch starts to take over. For some reason we tend to make a distinction between hearing a sound and feeling a vibration, in reality they are the same thing. Deafness does not mean that you can't hear, only that there is something wrong with the ears. Even someone who is totally deaf can still hear/feel sounds.

Thinking about the senses in this way, as a not rigidly differentiated field, is an idea that is very much coming into its own.

TOUCH AND HAPTICS

There has been a great deal of writing on touch recently, and particularly, in the wake of Deleuze and Guattari's *A Thousand Plateaus* (1987), on haptic media. *Haptic* is often taken to mean touch, and one finds the term frequently, for example, in discussions of computer interfaces. A search for haptic music turns up reams of articles on computer instrument interfaces, and again a large number on performers and performance. In contemporary media studies, however, *haptic* is not taken quite so literally. This sense of haptic comes, as I just mentioned, from Deleuze and Guattari, and it features prominently in works by theorists such as Laura Marks (2002) and Brian Massumi (2002). They take from *A Thousand Plateaus* the concept of Smooth and Striated space: "It seems to us that the Smooth is both the object of a close vision par excellence and the element of a haptic space (which may be as much visual or auditory as tactile). The Striated, on the contrary, relates to a more distant vision, and a more optical space—although the eye in turn is not the only organ to have this capacity" (Deleuze and Guattari 1987: 493; quoted in Marks 2002: xii). The intimacy of the senses with their theoretical world is here exceedingly clear: Striated space is allied with, though not limited to, an optical mode of apprehension, while Smooth space is haptic, that is, intimate, in contact, close, if not strictly speaking tactile.

It is this distinction that underwrites Laura Marks's wonderful book *Touch* (2002). She wants to offer a corrective to the often bleak, masculist, Eurocentric terrain of film theory, which has not succeeded in moving beyond an Enlightenment obsession with vision and perspective. Marks suggests that works in video and new media, in particular works by artists not from Euro-American cultures, often are haptic:

> Haptic *perception* is usually defined as the combination of tactile, kinesthetic, and proprioceptive functions, the way we experience touch

both on the surface of and inside our bodies. In haptic *visuality*, the
eyes themselves function like organs of touch. Haptic visuality, a
term contrasted to optical visuality, draws from other forms of sense
experience, primarily touch and kinesthetics. Because haptic visuality
draws on other senses, the viewer's body is more obviously involved
in the process of seeing than is the case with optical visuality. The
difference between haptic and optical visuality is a matter of degree,
however. In most processes of seeing both are involved, in a dialectical
movement from far to near, from solely optical to multisensory. And
obviously we need both kinds of visuality: it is hard to look closely at
a lover's skin with optical vision; it is hard to drive a car with haptic
vision. (Marks 2002: 2–3)

Haptics then, are closely tied to erotics, to the dissolution of boundaries, to an erosion of self-other distinctions. For both Marks and Massumi, this is a shift from positioning and identification toward a more dynamic account of the relationship between us and the things with which we interact. As Massumi (2002) puts it, "The problem is no longer to explain how there can be change given positioning. The problem is to explain the wonder that there can be stasis given the primacy of process" (7–8). This focus on process over position poses a challenge to theoretical models based on narrative and identification, though both are themselves processes.

ANTIPOSITION

Let us follow Deleuze and Guattari's "line of flight," in their language, away from narrative, alongside Marks and Massumi. The shift away from narrative identification and position draws a renewed focus onto somatic, haptic engagements with music (and other arts). As Marks (2002: 3) puts it: "Haptic images do not invite identification with a figure so much as they encourage a bodily relationship between the viewer and the image. Thus it is less appropriate to speak of the object of a haptic look than to speak of a dynamic subjectivity between looker and image."

Such a dynamic subjectivity demands a whole-cloth rethinking of the study of music. Following Deleuze and Guattari, and Marks after them, we can speak of auditory and haptic hearing; remember, they said that "the element of a haptic space . . . may be as much visual or auditory as tactile" (Deleuze and Guattari 1987).[6] If we take seriously the notion of a dynamic subjectivity, we will have to find a way to stop analyzing music as an object external to us, but rather to describe the dynamic nonhuman subjectivity that was in process in that small club in Greenwich Village.

xviii / Introduction

A dynamic subjectivity that comprises what we have for so long thought of as subject and object—scholar and music—might offer a way into thinking about ubiquitous musics. In fact, I want to go a step further than Marks: rather than a dynamic subjectivity between musicologist and music, or between subject (scholar) and object of study (e.g., a feature film), I am arguing that the two already share a large field of subjectivity, neither undifferentiated nor individualized, neither simply individual nor reductively social. Instead, I will argue that distributed subjectivity is a way of closing the gaps that plague us—gaps between ourselves and our objects, between ourselves and our students, between ourselves and a whole range of others. But, perhaps surprisingly, even works like *Touch* and Massumi's *Parables for the Virtual* presume that the engagements between and among listener(s) and work(s) will be fully attentive, and yet many, perhaps even most, of those engagements are not fully attentive at all.

ATTENTION

Attention is another term that requires careful thought and explanation—and connects with a startling range of issues. There is a significant scholarly literature on attention in cognitive psychology and neuroscience, and more recently in economics. Beginning with Herbert Simon's key talk, "Designing Organizations for an Information-Rich World" (1971), attention is seen as a resource or commodity that is increasingly scarce. As Simon so presciently argues, in an information-rich world, the thing that information uses will become scarce. And that thing is attention. This is no small matter in the current context, when information, including creative product, is overwhelmingly produced at rates no one can consume. (This is especially a problem for media makers working in forms based on advertising revenue, who need to capture attention as their main commodity, and for advertisers, who believe that positive attention will translate into sales of their product. For an interesting take on the place of music in the problem of what is being called "the attention economy," see the literature on sonic branding, especially work by Steve Goodman [2010], Devon Powers [2010], Leslie Meier [2011], Joy Roles [2010]).

While serious focus in the study of culture on the question of attention is still fairly new, I would argue that attention of a particular kind is what the defenders of a structural classical listening intend and assume, and sometimes even state outright. As one brief example, consider Daniel Barenboim's Reith Lectures, including specifically this passage from the

second one on 14 April 2006: "In other words what they are saying to the public is you don't have to concentrate, you don't have to listen, you don't have to know anything about it, just come and you will find some association, and we will show you so many things that have nothing to do with the music and this way you will go into the music. And I ask you, ladies and gentlemen, is that the answer to the so-called crisis in classical music?" But declarations such as these negate in one fell swoop most of the listening that most of us engage in every day—in the car, doing chores, on hold on phones, watching television, going to sleep, in the dentist's office.

While both Jonathan Crary (*Suspensions of Perception: Attention, Spectacle, and Modern Culture*, 1999) and Jonathan Beller (*The Cinematic Mode of Production: Attention Economy and the Society of the Spectacle*, 2006) have written admirable works on the question of attention, they are just scratching the surface of a truly huge question that we will have to confront in the arts and humanities, especially as attention becomes more and more fragmented with increasing numbers of new media forms. One important contribution to this problem is Katherine Hayles's (2007) essay, "Hyper and Deep Attention: The Generational Divide in Cognitive Modes," in which she argues that the deep, focused, long attention traditionally associated with the humanities is being replaced with a fragmented and multiple form of attention. Her focus is on the pedagogical implications of such a shift, but this is an important foray into the kinds of work on attention that are needed.

The questions of attention, and of reception or engagement more generally, will continue to press harder and harder on our theories as cultural forms become more and more interactive, and they are increasingly appearing in social theory concerned with immaterial labor, in economic studies trying to grapple with new forms of address to the senses, and in studies of affect. For the purposes of this study attention remains a central question: ubiquitous musics act, even when not engaged in a focused manner; the degree of attention one pays to them seems to rely on an enormous range of musicological, psychological, and sociological factors; and the relationship between listening and attention is anything but clear.

One way to think about this might be a kind of thought experiment: What would happen to (insert any piece of music here) if we considered the possibility that the piece was listened to in a restaurant while eating dinner with friends? or in my house while I'm cleaning? For example, in his chapter in *Listening Subjects* (1997) on the song "Intruder," David Schwarz describes Peter Gabriel's version this way: "Peter Gabriel's voice as he sings the verse is very close to the microphone; he sings purely,

quietly, as if right into the ear of the listener. For me, it sounds as if Gabriel were putting his arm around the male listener's shoulders and sharing with him the narrator's fantasy of intruding into the space of a woman" (91).

What interests me here is the "arm around the shoulder" simile (and not the fact that the listener is presumed to be male, although that, too, is worthy of further thought). That fantasy structure, of Gabriel whispering into the listener's ear, seems to me to work in some settings every bit as Schwarz describes it, but it depends on a certain set of acoustic qualities, and this is the source of my question.

In order to hear Gabriel's chummy stalker whisper as the kind of intimacy Schwarz posits, it has to be in the audio foreground so that it can rise to the attentional foreground. When someone whispers in your ear, it fills your field of audition, after all. And all the literature on microphones and intimacy, on Bing Crosby and Frank Sinatra and Jean Sablon, depend on the listener's field of audition being filled by the sound (Frith 2008; McCracken 2001). But the majority of music we hear, we hear as auditory background, even if the industry insists on calling it foreground music.

So what happens to Schwarz's analysis of "Intruder" if it's listened to on tiny, tinny mono speakers with no bass at a low volume in a store while shopping for a new date outfit? There is, of course, no simple answer to this question, but I am clear that the fantasy Schwarz found does not work the same way in those circumstances as it does in the ones (he didn't quite notice that) he was imagining.

Of course, this problem—of attention and consciousness—is central to the study of film music, even if all that the best scholars have been able to say is that we're not supposed to notice classical Hollywood scores. This is how I first became interested in attention, during the writing of my PhD dissertation on film music (which eventually became *Hearing Film*, 2001). In the case of traditional approaches to Hollywood scoring, film music should be beneath both attention and consciousness. But that doesn't make the two the same thing.

In 1988, I went to Sweden to study with Philip Tagg, and while there I read parts of Ola Stockfelt's PhD thesis, *Musik som lyssnandets konst* ("Music as the Art of Listening"), a chapter of which appeared as "Adequate Modes of Listening" in *Stanford Humanities Review*, reprinted in *Keeping Score*. In it, he says:

> For it to be possible to analyze this music adequately as it appears in everyday listening situations, a fragmented listening must guide us in determining both *which* parameters in the sounding music merit

> closer consideration in a more concentrated and reflexive study and *how* these parameters must be considered. Hence we must develop our competence reflexively to control the use of, and the shifts between, different modes of listening to different types of sounding events. In the same way that we must listen to the urban soundscape as "music" in order to make it more human, thereby developing the competence to draw up active goals for the "composition" of a more human sound environment, we must develop the competence to listen to that music precisely *as* a part of the soundscape in order to explain and change the position of music in this soundscape. Insofar as we strive to understand today's everyday music and/or want to develop pedagogical programs with real relevance for those who will live and participate in this musical life, we must develop our own reflexive consciousness and competence as active "idle listeners." (Stockfelt 1997: 143)

Such a posture toward music is counterintuitive, perhaps impossible. How can one study something to which one does not pay attention? How can one understand how people engage music inattentively through scholarly attention? And while reception can presumably be inattentive but conscious, can it be attentive but unconscious (in the sense of Freud's first topography)?[7] Or if so, which I think is correct, can it be fully not conscious? This last seems impossible, just as much as full, complete, rapturous attention does, but it bears further consideration. At the very least, however, it seems clear at this point that we need a notion of attention that includes a wide spectrum of activities that range between two impossible extremes—fully attentive and fully inattentive—and between modalities of the kind Hayles describes and more.

LISTENING

Of course, what is being done with varying degrees of attention is listening. I will say more about this in chapters 1 and 5 in particular, but for now at least a few words are in order. By *listening*, I mean *a range of engagements* between and across human bodies and music technologies, whether those technologies be voices, instruments, sound systems, or iPods and other listening devices. This wipes out, immediately, the routine distinction between listening and hearing that one often finds, in which the presumption is that hearing is physiological and listening is conscious and attentive. I insist, instead, that all listening is importantly physiological, and that many kinds of listening take place over a wide range of degrees

or kinds of consciousness and attention. So, the term *listening* here pushes against most of its routine uses in scholarship.

Ideas about listening undergird most music scholarship, and most of them rely in one way or another on theories of narrative. In *Introduction to the Sociology of Music* (1988), for example, Theodor Adorno's typology of listeners valorizes the expert listener above all others: "The *expert* himself, as the first type, would have to be defined by entirely adequate hearing. He would be the fully conscious listener who tends to miss nothing and, at the same time, at each moment, accounts to himself for what he has heard" (4). Such a listener is fully conscious, fully attentive, and able to hear longitudinal, structural relationships in large-scale musical works. Adorno goes on to say, "Spontaneously following the course of music, even complicated music, he hears the sequence, hears past, present, and future moments together so that they crystallize into a meaningful context" (4). The listening he describes is recognizable to all of us who have come through music education—it is in various ways the model of what we know about common practice or tonal music.

Adorno's model of listening is, for instance, a reasonable description of one way to listen to works in sonata allegro form. What's important for my purposes is its obvious structural analogy to more representational narrative forms. What it means to "hear the sequence" is the capacity to follow a theme throughout its journey, as narratologists would put it, away from and back to home. The listener who "hears past, present, and future together" is following the plot, relating current musical events to past and future ones, "so that they crystallize into a meaningful context" (Adorno 1988: 4). The identity of the expert listener, for Adorno, is predicated on his ability to recognize and follow the musical narrative.

In McClary's case, too, the presumption of narrative as an organizing principle is not solely of her own making. The developments of feminist theory in literary and film studies on which she draws relied heavily on psychoanalysis and on structuralist narratology. Of course, in McClary's case, she's entirely aware of her concern with narrative; in a footnote in the introduction to *Feminine Endings* (1991), she says: "The essays in this volume are concerned with problematizing the historicity of narrative processes in music" (171n21). In the text itself, she is never quite this blunt, but nearly. She goes on, shortly after that footnote, in the main text: "The sonata procedure that comes to characterize instrumental music of the eighteenth and nineteenth centuries features a more polarized version of that basic narrative paradigm. In sonata, the principal key theme clearly occupies the narrative position of masculine protagonist" (15).

McClary outlines five component strategies to her approach—musical constructions of gender and sexuality, gendered aspects of traditional music theory, gender and sexuality in musical narrative, music as a gendered discourse, and discursive strategies of women musicians. Of these, it is the third, gender and sexuality in musical narrative, that has occasioned the worst vitriol. Particularly controversial was her analysis of Tchaikovsky's Fourth Symphony, in which she argued that certain unconventional harmonic strategies might be read in relation to Tchaikovsky's sexuality. "For what we have is a narrative in which the protagonist seems victimized both by patriarchal expectations and by sensual feminine entrapment: both forces actively block the possibility of his self-development.... To deny [Tchaikovsky] the option of having devised unconventional stories—stories that were informed by his own experience (though always, of course, heavily mediated through the technical specificity of formal, harmonic, and orchestrational procedures)—is to continue to silence him by pushing him into some kind of assumed uniform patriarchal grid: precisely that against which he fought his whole life" (McClary 1991: 76–78). Think what you will about the relationship between the symphony and Tchaikovsky's sexual identity, but McClary's reliance on narrative and narration for the structure of her argument is as clear as was Adorno's.

The case I'm trying to make here is this: from the abstract, formal relationships heard by Adorno and his fellow expert listeners to the articulation of desire to harmonic procedure in McClary's theorization, our models of how to think about music rely on linear narrativity. And as much as thinking narratively about music has taught us—and I certainly think it has taught us a *great* deal—perhaps a different paradigm will offer us some new insights.[8]

In place of narrativity, I am proposing that we consider how we listen to ubiquitous musics, and how that listening engages us in sensual and sensory affective processes to situate us in fields of distributed subjectivities. But what does that mean in practice? Listening is a peculiar activity, after all. Like seeing, listening engages both representational (e.g., spoken language) sounds and sounds understood to be nonrepresentational (e.g., much of Western music, both classical and popular). But unlike visual culture, scholarly discourse is quite underdeveloped in many areas of listening and sound studies, and general public discourse is not any better. Because of this, theorizations of listening and formations of subjectivities have been relatively few; nevertheless, distributed subjectivity, as I am theorizing it, is very much an aural process.

I want, here, to argue that the production of affective responses to ubiquitous musics, through a range of partially attentive listenings, is how *distributed subjectivities* come into being. This is the last central term of this book, and it, too, will require some definition.

DISTRIBUTED SUBJECTIVITIES

Distributed subjectivity is my own version of a phenomenon many people have set out to describe in varying ways. Cyborgs (e.g., Haraway 2003), the network (e.g., Castells 1996–98), and rhizomes (Deleuze and Guattari 1987) are among the best-known versions. I am choosing a different term because I want to specify several things:

- Individual subjectivity continues to appear to us to function, even as many of the notions on which it was based have deteriorated or disappeared (the bourgeois family, Enlightenment individuality, and so on), so a plausible theory has to take account of its force in absentia, as it were, or what I earlier called the individual-subjectivity-function.
- Distributed subjectivity is constructed in and through our responses to acts of culture—speech, music, television, and the like—in ways very similar to how we once theorized individual subjects were formed, but through different processes.
- Music has a very privileged place in this formation; it is ubiquitous musics that bond and bind the field of distribution together. They are, in a sense, the channels of distribution. They put in place the experience of the network *avant la lettre*, as it were, creating the experience of distribution from the materials of broadcasting, that is, from the cables of Muzak and the airwaves of radio. In this sense, it is possible to suggest, along with Jacques Attali (1985), that in the circulation and engagement with music in its mass cultural forms, the shape of another social order in the making, the form that would supplant mass media culture, could be and indeed was heard.
- While the Enlightenment bourgeois subject has disappeared, the feeling, the apprehension of individual subjectivity, should not be belittled in our models (see Venn 1997). We are nodes in a massive, widespread field of distribution, it is true, but

nonetheless nodes with, potentially, an agglomeration of experiences and accretions of affect that are uncommon, or perhaps even unique.

Distributed subjectivity is, then, a nonindividual subjectivity, a field, but a field over which power is distributed unevenly and unpredictably, over which differences are not only possible but required, and across which information flows, leading to affective responses. The channels of distribution are held open by ubiquitous musics. Humans, institutions, machines, and molecules are all nodes in the network, nodes of different densities.

DISTRIBUTING SUBJECTIVITY

I have taken the language of "distribution" from another computer phenomenon, distributed computing, because it is an apt visualization of what I am trying to describe. But first, it is crucial to point out that distributed computing necessarily comes after the development of distributed subjectivity, and therefore makes a strange metaphor. Distributed computing is only possible because it was imaginable, and it was imaginable precisely because both the forms of thought and the physical forms were already in place to enable it, as I hope to clarify.

Desktop computing treats the computer as a discrete entity; like the Enlightenment subject, it relies solely on the processing power contained within itself. Distributed computing, however, links smaller units together so that they can share processing power in a pool of sorts. For example, *The Chronicle of Higher Education* (the U.S. academic weekly newspaper of record) reported on 29 November 29 2002 that "a team of university researchers has verified that a large-scale computer model employing distributed-computing technology can accurately simulate protein folding, a crucial biological process. The model was run on about 40,000 machines worldwide, taking an amount of work usually reserved for supercomputers and breaking it into chunks small enough for personal computers to handle over the Internet." In this way, the unused processing power of many small computers is aggregated to make enough power to address very large-scale questions.

Now, even what we might term something like "brain power" is distributed, as is clear in another protein-folding research project:

> Aristides is a typical 13-year-old boy. He plays basketball after school, is learning the clarinet, and in the evening sits in front of his computer playing games. There is one game that he is especially keen

on, however, which marks him out from his peers. Every day he logs on to www.fold.it, where, under the nickname "Cheese," he plays a game that involves twisting, pulling and wiggling a 3D structure that looks a bit like a tree's root system. He manipulates different lengths of these snaking green tubes until they fit into the smallest volume possible. It may sound like a rather bizarre game—a distant 3D relative of Tetris, perhaps—but it is in fact a brilliant disguise for one of the toughest conundrums facing biologists today: how do proteins fold? (Dartnell 2008)

By accumulating processing power—be it human or machinic—into a collective process, researchers are approaching problems that were until very recently well beyond the scope of human research. In fact, many research tasks are advertised as piece work on Amazon's Mechanical Turk page, where workers (who are a complicated group demographically; see Ipeirotis 2010) perform what are called "Human Intelligence Tasks," or HITs, for a few cents per item. For example, on 29 April 2012, there were 159,060 HITs available, including tasks such as finding email addresses of restaurant managers, providing Google Search ranking of particular URLs, or choosing the best category for a particular link. This enables people with some programming skills to access a collectivized pool of human intelligence to solve problems. (There have also been some intriguing art projects using Mechanical Turk; see, e.g., Koblin 2011.)

But once connectivity of these various kinds comes into being, it brings to the surface a new form of subjectivity that was already in process and that enabled the pieces to develop. Each computer and each person, then, is a dense node in a network, neither discrete nor flattened. Such a perspective on processing power offers a powerful description of contemporary subjectivity; each person—as well as many nonhuman components—is a dense node in an enormous field that is addressed by various participants in various ways and with varying degrees of power, composing, I am arguing here, a mobile terrain of ebb and flow, of power and information. Distributed subjectivity suggests a vast field, rather than a group of subjects or an individual subject, on which various connections agglomerate temporarily and then dissolve again. This field is significantly constructed through and with music.

AFFECT AND IDENTITY

The notion of distributed subjectivity could raise some concerns that have been leveled at Deleuze and at many works in his wake. How do identity

and identification work in this new form? And since so much of what we know about power and the political is based on identity in some form or another, how do we imagine the political as a realm when identity is seen differently?

Perhaps it's best to begin with an attempt to understand something like *identity* in relation to distributed subjectivity and affect. As quoted earlier, Massumi says about this question that position no longer seems obvious or central, and that process no longer seems beyond reach; rather, process leaves behind a residue of position, which is thus secondary. In other words, identity is the trace of affect. There has been an insistence that affect cannot deal with identity, because affect happens in constant flows and identity is static. Rather, the point is simply this—identity is one of the formations that are left behind after affect does its work. But, as I hope will become clear, identity only appears to be a static formation. From moment to moment, in different contexts, the boundaries of any given identity will shift and change, sometimes quite radically, which suggests that the idea that identity is positional and static is a description of something that is believed and not a description of how identity actually happens.

Some concrete examples might help here. When I am away from Armenians for a long time, my sense of my own Armenianness—my identity as an Armenian, or perhaps the place of "Armenian" in my identity— becomes attenuated. When I am in a particularly conservative crowd of Armenians—if strong nationalist, patriarchal, and heteronormative discourses are bouncing around the room—I feel even less Armenian. I feel "written out." This is the point of distributed subjectivity. Identity doesn't reside within a single subject; rather, it is a flow across a field, which constantly morphs into different shapes and contours, depending on the circumstances. Distributed subjectivity acknowledges that at some places at some points in time, I will—or will not—be included in any given identity category. While such identities seem static and positional, they are anything but, and they are constituted microsecond by microsecond according to affects that are in motion through and across a field that might be constituted of body parts, or verbal texts, or sounds, or machines, or groups, and most likely all of the above.

There is a statistical question here—what will become actual depends on the frequency of a particular kind of event on the plane of immanence on the one hand, and the frequency and size of actual events on the other. In *The Deleuze Dictionary*, Cliff Stagoll (2005) says: "A plane of immanence can be conceived as a surface upon which all events occur, where events are understood as chance, productive interactions between forces of

all kinds. As such, it represents the field of becoming, a 'space' containing all of the possibilities inherent in forces" (204). But "becoming" does not preclude events. If an event is common, as in the case of certain kinds of events for most identities, things will attach to it, it will get bigger, which means things will attach to it more easily. The singing of a national anthem might be a good example here. For many people—though certainly not all—their national anthem invokes pride and community, a warm feeling of belonging. Each singing is an affective event, creating a wave of feeling that flows across a group of any size, from one to thousands. Affect like that leaves behind residue that appears to produce a static identity. But the very fact that it needs to be done over and over suggests that something rather different is happening.

There is another crucial difference between the version of identity that I'm proposing here and the more standard ones. The latter are usually set within an individual, whereas nothing about the plane of immanence is containable, and nothing about distributed subjectivity operates through containment. This is perhaps the single most important difference to be contemplated, as well as the most challenging.

If we want to track the production of identity through affect in music in a particular case, it would be impossible; there are too many tiny little events, spread out over vast terrains. But a grossly oversimplified outline of a process would sound something like this:

- A series of sounds my mother is singing happen for and around baby me—a lullaby handed down through generations in my family. It has certain musical features, and it happens in the context of some of the few actualities a baby has: comfort, soft warmth (in this case, mother), and perhaps other arms and mouths (for me, great-aunt and grandmothers). On the plane of immanence, among all the many events taking place, there are bodily events being shared, quite literally, by my mother and baby me. The sounds themselves are also events on the plane of immanence.
- Those sounds attach to those bodily events, and there begins to be a relationship between the musical features of that song and a certain shared state.
- Across the years, I continue to hear similar musical features in music I hear in Armenian settings. Because in our household (as in many Armenian diasporan households), *Armenian* has a

very big place among categories of events, they frequently get labeled that way. (They could be labeled Turkish or Near or Middle Eastern, for instance, but never are.) More importantly, we hear them together, in conjunction with shared bodily events (increasing or decreasing heart rate, for example).

- On the one hand, such sequences of musical features have physiological correlates, because they are part of a response complex through previously accreted experiences, perhaps beginning with the lullaby. On the other hand, I recognize consciously that those responses come to me with similar music, and I think that those sounds are Armenian. And each experience deposits a bit more affect.

- Ultimately, over time and through repetition, I come to have a strong and recognizable affective response to Armenian music. This, along with similar processes related to food, art, language, stories, and the like, helps to produce what I think of as my Armenian identity.

Of course, the process I've outlined is simplified—to archive the process well would require a level of detail that cannot be of interest to anyone, not even me. And from another perspective it is completely impossible, since the plane of immanence is always virtual, in Deleuze's terms, not actual, but possible, not present, but "belonging to the pure past—the past that can never be fully present" (Boundas 2005: 297). Moreover, the Armenian part of my identity is the easiest to describe in this way, since it is musically distinct in certain ways; nonetheless, my gender, sexual, class, physical ability, and other identities are all formulated through similar processes. If we remember that affect is the physiological process that leaves behind deposits that we later recognize as emotion, then it is easy enough to see identity in Massumi's (2002) terms, as "retro movement, movement residue" (7).

From this perspective, identity does not need to disappear, nor does it need to be the first axis of thought. Identity is a position left behind by the work of affect, and while it has been perceived as positional—that is, as static—it now looks like a constant process.[9] Affect happens over microsecond intervals, moving on and leaving traces behind before we can even feel its presence. Affect both conditions and enacts identities and identifications, and it does so not within bodies, but across them.

THE CHAPTERS

The chapters that follow work at understanding the relationships of the six terms—ubiquitous musics, listening, affect, the senses, attention, and distributed subjectivity—in different settings. Chapter 1 is focused on the question of defining ubiquitous music, and thinking about how to understand distributed subjectivity. In it, I consider music at home, and especially imaginations of the place of music in homes of the near future, to think about what they tell us about listening.

Chapter 2 is about three works by Armenian women video artists from around the world, and it discusses ideas about affect and engagements with sounds. Chapter 3 considers the place of the senses in a type of film I think of as a new genre—the simplistic story with lots of sophisticated computer-generated images and great surround sound (and) music. These are films that clearly move away from organization around plot and character and depth toward a continuous roller-coaster ride of hyper sound and vision.

Chapter 4 discusses how music and television, those media that taught us a particular kind of attenuated, fragmented, unfocused attention, joined forces in a certain period to try to recapture our attention through creation of musical episodes for TV series. Chapter 5 describes three bands who draw on traditional Armenian musical materials and jazz to fuse them into something new, and how particular experiences of listening to their music helped me rethink how I live out my Armenian identity. Chapter 6 addresses the main form of ubiquitous musics, that is, what most people would casually refer to as "background music." It is about music in retail space, and the specific cases of Starbucks and Putumayo.

In the conclusion, I offer a recapitulation of my argument and the ways the central terms orbit each other. But I am more concerned there to open new questions and new problematics that arise from this perspective on listening, affect, and distributed subjectivity. What I am calling for is nothing less than a wholesale rethinking of the way we think about, talk about, and study music, and ourselves in it.

1 Ubiquitous Listening

MUSIC NOT CHOSEN

There are many kinds of music that belong in this book, given that its topic is all those musics that we listen to as secondary or simultaneous activities, often without choice. These include, of course, film and television music (as discussed in chapters 2 through 4), but also music on phones, music in stores (see chapter 6), music in video games, music for audiobooks, music in parking garages, and so on. Jonathan Sterne's "Sounds Like the Mall of America" (1997) long ago confirmed my suspicion about that music: we hear more of it per capita than any other music.

The 21 October 2000 issue of *The Economist* had a graph showing annual world production of data, expressed in terabytes.[1] According to researchers at the University of California–Berkeley's School of Information Systems and Management, about 2.5 billion CDs were shipped in 1999.[2] Music CD production far outstrips newspapers, periodicals, books, and cinema. And most of the music is being heard often, if not most often, as a secondary activity. If we then add cinema, television, and video games in as partially musical media, then stunning amounts of music are created and produced in any year, and the vast majority of it is not destined for attentive engagements.

MUSIC TO FOLLOW YOU FROM ROOM TO ROOM

In the early days of the new millennium, by most reckonings, the capacity to listen to music anywhere and everywhere was a trend that would continue to increase for some time to come. One mark of that might be Bill Gates's ideas for the "house of the future." All residents would have unique microelectronic beacons that would identify their wearers to the

house. Based on your stored profile, then, "Lights would automatically come on when you came home. . . . Portable touch pads would control everything from the TV sets to the temperature and the lights, which would brighten or dim to fit the occasion or to match the outdoor light. . . . Speakers would be hidden beneath the wallpaper to allow music to follow you from room to room" (CNN.com 2000).The Cisco Internet Home Briefing Center imagined a similar musical environment: "Music also seems to have no boundaries with access to any collection, available in virtually any room of the house through streaming audio. A Digital Jukebox or Internet Radio eliminates the limitations of local radio, and can output music, sports and news from around the world."[3] (Cisco n.d.).

These ideas are among the most basic and least radical in the field known as ubiquitous computing.[4] First articulated in the late 1980s by Mark Weiser of Xerox PARC (Weiser 1991; Gibbs 2000), ubiquitous computing became a very active field of research. It was concerned with "smart rooms" and "smart clothes," with the seamless integration of information and entertainment computing into everyday environments. This would be akin to the penetration of words, or reading, in everyday life. Texts were first centrally located in, for example, monasteries and libraries; next, books and periodicals were distributed to individual owners; now, words are almost always in our field of vision, on labels, bookshelves, files, and so on. Written language is ubiquitous, seamlessly integrated into our environments.

From the perspective, for example, of the Broadband Residential Laboratory built by Georgia Tech in the late 1990s, these "stereo-piping tricks of 'smart' homes . . . [are] just a starting point" (as quoted in Gibbs 2000). Their Aware Home had several audio and video input and output devices in each room, and several outlets and jacks in each wall. The MIT Media Lab, as Sandy Pentland said, went in a different direction. They "moved from a focus on smart rooms to an emphasis on smart clothes" (Pentland 2000: 821), because smart clothes offer possibilities that smart rooms don't, such as mobility and individuality. For example, the Affective Computing Research Group "built a wearable 'DJ' that tries to select music based on a feature of the user's mood" as indicated by skin conductivity data collected by the wearable computer (Picard 2000: 716).

WHAT DO WE KNOW
ABOUT MOST OF THE MUSIC WE HEAR?

Music scholarship across the disciplines is utterly unprepared to think about such practices, even ten years after I first published a version of this

chapter. There are few studies of the music that follows us from room to room, variously called programmed music, background music, environmental music, business music, functional music (Gifford 1995; Bottum 2000). One landmark study is Joseph Lanza's book *Elevator Music* (first published by St Martin's Press in 1995, expanded in a second edition from University of Michigan Press, 2003). *Elevator Music* is first of all a history of music in public space, and secondly a defense of the intramusical features that were part of elevator music in its prime: lush strings, absence of brass and percussion, and consonant harmonic language. The book is an invaluable resource, and it makes some fascinating arguments; for example, Lanza suggests that elevator music is the quintessential twentieth-century music because it focuses, as do many of the century's technologies, on environmental control.

Sterne's "Sounds Like the Mall of America" takes another tack. Commoditized music, Sterne argues, has become "a form of architecture—a way of organizing space in commercial settings" (1997: 23). Not only does the soundscape of the mall predict and depend on barely audible, anonymous background music of the "Muzak" type, but it also shapes the very space itself. The boundaries between store and hallway are acoustically defined by the different music played in each space: "To get anywhere in the Mall of America, one must pass through music and through changes in musical sound. As it territorializes, music gives the subdivided acoustical space a contour, offering an opportunity for its listeners to experience space in a particular way" (31). For Sterne, the issue is one of reification—music has become a commodity relation that supplants relations between people and that presupposes listener response.

Ola Stockfelt offers yet another perspective on listening and context; in "Adequate Modes of Listening" (1997), he argues that modes of listening develop in relation to particular genres—he calls these "genre-normative modes of listening"—and the style itself develops in relation to its listening situation. He says: "Each style of music . . . is shaped in close relation to a few environments. In each genre, a few environments, a few situations of listening, make up the constitutive elements in this genre. . . . The opera house and the concert hall as environments are as much integral and fundamental parts of the musical *genres* 'opera' and 'symphony' as are the purely intramusical means of style" (136).

In Stockfelt's argument, modes of listening, listening situation, and musical style coproduce each other. In terms of background music, this helps explain the musical parameters we all know. What Stockfelt calls "dishearkening" has produced a particular set of practices for arranging

4 / Ubiquitous Listening

background music. (The word he uses in Swedish is literally "to hear away from," which shares with "dishearken" a rather higher implication of agency than I think is useful.) There is a focus on moments of pleasant "snapshot listening" rather than development over time, and a focus on comforting timbres (legato strings) over vivid ones (brass).

None of these studies, however, can cope with the world of ubiquitous computing proposed by Xerox PARC and the MIT Media Lab, nor with some of the developments that came from those early projections, and certainly not with what is in the process of becoming. Prevailing scholarly notions of listening, subjectivity, and agency, even in the most innovative works, will not account for the music we wake up to.

I call the music that first began with radio and the Muzak corporation (originally called Wired Radio, Inc.), the kind of music that we listen to as part of our environment, "ubiquitous music." Muzak in particular, by broadcasting music into commercial spaces, established that music could come from "nowhere" and invisibly accompany any kind of activity. Mark Weiser's description of ubiquitous computing was the best description of this phenomenon I've ever seen, even though he was describing something that hadn't been developed until sixty or more years after Muzak's first broadcast.

WHERE DID THIS MUSIC COME FROM?

> I lead a happy life. Every day I wake in the best of possible moods and dance my way around the room as I get dressed. Then, while I prepare a pleasant breakfast in my tiny kitchen, several happy bluebirds land on my windowsill and twitter cheerfully. Outside, a tall man in coat-and-tails tips his hat and bids me good-day. A half-dozen scruffy children chase a hoop down the street, shouting gleefully. One of them cries out, "Mornin' mister!"
>
> Ah yes, life is wonderful when you live in a musical from the fifties. Now, perhaps you're wondering, "How could this possibly be true?" Well, I have the unspeakable good fortune to live directly behind my local supermarket and each morning I wake up to a careful selection of merry tunes which easily penetrate my thin walls to rouse me from my slumber. (Schafer n.d.)

So does Tokyo resident Own Schafer begin his eloquent, elegant think piece about Muzak. Sedimented here is a trace of one of functional musics' siblings, that is, film music and musical theater. To tell functional music's

history, one might begin with music hall, or even earlier. Another trace could be followed to radio, and from there to music in salons and gazebos. Or from workplace music to work music and chants. Strangely, these remain untold histories of the omnipresence of music in contemporary life in industrialized settings.

Two histories *are* told—an industrial one and a critical one. The former begins with General George Owen Squier, chief of the U.S. Army Signal Corps and creator of Wired Radio, the company now called Muzak. This history, best represented by Lanza's book and Bill Gifford's *FEED* feature "They're Playing Our Song," continues through shifts in technologies and markets, to Muzak's "stimulus progression" patents, to the 1988 merger with small foreground music provider Yesco (Gifford 1995), bankruptcy, the rise of competitors such as DMX, and ultimately satellite radio.[5]

The other documented history is a counterhistory, a story of how a music came into being that could be confused with functional music, but is of course nothing like it—ambient music. That history begins with Erik Satie's experiments in the teens and twenties with *"musique d'ameublement"* (furniture music), soars through Cage's emphases on environmental sound and on process, and leads inevitably to—Brian Eno, from whose mind all contemporary ambient music has sprung. (For versions of this story, see any of the scores of ambient websites, and especially Mark Prendergast's *The Ambient Century*, 2003.)

This history goes to great pains to distinguish ambient from background music on the grounds of its available modes of listening. As musician/fan Malcolm Humes put it in a 1995 online essay: "Eno . . . tried to create music that could be actively or passively listened to. Something that could shift imperceptibly between a background texture to something triggering a sudden zoom into the music to reflect on a repetition, a subtle variation, perhaps a slight shift in color or mood" (Humes 1995). What is important to defenders of the faith is ambient music's availability to both foreground and background listening. But since the mid to late 1980s, background music *has become* foreground music. In the language of the industry, background music is what we call "elevator music," and foreground music is works by original artists. While background music has all but disappeared, you can now hear everyone from Miriam Makeba to the Moody Blues to Madonna to Moby in some public setting or other and quite possibly all of them at your local Starbucks. (See chapter 6 for a discussion of music in Starbucks, coffeehouses, and retail spaces more generally.)

Foreground music seems to make talking about music in public spaces impossible—and perhaps it should be. Certainly there is a several-decades-long history of debate about the dissolution of public space and the public sphere. As Japanese cultural critic Mihoko Tamaoki has argued in her work on coffeehouses, Starbucks transforms customers into not a public, but an audience. Moreover, she argues, "Starbucks now constitutes a 'meta-media' operation. It stands at once in the traditional media role, as an outlet for both content and advertising. At the same time, it is actually selling the products therein advertised. And these, in turn, are themselves media products: music for Starbucks listeners" (Tamaoki n.d.: 4). This is Starbucks's genius as a music label; it is a meta-media operation that produces its own market for its own product all at once, in what once might have been public space. But if we focus too closely on the distribution of recordings, we will not fully address the problems foreground music poses to contemporary listening.

HOW DO WE LISTEN TO FOREGROUND MUSIC?

If one attends to public and popular discourse about music in business environments, it has hardly registered the change from background to foreground. By and large, most people talk about music in business environments as annoying and bad, and there are frequent references to Muzak and strings, as if there has been no change whatsoever. The reason, I want to argue, is that they are not discussing music, but rather a mode of listening about which most of us are at best ambivalent, thanks in no small part to the disciplining of music in the Western academy.

In the wake of Michel Foucault, critiques of music's disciplinary practices have been well argued. We have discussed canon formations, architecture, and training; we have argued about analysis and we have talked about transcription. We have discussed, at length, the expert listening held in such high regard by Theodor Adorno and so carefully cultivated by Western art music institutions such as the academy and symphony orchestras. It is perhaps primary among the forces that produce and reproduce the canonical European and North American repertoire.

But in all these discussions, we have not taken our own collective insights quite seriously enough. Logically, if expert, concentrated, structural listening produces the canon, don't other modes of listening produce and reproduce other repertoires? (While a bit of work has been done in this tradition on the rock canon, I think we have a long way to go before the

critique of canonicity is widely spread throughout art music scholarship, much less popular music studies and ethnomusicology.[6])

This is, I believe, Stockfelt's most important point. Through a study of changes in arrangements of Mozart's G-minor Fortieth Symphony, he argues that different settings, different sets of musical features, and different modes of listening are coproductive. Text, context, and reception create each other in mutual, simultaneous, and historically grounded processes. But as foreground music programming has increased, this combination or mutual dependence seems less and less consistent or predictable. When *anything* can be foreground music, does it still make sense to talk about a specific background music mode of listening?

DO WE HEAR OR LISTEN?

One possibility is to think of this most disdained activity as hearing rather than listening. This idea appears repeatedly, including in the sales literature of programmed music companies. But the distinction poses some interesting problems. In Merriam-Webster's *Dictionary of English Usage*, each term is defined by the other:

hear vt

transitive verb

1: to perceive or apprehend by the ear

2: to gain knowledge of by hearing

3a: to listen to with attention: heed b: attend <*hear* mass>

4a: to give a legal hearing to b: to take testimony from <*hear* witnesses>

intransitive verb

1: to have the capacity of apprehending sound

2a: to gain information: learn b: to receive communication <haven't *heard* from her lately>

3: to entertain the idea—used in the negative <wouldn't *hear* of it>

4: often used in the expression *Hear! Hear!* to express approval (as during a speech)

listen

transitive verb

archaic : to give ear to : hear

intransitive verb

1: to pay attention to sound <*listen* to music>

2: to hear something with thoughtful attention: give consideration <*listen* to a plea>

3: to be alert to catch an expected sound <*listen* for his step>[7]

One obvious problem with the distinction is the circularity of the definitions, but that is, as we know, in the nature of language. That notwithstanding, we could probably agree that hearing is somehow more passive than listening, and that consuming background music is passive. Certainly everyone—from Adorno to Muzak—seems to think so.

The connotation of passivity in the term *hearing* is precisely why I prefer *listening*. To the extent that *hearing* is understood as passive, it implies the conversion of sound waves into electrochemical stimuli (i.e., transmission along nerves to the brain) by a discretely embodied unified subject (i.e., a human individual). Yet our engagements with programmed music surely extend beyond mere sense perception, and as I will suggest below, mark us as participants in a new form of subjectivity.

Is there, then, a programmed music mode of listening? Here I want to offer an anecdote as a beginning of an answer. When I was teaching at Fordham College at Lincoln Center, I asked the students in my popular music class to write an essay on a half-hour of radio broadcasting. Ryan Kelly, a member of the New York City Ballet corps de ballet at the time and now an artist/choreographer, began his essay by identifying himself as a non-radio listener. He described sitting down to listen to the tape to begin his essay, and ten minutes later finding himself at the kitchen sink washing dishes. This is, of course, only one story, but an eminently recognizable one. We are so used to music as an accompaniment to other activities that we forget we are listening.

A friend described to me a proto-wearable computing kind of system he had set up—he has speakers under his pillow, so that he could sleep listening to music without disturbing his wife and without the intrusion of headphones. (He also listens to music constantly at work.) He was profoundly articulate about this matter—he thinks of music as an "anchor," keeping his mind from spinning off in various directions. Last year, I got a pillow with a jack and little speakers in it as a gift—what my friend had to rig ten years ago is now a product. Parents of children with attention deficit disorder are often advised to put on music while their kids are working for just such purposes.

From its inception, Gifford says, Muzak was about focusing attention in this sense. Workers' minds "were prone to wandering. Muzak

sopped up these non-productive thoughts and kept workers focussed on the drudgery at hand" (Gifford 1995). (See also Christina Baade's *Victory through Harmony: The BBC and Popular Music in World War II*, 2011, for documentation of discussions about how music would help in alleviating boredom and increasing productivity.) One of my daughter's babysitters, Anett Hoffmann—and many of my students at Fordham—reported leaving the radio or MTV on in different rooms, so that they are never without music. They say it fills the house, makes the emptiness less frightening. Muzak's own literature says, "Muzak fills the deadly silence." Of course, now the silence is far more frequently filled with headphone listening to MP3 players, but the logic is the same.

These have always been background music's functions. We learned them from Muzak, and now they are a part of our everyday lives. As Muzak programming manager Steve Ward says: "It's supposed to fill the air with sort of a warm familiarity, I suppose. . . . If you were pushing a cart through a grocery store and all you hear is wheels creaking and crying babies—it would be like a mausoleum" (as quoted in Gifford 1995). All these listeners and music programmers and writers share a sense of listening as a constant, grounding, secondary activity, regardless of the specific musical features.

A UBIQUITOUS MODE OF LISTENING?

Those of us living in industrialized settings (at least) have developed, from the omnipresence of music in our daily lives, a mode of listening dissociated from specific generic characteristics of the music. In this mode, we listen "alongside," or simultaneous with, other activities. It is one vigorous example of the nonlinearity of contemporary life. This listening is a noteworthy phenomenon, one that has the potential to demand a radical rethinking of our various fields.

I propose that we call this mode of listening "ubiquitous listening" for two reasons. First, it is the ubiquity of listening that has taught us this mode. It is precisely because music is everywhere that Ryan forgot he was doing an assignment and got up to wash the dishes.

Second, it relies on a kind of "sourcelessness." Whereas we are accustomed to thinking of most musics, and most cultural products, in terms of authorship and location, this music comes from the plants and the walls and, potentially, our clothes. It comes from everywhere and nowhere. Its

projection looks to erase its production as much as possible, posing instead as a quality of the environment.

For these reasons, the term *ubiquitous listening* best describes the phenomenon I am discussing. As has been widely remarked, the development of recording technologies in the twentieth century disarticulated performance space and listening space. You can listen to opera in your bathtub and arena rock while riding the bus. And it is precisely this disarticulation that has made ubiquitous listening possible. Like ubiquitous computing, ubiquitous listening blends into the environment, taking place without calling conscious attention to itself as an activity in itself. It is, rather, ubiquitous and conditional, following us from room to room, building to building, and activity to activity.

However, the idea of ubiquitous listening as perhaps the dominant mode of listening in contemporary life raises another problem: if there is a ubiquitous mode of listening, does it produce and accede to a set of genre norms? In the articles on which this chapter is based, I argued for something like a ubiquitous genre based on production practices and mode of listening and some other features, but I now think that that was not quite right. Rather, I think genre has receded significantly in importance, as Melissa Avdeeff (2011) has argued in her ethnographic study of young women listeners. Since the earliest days of electronic dance music, genres have begun proliferating according to all sorts of parameters, though most obviously bpm (beats per minute). In addition, the widespread use of streaming sites like last.fm, Spotify, and even YouTube have meant that there is as much reason to differentiate your music (as both a producer and a consumer) as there is to ally it with others. Genres like steampunk (Abney Park, Dr Steel, The Cog is Dead) and dark cabaret (Birdeatsbaby, the Dresden Dolls) are enabled by the ability of the Internet to disperse and collect information and interest; twenty years ago, these would almost certainly have been individual quirky bands with small, local followings. In other words, before the Internet, most bands would try, because of the contours of production and distribution in the music and media industries, to create music that could fit in existing genre categories.

This shift, following the widespread penetration of the Internet and digital distribution into everyday musical life, means other significant changes in this argument as well. When I was first writing on this topic, I looked into how researchers were imagining future uses of music. I focused on ubiquitous computing, from which I took the term *ubiquitous* to describe the omnipresence of music in contemporary every-

day life in developed and especially urban nations and contexts. Any even basic searches for, for example, the house of the future led to a great many proposals of how listening to music would be changed by ideas that came from ubiquitous computing researchers.

What was first called ubiquitous computing seems to have settled on new names, such as pervasive computing and ambient intelligence, and ideas about wearable computing that were coming into focus in places like the MIT Media Lab have established a field of their own. In pervasive computing, ideas revolve around ways for your environment to sense and identify you—such as RFID (radio frequency ID) tags—in order for it to know what kind of music (and lighting and temperature and visual arts) you prefer. The projections here include the music following you around as you walk through your home, and the home's ability to coordinate other features of the environment to your music, which is in turn coordinated to your preferences.

In wearable computing, sensors on the inside of clothing lie in contact with your skin, informing a small onboard computer of your skin temperature, heart rate, and so on, so that it can respond to your emotional needs. Wearable computing has been used to develop ski jackets that are aware of your physical state and can call for emergency assistance in case of an accident, clothing that can detect the onset of epileptic seizures, ways to detect when a student is losing interest so that an automated learning system can change approaches, and other very useful possibilities.

Each of these has significant appeal, but also substantial flaws. I subscribed to the journal *Pervasive Computing* for about three years, and never once did I see anyone discuss how to handle two competing sets of instructions from different RFID tags. I have yet to see an article on wearable computing that accounts for more complex needs and desires on the part of the wearer—the MIT Media Lab's Wearable DJ, for instance, presumed it knew what to program for a wearer given her or his physical state. (Perhaps the utter disappearance of this project is a sign that the researchers realized the problems with this approach?) An article from 2010 points out some of these issues in its abstract: "One important but often overlooked aspect of human contexts of ubiquitous computing environment is human's emotional status. And, there are no realistic and robust humancentric contents services so far, because there are few considers about combining context awareness computing with wearable computing for improving suitability of contents to each user's needs" (Lee and

Kwon 2010: 1). So the problems both with pervasive/ubiquitous computing and with wearable computing since their outset still persist. (See Cook and Song 2009 for a survey of the recent state of play at the intersection of these fields of research.) Intriguingly, wearable computing is now mainly being researched, as the examples I listed earlier suggest, for medical and educational purposes, and a certain level of pervasive computing is on the market. But both wearable and pervasive computing are also appearing in art projects of many kinds. For example, Arduino, an open-source platform created for artists and designers, is enabling projects like little fabric speakers and many other new kinds of art forms.[8]

Ambient intelligence has found its métier in the home of the future. When I first began this research, the home of the future was all about Internet wiring that would make your whole record collection available at the push of a button. Now that that's the stuff of everyday life, there's actually very little about music in the homes of the future, such as the currently available model featured on UK's "Gadget Show," which can remember your preferences for lighting, awaken you, draw your bath, and close your curtains from a variety of voice or RFID cues.[9] Like this one, most "homes of the future" hardly show any new musical ideas at all. One recent home of the future, Living Tomorrow in Brussels, barely mentions that music is available around the house.[10] Another, "South Korea's Home of the Future," has walls that coordinate images on the digital wallpaper to the mood of the music you've chosen—hardly a very advanced imagination of the role of music (or digital wallpaper, for that matter).[11] In another, a German-design cylindrical chair called the Sonic Chair—it looks a bit like a tin can tipped on its side—has three speakers around you (left, right, and above) and the back soft cushion you lean against is the bass speaker behind you.[12] None of these are as intriguing and full of possibilities as was a hard drive containing all of your thousands of music tracks that could be accessed from anywhere in the late 1990s, when I was first researching these issues.

But there is a new form of technology that is bridging the gap between pervasive and wearable computing, in a very intuitive, widespread way, and it is changing the nature of our relationships to music just as surely as its predecessor, the MP3 player, did. Smart phones—and the apps you can have on them—are an intriguing scale of entertainment and programming. They are challenged by some simple things, and most apps don't expect you to remain engaged with them for extended periods. Nonetheless, they are creating a whole new world of musical possibilities for users.[13]

In awarding Steve Jobs the 2010 Innovation Award in the area of Consumer Products and Services, the *Economist,* offers some perspective on the economic performance of the iPhone:

> As of April, 2010, the App Store offered more than 185,000 applications for the iPhone written by more than 28,000 developers. More than 4 billion apps, some free, some for sale, had been downloaded as of April, 2010. Apple provides 70% of revenues from an application sold in the store to the software developer and while that may have contributed tens of millions of dollars to its sales, it's not a huge revenue generator given the size of the company. More importantly, the wide diversity of the applications has increased the functionality of the iPhone, contributing to its enviable consumer popularity. Apple had sold more than 51 million iPhones as of March 31, 2010. Market watcher IDC said Apple's iPhone was the third-best selling smartphone in 2009 with a 14.4% share of the market as sales for the year soared 82%.[14]

These statistics are already quite out of date, and their implications are staggering. For just one small example, on 2012 May 9, RovioMobile posted a video to YouTube announcing that 1 billion copies of the Angry Birds games had been downloaded. Sales of apps for Android smart phones passed 1 billion in December 2011.[15]

There are some interesting controversies around the iPhone that will bear consideration as this market develops, such as differences among smart phones and their policies. A PhD student told me when we were discussing this project that when she was shopping for a smart phone, people told her there is more freedom in writing apps for Android, since they are not as carefully screened as iPhone apps are before being included in the iTunes store. An app developer agreed; according to him, Apple's intensive testing means that all products available in the iTunes AppStore are quite strong and without glitches, but that it also discourages certain more experimental approaches (Warren Bakay, personal conversation, 25 February 2011).

Nonetheless, there is a seemingly endless supply of music apps for the iPhone. There is no way to pin down a meaningful figure, given the rate of release of new apps, but as of 23 January 2012, the Apple iPhone app page says there are over five hundred thousand apps available.[16] While they are too new to say anything very definitive about them yet, so far most music apps seem to fall into one of these nine genres:

 1. Listening apps: There are a number of these, including some PC standbys such as Spotify and Last.fm, as well as things like

Tuner Internet Radio, which gives you access to thousands of radio stations worldwide.[17]

2. Music management apps: My favorite of these is Moodagent; it was to research this app that I originally got my iPhone. It has five sliders (joy, tender, sensual, anger, and tempo) that you can set to varying levels, and according to those choices the app will create a playlist from the music on your iPhone. It was voted third-best music app in 2011 by the readers of *Laptop* magazine.[18]

3. Apps to identify music: Shazam and SoundHound are popular versions of this type of app. The idea is that you point your iPhone at the source of the music and the app identifies the song.[19]

4. Mixing and DJ apps: These range from simple DJ apps that let you smooth transitions from one tune to the next to apps that let you scratch and remix. 3DJ offers a range of remix apps by genre, such as Dance Remix.[20] Others in this line of products include ska, reggae, and soul. Other products in this genre include apps from individual DJs, though I haven't yet found one of these with good reviews.

5. Music games: There are many examples of games that depend on music for part or all of the game play. One such game is Balls, which allows the user a startling range of temperaments and a few instruments according to which the balls on the screen will make music. They make sounds by hitting each other or bouncing off the wall, and the user can affect the way the balls move by either tipping the phone so that the balls react to "gravity" or by pushing them with a finger.[21]

6. Instruments: *Music Ally*, a music blog, and many other sources have rated Ocarina as one of the top five or top ten music apps, and a band called the Mentalists used it as one of their i-instruments to make a cover of MGMT's "Kids." As of March 2009, seven hundred thousand people had bought Ocarina. You play Ocarina by blowing into the microphone and pressing on images of circles on the screen of the phone. But it also has a GPS component, in which you can see a rotating map of the globe that lights up everywhere that someone is playing Ocarina, and you listen in to what other people are playing.[22]

7. Music education apps: Karajan is an interesting example of this category. It was selected by *Music Think Tank*, a website for the music industry, in May 2010 as one of the four best apps that can make you a better musician.[23] It allows the user to practice recognizing intervals, beats per minute, key signatures, and scales and modes, and it offers many basic ear-training exercises. There are a wide range of such apps available, including ones to help instrumental students, practicing sight-reading skills, rhythmic ability, and so on.

8. Music tools: these include tuners for specific instruments, metronomes of various kinds, dictionaries, and more. I have both Guitar Tuner and Drum Beats (a little drum machine app) on my phone.

9. Generative music: Bloom, Air, and Trope are the best-known generative music apps, made by Brian Eno in various collaborations, though there are many others, from simple free ones like RjDj to more professionally oriented ones like Mixtikl. The term itself is Eno's, according to a range of sources, including Wikipedia, although it long precedes smart phone apps. Each of the apps from Eno's group has multiple moods and several adjustable parameters, including delay. The sounds are coordinated with visuals, and they can be used either actively, with the user tapping and dragging on the screen to create both visual and audio events, or passively, where the app generates audiovisual content in a particular ambient-style mood.[24]

The Eno generative music apps have appeared on many "best of" lists, especially Bloom. But some of the user comments may offer a bit of insight into how they are understood and used. These are taken from the iTunes Preview page for Bloom, which was the earliest of the three.[25]

Short-Lived Fun

***** (5)

by Justin Norman

This is quite a unique app for simple composition and it offers cheap musical entertainment for a short amount of time. The idea behind it is great: easily compose moody soundscapes on the go, even if you're not a musician. The game's design basically makes it impossible to fail. For the money, Bloom delivers a good number of different variables to work within, and it is fairly enjoyable. However, I quickly lost interest in it and moved on to other, non-musical applications,

saving music creation for my desktop computer. Others might find it more interesting than myself, but I found the musical confines the app provides to be a bit too limiting to mess around with for long.

Bloom

****** (6)

by CheshireAliCat

This is a pleasant little application that becomes quietly addictive. It's beautiful, and I can't praise it's [sic] calming ability enough. My kids enjoy it as well! I wasn't sure it would be, but it turned out to be well worth the few dollars!

Disappointment

* (1)

by wasswasswass

I was really [sic] forward to using this app. But all the moods are WAY TOO SIMILAR. The sounds they have and how they repeat the user's input seem the same to me. There is NOT ENOUGH VARIETY. I wish I had NOT PURCHASED IT.

It seems quite clear that Bloom is not meant to hold a user's attention for long periods of time, nor is it designed for musicians to use (although one comment on the announcement of Trope in *Synthtopia*, a web magazine of synth and electronic news, says, "Without these apps, my intros would be so much lamer . . . the price is perfect as well if this was a rating system from 1 to 10, I give it an 11."[26]). Because there are no other listeners and the music and visuals that one produces are completely transient—there is, for instance, no "save" function—these generative music apps are toys. Or relaxation tapes—they can be used in "listen" or "create" modes, and listening is quite relaxing. Or sleep inducers—like many audio iPhone apps, they come with a sleep timer. What they do *not* bear up to—and this is no surprise, given their creators—is long, focused listening.

A NEW ENVIRONMENT?

In general, music apps vary in relation to the level of activity they require, the duration of interest they are likely to command, the degree of attention they may occupy, and so on. They are certainly not in any sense a single type of activity. But many of them can be thought of as ways of managing one's audio environment. It then becomes clear, I think, that it may well be productive to think of a group of iPhone apps as a cross between wearable and pervasive computing—on the one hand they are

small and always with you, like wearable computing, and they can respond to your mood—but on the other hand they both interact with and create your environment.

Simply to bring my point home, I want to remind you of the *Gadget Show*'s eHome, which remembers your preferences and responds to your voice. Not only can one control one's audio environment in the here and now, but one can control one's home environment from hundreds or even thousands of kilometers away, simply by the touch of an iPhone. In practice, this means that not only can you rest assured that you didn't forget to turn the lights off when you left home, but you can come home to a hot bath waiting for you, with the music you prefer at that moment. Or, for a lot less money, and on the level of the micro-environments I'm interested in, Aqueous, an audiovisual relaxation app, provides you with choices of water sounds, nature sounds, and musical tracks, simultaneously, so that you can run your fingers in virtual water and create a sound environment with waves, birds, crickets, and Balinese trance music with just a few taps of your finger on the screen.

This is a new way of engaging—or, to a significant extent, creating—our sonic environments. Rather than thinking about the acoustic qualities of building materials and activities in the neighborhood, or of the quality, complexity, and placement of speakers in a surround sound system, apps can offer small-scale creations of small-scale environments—environments that are the size of an iPhone screen, for instance, and can be heard by only one person. The place of these small bits of programming in environmental experience is creating a whole new category of environments.

My point is simply this. iPhone apps are a new "size" of interaction with environment, a new place of processing between wearable and pervasive computing, a new set of audio-visual relations, and a new form of soundscape management. They offer users worlds of possibilities, figuratively and literally, for somewhere between no cost and twelve euros as the most expensive music app I've seen so far. They enable users not only to become composers in the sense that includes what Jacques Attali, DJ Spooky, and Brian Eno all are interested in, but also in the way that the programmers of *Ball* are imagining, where the app helps them create aleatory compositions in twenty different temperaments with eight timbres and from one to seven vectors to control. These apps are enabling users to compose (in many different senses of this word) their sound and visual environments in small units for highly variable lengths of time. They require methods of analysis that can understand these very small-scale activities that do not have a major place in people's lives, that take place in the margins between

times and places, and that do not obviously suggest a mode of study. Nonetheless, they are begging for us to try to understand the changing nature of the many new "environments" that they are putting on offer.

WHAT IS UBIQUITY?

Mark Weiser's ideas about ubiquitous computing were unbelievably prescient. But so, too, were George Owen Squier's ideas about listening. The ubiquity of listening, the omnipresence of music in daily life that grew throughout the twentieth century and continues to grow in the twenty-first, would shock a listener from before the invention of recorded music. Of course there are enormous variations among listeners according to all sorts of parameters, including individual proclivities, but it would be a very challenging task to try to get through a week without coming into contact with music, and for most of us in the industrialized world, a musicless day would be highly unlikely indeed.

As I have been arguing, listening as a simultaneous or secondary activity—that is, ubiquitous listening—has profound implications in many directions: it modulates our attentional capacities, it tunes our affective relationships to categories of identity, it conditions our participation in fields of subjectivity. If the insights of the past thirty years of theories of culture are to be taken seriously, insofar as even the most widely divergent have insisted that engagements with culture are an integral part of both the social and the individual, however those two categories are understood, then surely ubiquitous listening, which is involved in many kinds of cultural activities (from restaurants to movie theaters to clothes shopping to domestic life), should be taken very seriously. But more than that, I am arguing that music is articulated to affect, and that it can help bring or suppress attention, and that we know ourselves in and through musical engagement, then

1. the quantity of music we hear, as well as its features, including the frequency ranges, volume, timbral qualities, meaning processes, and affects demand much closer attention than they have been given so far;
2. the music to which we listen so frequently and how we listen to it should be taken very seriously indeed, not least in terms of how and why we encounter the musics we do and what we might be doing with them.

What I am advocating is a whole new field of music studies, in which we stop thinking about compositional process, or genre, or industrial factors as the central matters. Those approaches have yielded some very important insights, and no doubt they will continue to do so. But as a transdisciplinary scholarly community—across music history, music analysis, popular music studies, ethnomusicology, communications, media studies, sociology, anthropology, cultural studies—we have had far too little to say about most of the relationships between most musical events and most people in the industrialized world. Whether it is through living behind a supermarket in Tokyo, like Own Schafer, quoted earlier in this chapter, or the audiences of television musical episodes (see chapter 4), or my own listening to Armenian jazz albums (see chapter 5), these complicated, shifting, amorphous encounters require much more thought than they have had to date, both because they influence other forms of listening (recall Ryan Kelly earlier in this chapter) and because they are profound engagements with the field of culture/distributed subjectivity/labor that is everyday life.

2 Listening to Video Art and the Problem of Too Many Homelands

If ubiquitous listening is the condition of possibility of distributed subjectivities, as I have been arguing, then one of the important places to try to engage it and understand its operations must be the sounds of ethnic and national identities. Not only are these among a handful of very powerfully expressed identities—along with, for example, gender, sexuality, class, dis/ability—but they are very commonly expressed musically and aurally. The feelings that well up for many at the playing of the national anthem, or a genre typical of one's region or nation, or even the sounds of particular machines or animals that are a telltale feature of the soundscape of home all connect affect and ubiquitous listening. But how does this listening get articulated to distributed subjects of a nation, for example? How do sounds and sounding materials, such as those I will discuss in this chapter, trigger such deep responses, on the one hand, and get articulated to the nation, on the other?

As I said in the introduction, one definition of affect is the circuit of physiological responses to stimuli that take place before conscious apprehension. But this is an oversimplification—for one thing, affect does not take place in discrete human entities. Rather it diffuses across fields of distributed subjectivity. There has been a great deal of thinking and writing on the post-human, attempts to take the discrete Enlightenment subject, the intact human mind/body, out of the center of cultural and social theory. Distributed subjectivity, as I am theorizing it here, is one way to de-center the individual without losing the (very powerful) notion—and experience—of subjectivity.[1] The central idea of this chapter, thus, is how these videos set affect in motion, across global swaths of communities, distributed fields of subjectivity, through audiovisual engagements.

This chapter takes as its substrate three videos made by Armenian women filmmakers (of different ages and in different geographical locations) in the late 1990s. I have chosen these pieces for several reasons. I know them through working on several Armenian film festivals (New York City, 2002, 2004; San Francisco, 2004, 2006) in which we programmed primarily contemporary short works like these. But I decided to write about these particular pieces in this book because they raise theoretical issues about diasporan cultural production, distribution, and reception that are crucial to my general project in this book.

Armenian identity is at a moment of enormous complexity and flux in all its communities, diasporan and homeland. Everywhere that Armenians live is in crisis, or has been in recent memory: Lebanon; Iran; the Soviet Republic in the Caucuses; the United States; France; and the smaller communities scattered throughout Israel and Syria, Iraq, the rest of the Arab world, and Latin America. And yet most Armenians continue to insist that we share an identity across all of these vastly different historical, geographical, cultural, and social differences. I will consider here the listening in such communities to video works that have been produced in other Armenian communities; the listening, thus, often takes place outside of the recognizable contexts of the work's production. Do the works evoke the same affective responses in Armenian audiences worldwide? In part, this is the old recognizable argument about whether encoders and decoders share the same codes. But in the context of a presumed sameness dispersed over widely varying experiences, this question takes on new urgency. Do the works leave behind traces similar to those left by the others? For the range of listeners who self-identify as Armenians? For those who don't? As such, this chapter is not only about affective listening and distributed subjectivity; secondarily, it is a critique of Armenian nationalist discourses and an intervention into both diaspora studies on the one hand and audiovisual studies on the other.[2]

Diaspora studies has largely been concerned with the Jewish, African, and South Asian diasporas—each case, for different reasons, less (though by no means un-) troubled by the problem of homeland than by their social and political situations in their current location. But I hope to show that the fantasy of identity—that is, sameness or similarity—depends on a fantasy of origin that is deeply problematic as well. Similarly, film studies has spent its time and energy on visual images and relations of looking, ignoring for the most part the aural component of the form. Film is taught in "Visual Culture" programs, and it is tied to art and photography, institutionally erasing its multisensory dimensions. Through consideration of specific

works of video art, I will argue first, that affect is our primary means of engagement with our national identities;[3] second, that ubiquitous listening is a primary site where affect gets "caught" by identities; and third, that if diaspora studies in general and Armenian studies in particular could listen to their communities through art and culture, and in particular through affective listening, they would have a better understanding of how identities take hold and reshape themselves.

As an aside, however, I want to address why we should think about sound and music in video art, when its viewership is far smaller than many other audiovisual forms, and about why a community as numerically small and geopolitically insignificant as Armenians is worth writing on. The former question is, to some extent, beyond the scope of this chapter, but perhaps it will suffice to point out that (1) as with other "high" arts, experiments in video art are quite likely to find themselves at some later point in films, television shows, music videos, and other more popular forms, and (2) they often offer a critique of more mainstream, high-budget, widely experienced films and videos. (For a thoroughgoing consideration of video art and music, see Holly Rogers's *Sounding the Gallery, 2013*.) As for the second question, as I already indicated, the Armenian "case" raises provocative questions for the field of diaspora studies. Armenians have been in diaspora for many centuries, and for many different kinds of historical reasons, not least throughout the region sometimes referred to as the Near East. And there are at bare minimum two distinct linguistic and cultural communities: Western Armenian, which is primarily from Anatolia and was, at least until the 1990s, the language most contemporary diasporans in the West spoke, and Eastern Armenian, spoken by Armenians from the Caucasus (the area of the former Soviet Socialist Republic and now an independent political entity) and Iran. These small facts are suggestive of the larger point to which I will return—Armenians worldwide construct themselves as a single diaspora, when there is arguably no single homeland to which they could plausibly be referring.

This disparity between history and fantasy produces some very difficult situations for video artists and artworks. They face several layers of challenge: the routine difficulties of video makers to find funding and to convince potential funders that their work is important, the absence of infrastructure for funding and screening in Armenian diasporan communities, the small size of Armenian communities worldwide, and the cultural and linguistic differences of the communities. The lack of a shared history doesn't just mean that there's one diaspora speaking in many voices; it means, rather, that the voices aren't simply speaking to each

other, or even speaking the same language, even at the most literal level. This poses distinct challenges to understandings of how diasporas hold themselves together.

One marker of these important differences is the sound track. Through readings of three works made in very different contexts, I am extending the idea of ubiquitous listening into the areas of sound and experimental works, on the one hand, and into ethnic and national identity on the other. Because it does not have the complicated history of vision's association since the Enlightenment with science, knowledge, distance, and objectivity, sound—and especially musical sound—has a denser capacity to engage affect and evoke distributed subjectivities. Each of the artists I discuss below makes very pointed, vivid, and unusual sound and music choices, and I argue that those choices set affect in motion powerfully, and across a number of apparent obstacles.

THREE PIECES, THREE PLACES

The three works I chose to bring together here are all video pieces produced since the 1990s by artists who consider themselves Armenian. Diana Hakobyan is an artist in her thirties, living in Yerevan, Armenia's capital, who, like a number of young Armenian artists, makes low-tech video works that combine performance, videography, found materials, and written language to make short installation pieces. In this case, the video is from 2004 and is entitled *Life Is Sweet*, a meditation on gender and contemporary political life.

Several things distinguish Hakobyan and her context from the other two artists being considered here. First, most Armenians living in Armenia did not arrive there through recent displacement. Unlike Armenians elsewhere, many of them come from families untouched by the *Aghed*, the Catastrophe of 1895–1921.[4] Second, they do not share an art history with diasporan Armenians. There has always been Armenian filmmaking in Armenia, which is not true in the major diasporan communities, that is, Lebanon, Iran, France, the United States.[5] The *Aghed* precedes any systems of film production such as national film boards or studios, and in diaspora, Armenians have always been a relatively small minority, with limited access to the massively expensive technologies of filmmaking. Moreover, the art film production in Armenia valorized highly symbolic, minimally narrative works best known through the works of Sergei Paradjanov.[6] (Artavazd Pelechian is today the most widely recognized inheritor of this

tradition; he conceives of his work in relation to his theory of distance montage, a nonlinear approach to editing.[7] There was, of course, also more mainstream narrative film production in Armenia, beginning in the silent period and continuing to the present.) Often, too, these Armenian art film practices were conceived as oppositional to Soviet art and social policy. In this sense, video art in Armenia developed out of a theoretical and stylistic history distinct from those of diasporan Armenian artists. The work of diasporan artists has developed in relation to their own local film and video contexts, and for them, therefore, being a self-consciously *Armenian* artist is a matter of both psychic and material labor.

Sonia Balassanian is a video artist born in Iran, now living between New York and Yerevan, who makes low-resolution works oriented toward gallery exhibitions. She has a master of fine arts degree from Pratt Institute and has been in the United States since 1965, though she continued to spend significant time in Iran. Her current second home, however, is not Tehran but Yerevan. Sonia and her husband, Ed Balassanian, are the founders and directors of *Norarar Portsaragan Arvesti Gendron*, the Armenian Center for Contemporary Experimental Art, in Yerevan, and through the center, Balassanian has been instrumental in bringing diasporan artists into dialogue with artists in Armenia. She was an abstract painter and poet in Tehran; in the 1960s there, she would have seen most of the work available later to both Hakobyan and Tina Bastajian. Films from the United States, France, Italy, and the Soviet Union seem to have played regularly in Iran during this period, and the large Armenian community of Tehran would probably have brought Soviet Armenian films as well. Much of Balassanian's work in the 1980s focused on veiling, in particular, the *chador*, gender and power, while later works address the war in Nagorno-Karabagh.[8] The piece I am considering here, *Lamb* (2000), loops tight close-ups of butchering with non-synched graphic sounds of butchering and knife sharpening. Several of Balassanian's works from around this time, including *Lamb* and *Brooding* (1999, which shows the annual process of beating the cotton from mattresses to clean and fluff it, work usually done by older itinerant women workers), use everyday life practices as the concrete, material base on which to build metaphors. Her work takes the long tradition in West Asia of florid poetry and turns it on its head, using quotidian activities as images of political and economic struggles.

Tina Bastajian is a filmmaker and artist born in Los Angeles; she studied at San Francisco State University at the height of that program's prominence and has, like Balassanian, exhibited worldwide. Her work is the longest and most technically complicated of this group. *Jagadakeer . . .*

between the near and East runs nineteen minutes and fifteen seconds and is a complex layering of both visual materials (film footage [both found and shot], video, and photographs, often altered) and of sound (from the footage itself, from oral history interviews, from actors and musicians, and from various sound effects, rarely synched to the visuals).[9] One recurring trope is footage run backward and forward, so that we see a hand catching a pair of dice, a piece of lavash bread being uneaten and reassembled, and so on. Similarly, phrases undo and redo themselves: "Tell me what you cannot remember, remember what you cannot tell." Bastajian has said that one of the inspirations for these gestures is Jean-Luc Godard, who uses this strategy throughout his works. In *Vent d'Est*, for just one example, there is a text screen that reads: "Ce n'est pas une image juste, c'est juste une image." In Bastajian's hands, however, the reversal becomes an articulation of the slipperiness of diasporan life, of the trauma of memory and the impossibility of narration: "Tell me what you cannot remember, remember what you cannot tell." While Hakobyan was being raised on Paradjanov and Pelechian, Bastajian saw no works by artists who self-identified as Armenian when she was young, except for Mike Connors's 1970s television cop series *Mannix*. (Mike Connors is an American television actor of Armenian descent; his birth name was Krekor Ohanian.) She "grew up" filmically on Hollywood, *la nouvelle vague*, classic avant-garde, Trinh Minh-Ha, and 1970s feminist filmmakers.

Many questions arise, just from these descriptions. It would be facile to suggest that Bastajian can make longer, more technically complex work because she has the privileges of a U.S. citizen. Balassanian in fact has found a way to devote herself nearly full-time to her practice, while Bastajian was working as a freelance media specialist in Los Angeles museums in order to pay the rent. But Balassanian shows no interest in fetishized technology, while *Jagadakeer* displays an enviable, seductive technical polish and craftsmanship.

THREE PLACES, ONE CONVERSATION?

The very status of these approaches to technology highlights one of the difficulties of thinking about anything one might call "Armenian video art." First of all, the material conditions of production across the Armenian communities are almost illegible at this point. Funding for making videos has dwindled significantly in the United States, and American-Armenians are both too small in numbers and too conservative to have organized to

get arts funding. (In this sense, the San Francisco Armenian Film Festival was a brief exception, having received significant grants from both United Artists and San Francisco's Cultural Equity Commission.) Moreover, to the extent that diasporan Armenians give money to artists, they trip over themselves to send money to Armenia. I have not said much about the other major diasporan communities—France, Iran, Lebanon—but let me touch on them briefly now.

Many Armenians emigrated from Beirut during and after the Civil War of the 1970s and 1980s, and with them much of the money that supported artists. I know of only one Armenian filmmaker, Nigol Bezjian, in Beirut at this time, and he went to graduate school and made his first films in the United States. Other Armenian filmmakers from Beirut, such as Ara Madzounian, Gariné Torossian, and Hrayr Anmahouni, are living and working in North America.

In France, Armenian filmmakers are thriving, at least comparatively, and seem to be able to find funding for their work, although it is difficult to tell the realities of a situation at this distance. At least, works by Armenian artists on Armenian themes continue to be produced in France. The best-known among them, Henri Verneuil (Achod Malakian) died in 2002; currently, Serge Avedikian, Stephane Elmadjian, Robert Kechichian, Philippe Khazarian (who now resides in London), Levon Minasian, Arby Ovanessian (who is originally Iranian), and others are very active.

In Iran, Armenians have been part of filmmaking since its inception; the first feature-length fiction film made in Iran, *Abi and Rabi* (1930), was directed by Ovaness Ohanian, an Armenian who had studied at the Cinema Academy of Moscow (Talachian n.d.). However, there is no self-consciously Armenian filmmaking that I have been able to locate in Iran. For example, Ovanessian's feature length *How My Mother's Embroidered Apron Unfolds in My Life* was made after he moved to Paris; his films in Iran, such as *Spring* from 1972, may stem from Armenian sources but are received as Iranian cinema. Iranian-Armenians like Edwin Khachikian continue to this day to be integrated into the simultaneously flourishing and constrained Iranian film industry.

In Armenia, the situation is beyond desperate. Where once there was a complex system that both supported and tightly controlled filmmaking—and here Paradjanov is only the most recognizable example—now the films in the Filmadaran, the state film archive, are rotting and there is little or no state production budget. Hay Kino, the former state-run film production unit, has been privatized. What will happen to the decaying films is an open question.

The second obstacle to a notion of "Armenian" video art is that artists and audiences don't share film or cultural or linguistic histories. Audiences in the United States and Armenia have not seen the same films, do not speak the same Armenian, and do not share cultures, political philosophies, or educational values. There have been no canon critiques in Armenia, nor feminist nor postcolonial theory.[10] The situation in West Asia is quite different—at least some aspects of, for example, French literary theory of the 1960s and 1970s were available to intellectuals and artists in Lebanon, and they were being discussed. Finally, diasporan Armenians in North America and Western Europe have spent our lives wallowing in capitalist media product, even though its critique has been a hallmark of video art production. Unlike Armenians in the Republic, we have never *not* been inundated by media product. Even from this very brief description, it is probably obvious that there is very little by way of a shared context of artistic and cultural production and reception.

It becomes clear, then, that anything we might hope to hold together under the sign "Armenian video art" is far too disparate and discontiguous a set of practices to be a theoretically coherent object of study. While video styles range widely internationally in much the same way that these three pieces do, my point is that these works imagine themselves in a shared conversation without actually being in one. Each is distinct from the others in its formal strategies, its manifest content, and the conversation into which it is speaking. In the next section, I will describe each of the works briefly before turning to thinking about their aural worlds.

THREE PIECES, THREE APPROACHES

Life Is Sweet alternates long takes of a long shot of a woman writing in the air with sequences of fast intercut mediated images. It is a stark change from the filmmaking approaches of the past thirty years in Armenia. Reminiscent of early feminist filmmaking in the United States such as *Joan Does Dynasty* (Joan Braderman, 1986) and *Technology/Transformation: Wonder Woman* (Dara Birnbaum, 1979), it is, however, unlikely Diana Hakobyan has seen much of such work. Given that most filmmakers even in the United States have not seen classic works from the 1970s and 1980s by feminist filmmakers, and given that most film and video production from North America and Western Europe still remains unseen in Armenia, it seems much more likely that *Life Is Sweet* is a case of what we might call "parallel evolution." In *Life Is Sweet*, audio and visual elements both are used, though in different ways, to produce a sense of being under siege.

28 / *Listening to Video Art*

Lamb uses looped close-ups of the flesh and skin of the lamb being butchered. Balassanian here incorporates the performance art and ethnographic film genres in order to take an ordinary practice of traditional life and turn it into a metaphor for misery. Certainly, it draws on the omnipresence of sheep as figures of rural Armenian life in such films as Parajanov's *Naran Kouynuh* (*The Color of Pomegranates*, 1970), Pelechian's *Tarva Yeghanakner* (variously translated as *The Four Seasons*, *The Seasons*, and *Seasons of the Year*, 1975), Parajanov's *Ashik Kerib* (1988), Egoyan's *Calendar* (1993), and many others. The lamb of the title makes direct reference to all these works; it would be difficult to read this work well without a background in Armenian filmmaking. In some, the lambs signify idyllic rural countryside; in others, the annual cycle of farm activities (lamb is the main source of meat for Armenians); in yet others, they are hapless victims. All of these threads of how lambs are seen by Armenians come together in Balassanian's work.

And *Jagadakeer . . . between the near and East* is built on a dizzying array of camera and postproduction techniques. It draws on color-drenched experimental films such as *Unsere Afrikareise* (Peter Kubelka, 1966), *Adynata* (Leslie Thornton, 1983), and Parajanov's *Ashik Kerib*, on colonialist films like *Black Orpheus* (Marcel Camus, 1959), on Godard's films and writings, and on the development of contemporary genres that straddle the boundary between documentary and fiction. *Jagadakeer*—which means "fate" or "destiny" (literally, "written on one's forehead")—evokes both experimental traditions and colonialist film discourses by using both film and video, with very different color palettes and shooting styles.

Life Is Sweet, *Lamb*, and *Jagadakeer* speak to performance art, ethnographic film, and the personal essay respectively, and they speak to different film histories. Their sense of Armenianness is also quite distinct. *Life Is Sweet* offers a woman besieged by mediated images—a newer, and therefore quite different, problem in Armenia in comparison to western Europe and North America. *Lamb* is recording a way of life that may be at risk in both its literal and metaphoric form. And *Jagadakeer* contemplates loss and memory themselves, in ways very recognizable among U.S. diasporan thinkers and artists. In each case, one experiences an identity at risk, but in very different and geopolitically specific processes.

THREE SOUNDS, ONE CRITIQUE

There is one strategy that all three works share, however—the use of highly technologically mediated, non-synch sounds. Given how important

the little film theory there is on sound has understood synching to be, this bears notice. Both Kaja Silverman and Mary Ann Doane have argued that synch sound, especially speech, is an important guarantor of the fantasy of a unified subject. The refusal of synchronicity has for precisely this reason become a recognizable gesture in more experimental works, and these are no exception. But I think all three works under consideration here go one step further, insisting on the use of recurring and often iterative sounds as a practice in which to locate complexity and dislocation. In *Life Is Sweet*, there is a repeated sound of a person saying "ha" over and over in a sound loop during the sequences of the filmmaker writing on a glass wall, creating a sense simultaneously of human presence and technological iteration. During the edited sequences of mediated images, the sound track is a percussion techno track. Techno, as I will argue in chapter 3, disrupts narrativity with its iterative structure; in *Life Is Sweet*, both forms of the sound track evoke a sense of stasis through relentless repetition, and thus evoke a sense of hopelessness in relation to the constant and relatively new (at the time) barrage of images demanding performances of particular identities and practices, particularly performances and practices of femininity. In *Lamb*, Balassanian begins with an aural close-up of knives being sharpened and the wet sounds of butchering, drawing audience members into an aurally and affectively intimate and disturbing relationship with the flesh on the screen. The sounds push the audience away, enter our bodies, ask us to hear ourselves being flayed. The sounds are intrusive and upsetting, insisting that we hear the sharp edge of the knife blade, the soft penetrability of the wet flesh, and the violent contact between the two. In *Jagadakeer . . . between the near and East*, we hear many sounds—a film projector, traffic, cicadas, static. Early in the film, an image of hands opening a pomegranate is synched to the sound of an old-fashioned flashbulb popping. There is also the sound of impedance feedback, as one heard when tuning an old vacuum-tube console radio. The sounds document memory's mediators (photos, film, radio), reminding us that memory is constantly made and unmade by mediation.

In each case, the sounds invite responses and relationships far more variable and dense than film theories have articulated: nonnarrative and therefore not trading in identification, these works induce, evoke, provoke affective, visceral responses. In *Lamb*, distance from the being-butchered flesh is impossible, primarily because of the intimacy and insistence of the sound. In *Life Is Sweet*, the iterative sounds draw us into a machinic place, where the filmmaker is no longer figuring herself as a subject at all. And *Jagadakeer* relies on sound to produce a sense of nostalgia in a

different register than the visual images; it is in the collision of the sound and the visual that the film takes place. The visual images are of the "old country"—family photographs and staged scenes of rural nineteenth-century Armenian life. The sounds, however, are predominantly American and twentieth century: the sounds of flashbulbs, old radios, and a game of *Jeopardy* (a television game show that has run with a few gaps since its 1964 debut). Three voices—two contestants and a game show host—are intercut throughout the film. The questions center on facts about Armenia and the 1915 genocide; some are obvious, others less so. But the game show format suggests that our identifications as U.S. Armenians are highly mediated, both by our geographical displacement and lack of intimate knowledge, on the one hand, and by Armenia's absence on the American cultural map on the other.

The music of *Jagadakeer* also begs reading. The first cue begins just before the words "a KINOstudio film" appear in white lettering on the black screen. It fades out before the first image appears; it is a solo oud, an instrument of some debate in Armenian communities.[11] The oud is a central instrument in the musical practices of Anatolian Armenians, those who constituted the vast majority in the diasporan communities of West Asia and North and South America for most of the twentieth century. It is also an important part of Arab and Turkish musical cultures. It is, one might argue, a distinctly post-Ottoman instrument.[12]

The oud does not, however, figure largely in the musical practices of Armenians in the Caucasus. The republic's status as the homeland of diasporan fantasies was relatively untroubled when it was understood as Communist, because Soviet Socialism made participating in life there both practically difficult and ideologically undesirable for most diasporan Armenians. Now, there are no practical and few ideological obstacles to participating in the life of the homeland, and the vast differences in language, food, music, and the like are center stage. For example, whereas a film made in Armenia would likely begin with a *duduk* (a native wind instrument made famous in the west by Djivan Gasparyan's playing in Peter Gabriel's score for *The Last Temptation of Christ*), Bastajian's choice of oud refers to both West Asian practices and ninety-plus years of Armenians in America making music. Armenians from the republic often disapprove of our attachment in the diaspora to the oud, precisely because it brings with it associations to the Turkish and Arab worlds that they find undesirable. (Given that they share borders with both Turkey and Iran, this always seems to me a strange moment of hairsplitting, and deeply imbedded in both Armenian anti-Muslim prejudice and the

aspiration to European belonging.) The very instrument, or its aural presence as a timbre in even a short cue, makes a declaration that this film is a diasporan production that is concerned with the questions that haunt diasporan Armenians.

THREE CONCLUSIONS

This consideration of three works by contemporary women video artists has addressed several different levels of concerns with ubiquitous listening: first, as I (and many other sound and music scholars) have argued, that videos cannot be understood or studied as "visual culture"; second, that the shifts in reception context between diaspora and homeland make reading the films complicated;[13] and third, that identity needs to be articulated to affect, as I suggested in the introduction.

This is no small matter, of course. From Deleuze and Guattari (1987) through to contemporary theorists, affect is understood as a swirling, whirling field of intensities that cannot be contained or held still or made positional. And yet in the major works in the field, there are hints at such a need. As I discussed in the introduction, Massumi (2002) says about the relation between stasis and process, "The problem is no longer to explain how there can be change given positioning. The problem is to explain the wonder that there can be stasis given the primacy of process" (7–8). It is clear here that by positioning he means at least in part the primacy of identity in the theories of culture over the past thirty or so years. But he doesn't say that positioning doesn't exist, or that it should be ignored—he says, rather, that it is a "wonder" that it can exist.

In the videos that I have been discussing, ubiquitous listening is a strong component of the way they do their work on audiences. Without listening to the works, many of the articulations between the swirl of affect and positional identities would be less clear. The presence of the United States in *Jagadakeer* is almost purely aural. The intense affect associated with the media blitz of *Life Is Sweet* would be lost without the sound track's mechanically repeated sounds. And the intimacy of the wet sounds of the lamb flesh and the sharp, grating sound of the knives being sharpened conditions, I would argue, bodily experiences of the flesh being cut that first trigger a transbodily response, a shared shudder, before becoming a sense of horror of both sides of the experience of butchering the carcass in *Lamb*, and that is at least as important to the way the video works on its perceivers as is the history of sheep in Armenian films.[14] The audio

track, in other words, uses the affective response that takes place to draw us into a very temporary distributed subjectivity. Then listener/viewers, non-Armenians and Armenians alike, no matter where our Armenianness is rooted, feel with the Karabaghtsis (understood as nationalist freedom fighters, both soldiers and their families) who are invoked by the carcass. What is produced, then, may or may not attach itself to a national identity; the distributed subjectivity, in motion as always, draws on only the sounds of blades and flesh to evoke horror and loss.

In all three works I have discussed in this chapter, affective responses draw us as listeners and viewers into a temporary flow of distributed subjectivity. Our responses will not all be identical—we won't all know what lambs or ouds mean, for just two blatant examples—but the power of these artists is in ensuring that that doesn't matter. The affects being evoked, whether loss or horror or besiegedness, do not require knowledge, or a particular point of origin, nor do they require a particular end point, such as identity. Rather, they come into being for a short period of time, drawing their perceivers into a shared field of subjectivity. Whether we then opt to freeze them into an identity, and to what end, will depend on many factors, but for the duration of the works and for a brief while afterward, something very fragile and temporary came into being—a new field of distributed subjectivity.

3 "BOOM!" Is the Next Big Thing

> As a system by which the conceptual territories noise/music/
> silence are mapped and managed, the political ontology of
> sound is also a political theory of relationships: there is no
> quiet without less quiet, no noisy without less noisy, no music
> without its forbidden others. . . . They all make their way . . .
> into the mechanisms by which the public sphere is managed,
> into the discourses by which noise-obsessed neighbours, anxious
> public license granters, social theorists and policy makers seek to
> discipline and silence the social.
>
> IAN BIDDLE, "Visitors, or The Political Ontology of Noise" (2009)

The boundaries between and among the terms *noise*, *sound*, and *music* have been receiving some scholarly attention lately, and from interesting directions. In "Visitors, or The Political Ontology of Noise," Ian Biddle argues that noise is fundamental to sociality, in much the same way as this book argues for sound and distributed subjectivity. There is scholarship on noise music (Hegarty 2007; Demers 2010), and there is the growing field of sound studies. Significantly, the examination of these boundaries comes at a time when the divisions are less and less clear in the experiential sound world.

In his essay "Music" in *Key Terms in Popular Music Studies* (1999), David Brackett argues that many new forms of music are labeled noise. He compares the discourses surrounding the advents of rock and rap, showing that each was received as noise in their early years. He suggests from this that music is defined by the displacement of social fears onto aesthetic criticism. He says: "The dominant beliefs of the early fifties that excluded rhythm and blues from consideration as music and the point of view that dismissed rap as non-music (even rappers celebrated its noisiness) may be fading, but covert assumptions about what music is and is not continue to play a crucial role in how social groups associated with particular types of music are portrayed in the mass media" (Brackett 1999: 139). With, for example, Jacques Attali (1985) and Ian Biddle (2009), Brackett is here pointing out that noise and music are embedded in—that is, both define and are defined by—relations of power. As Attali puts it: "When power wants to make people *forget*, music is ritual *sacrifice*, the scapegoat; when

it wants them to *believe*, music is enactment, *representation;* when it wants to *silence* them, it is reproduced, normalized, *repetition*. Thus it heralds the subversion of both the existing code and the power in the making, well before the latter is in place" (Attali 1985: 20). Attali's well-known argument is that music has a singular capacity to signal power relations in the making, that we can, in other words, hear power before we see it or feel it, if we choose to listen.

According to Attali's logic, then, Brackett's argument might well also be inverted. Perhaps rock and rap *are* noise, in that they ask us to hear the history of music in the twentieth century as an increasing absorption of noise into music. Perhaps they herald new relations of power. Certainly a range of examples—from John Cage's writings and compositions to guitar feedback to scratching—supports such a contention. Sampling takes this a step further, however. In providing the raw material of both contemporary urban and electronic genres, sampling technologies have turned music into sound and back again, treating previously recorded music as the functional equivalent of industrial sounds and noises for composers of *"musique concrète"* and groups like Kraftwerk. From a different direction, the growth of Muzak over the twentieth century has turned music into sound or noise for most of us at one point or another.

The evaporating segregation of sound, noise, and music has had a pronounced effect on film sound editing and scoring practices. For example, Daniel Falck (n.d.) has argued that speech in *The Thin Red Line* (1998, directed by Terrence Malick, music by Hans Zimmer) is often deprivileged, mumbled; in these cases, he suggests that it can be thought of, after Michel Chion (1994), as "emanation speech," a "line of contour of a speaking body . . . in the same way as a silhouette is a line of contour of a visual body." Falck makes the case that music, speech and sound in *The Thin Red Line* are leveled out and used together to create a world not dependent a priori on the images.

STRUCTURES AND BOUNDARIES

Falck's observation is one among many examples of the dissolving boundaries among kinds of sounds in which I am interested. The sound track of *The Cell* (2000, directed by Tarsem Singh, music by Howard Shore), which I will consider here in some detail, is not primarily, or even substantially, musical; it projects the interior world of its characters in sound as much as it envisions them in images. (The plot is relatively simple: a serial killer has become catatonic, and Jennifer Lopez works with an

experimental technology that enables her to get into someone's mind. With this method, they hope to find the girl that the killer's got locked up before his preset machinery drowns her.) For example, the opening sequence takes place in a desert, with sweeping vistas of dunes. The instrumentation of the musical cue includes *ghaita* (an Arab double-reed instrument), *lira* (a bamboo flute), and double-headed Moroccan drums. Parts of the music use microtonal modes typical of Arabic musics, suggesting in some of the basic musical materials that the setting is "Middle Eastern," even though we eventually learn that the landscape is in the mind of Edward, a psychotically disturbed young boy in Southern California.[1] But while the markers signifying the Middle East are clear, there are other musical sounds as well. In fact, the cue signals the unusual strategy of the entire score; it is a work that is as much sound design as composition.

The Cell is a very clear example of the dissolution of boundaries among noise, sound, and music. Howard Shore is well known for using this compositional strategy, but there are many other examples across styles and genres. Two brief examples: (1) at the onset of the terrible, incurable headaches that attack main character Max Cohen (Sean Gullette) in *Pi* (Darren Aronofsky, USA, 1998), what sounds like the beginning of a dance bass line becomes the throbbing of his head, mixed with sounds that may or may not be what Max hears and may or may not be music. (2) The opening sequence of *Hackers* (Iain Softley, USA, 1995) combines machine throbs, dog barks, a music box, and other sounds that both do and do not connect to visual materials, followed after the cut from slo-mo to real-time visuals by a thumping machine sound that could easily be a drum machine. These examples suggest at least that a very wide range of sounds have become credible and commonplace compositional materials since at least the mid–1990s.

In this chapter, I'm using *The Cell* as both a case study and a point of departure to consider this dissolution as one (among several) auditory markers of a shift in narrativity. And while there has been, at least since Jean-Francois Lyotard's *The Postmodern Condition* (1984), a discussion of the demise of grand narratives, most models of power and culture still rely on grand narratives of one kind or another. To my ears, then, *The Cell* and other films like it sound a call to rethink how to study power and culture, a call that is being heard in work on the senses, on affect, and in a range of places around the academy.

Before turning to *The Cell*, however, I want to take a detour into video game studies, where the question of narrative was, for a time, hotly debated. In the late 1990s, video game scholar Gonzalo Frasca posited a

distinction between ludologists, whom he argued saw games as a distinct cultural form, and narratologists, whom he represented as believing that games are narrative forms. This debate continued for quite some time, with many people arguing that there really was no debate, and that the positions had been caricatures. Even Frasca himself argued this in his 2003 essay "Ludologists Love Stories, Too: Notes from a Debate That Never Took Place." In the abstract of that article, he says: "This article aims at showing that this description of the participants is erroneous. What is more, this debate as presented never really took place because it was cluttered with a series of misunderstandings and misconceptions that need to be clarified if we want to seriously discuss the role of narrative in videogames." There were a number of defenses of a formalist approach to game studies, one that focused on game processes and mechanics; the main names associated with this approach are Frasca, Espen Aarseth, and Jesper Juul. The narratologists are a bit harder to identify, although the one name that is frequently mentioned in this regard is Janet Murray. In 2005, however, in her preface to the keynote talk at DiGRA (Digital Games Research Association), which was entitled "The Last Word on Ludology v Narratology in Game Studies," she said: "In fact, no one has been interested in making the argument that there is no difference between games and stories or that games are merely a subset of stories. Those interested in both games and stories see game elements in stories and story elements in games: interpenetrating sibling categories, neither of which completely subsumes the other. The ludology v narratology argument can never be resolved because one group of people is defining both sides of it. The 'ludologists' are debating a phantom of their own creation" (Murray 2005: 3). The point in game studies is identical to the point I will make throughout this chapter: it is not a matter of whether or not something is narrative in form or structure, but rather whether or not narrative is the primary motor of its internal logic. Whereas some games are highly story-driven, it is more common for them to be organized by the features of game play. And whereas most films are highly narrative, some films, like those under discussion in this chapter, focus more centrally on the sensory experience rather than the traditional features of narrative, such as plot structure and character development.

THE CELL

In the opening sequence of *The Cell,* sounds enter in the following order: wind, *lira,* jangling metal, whooshes, cello drone, horse galloping, cellos,

Moroccan percussion, *ghaita*. And that's just the first minute or so of the cue. This layering of sound signals the strategy of *The Cell*'s score, exemplifying the evaporating segregations among aural materials. It suggests, among other things, a different register for the sound track, perhaps laying to rest once and for all the presumptions that sound and music should be considered separately, and that they are secondary to a film's visual materials.

The sound track of *The Cell* is not primarily, or even substantially, musical. Nor does it subordinate its aural world to its visual one. *The Cell* projects the interior world of its characters in hybrid sound forms as much as it envisions it in images. To return to the film's opening sequence, the overall effect is more layers of sounds than a through-realized cue. The invocation of West Asian or North African music (the musicians are Bachir Attar and the Master Musicians of Jajouka) serves a sensory rather than a narrative purpose; it signifies dryness and desert, the absence of water, the stuff that so terrifies Edward. In fact, the same timbres and textures appear next alongside a sweep of dry, brown fields in central California, and follow a cut to our first view of Carl Rudolph Stargher (Vincent D'Onofrio), a serial killer, but the *lira* and *ghaita* do not accompany the subsequent cuts to the same terrain. They appear next not on the next cut to Stargher in the same setting, but when Catherine (Jennifer Lopez) dreams of Edward's internal desert scene, and then much later when she enters Carl's mind for the second time, a moment that shares nothing obvious with any of the prior Moroccan cues. But since water also figures so prominently in Carl's imagination—his trauma also having been triggered by a water event, his baptism—the sounds of the Master Musicians of Jajouka slip from signifying deserts to mindscapes. The uses of the timbres and melodic materials of Jajouka do not follow a simple or linear logic in the film; rather, they are given new meanings by their uses in the score.

Many of the cues are built of layers of traditionally musical and traditionally sound effects materials, utterly blurring the boundaries between the two. For example, Catherine's first entrance into Stargher's mind begins with a throbbing bass string sequence that clearly signifies "ominous." Layer upon layer is added to it: tympani, midrange strings, horns, a cash register, a baby crying, birds, the distorted sounds of a baptism, machine sounds. The sounds recede layer by layer and are replaced by extremely distorted sounds matched by surreal images: tight close-ups of a drop of blood falling in water and a grasshopper jumping, followed by a medium shot of a dog shaking off water and blood. The sound associated with each

is extremely exaggerated and bears no resemblance to what one might hear from any of the visually represented spaces. Catherine finally meets up with the young boy Carl in a tiled room with a horse and a clock, with extreme echo in the ambient sound, pronounced ticking of several clocks, and increasing layers of sounds and instrumental timbres.

This is neither music nor not music, but rather a textural use of sound that disregards most, if not all, the "laws" of classic Hollywood film scoring technique. (On the basic rules of this practice, see, e.g., Gorbman 1987: 73 et passim; or Kassabian 2001a: 37–60.) Instead, in this cue, the sound music is foregrounded for attention; it is not a signifier of emotion, nor does it provide continuity or unity. It is not subordinate to the narrative or the visuals, but rather on par with them in producing a jumble of affect.

The Cell initiates a different kind of sound track where the boundaries we are used to recede in favor of a different logic. In an impressive early essay, Mary Ann Doane argues that synch sound in film is an important ideological force: "The drama played out on the Hollywood screen must be paralleled by the drama played out over the body of the spectator— a body positioned as unified and nonfragmented. The visual illusion of position is matched by an aural illusion of position. The ideology of matching is an obsession which pervades the practice of sound-track construction" (Doane 1985: 60). But *The Cell* actively strives to break that illusion, to mismatch visual and aural position, to create an affective sound world by using a range of techniques such as sound close-ups (e.g., the horse's breathing in the opening sequence) and extreme echo (e.g., Catherine's and Edward's voices in the opening sequence) to signify perceived rather than objective sound. This is not a sound track of the conscious, material, rational world, not realist in any sense. It does not follow Doane's logic. It is driven instead by the logic of affect, by the loss of boundaries. And not only are the boundaries of sound, noise, and music and those of the character erased—the technology central to the film's plot erases the boundaries between and among subjects, so that we cannot distinguish between the sound worlds of the psychologist and the patient, or ultimately among those of the cop, the psychologist, and the patient together.

Much of the film takes place inside the mind of Stargher, the serial killer, who has Waylon's Infraction and whose mind Catherine has entered through an experimental technology in order to find his imprisoned, soon-to-be-next victim.[2] As she meanders through the rooms and corridors of his strange mind, we are led through it by richly textured terrains of both aural and visual materials not organized by principles of narrative or of

conscious, rational thought. It is reasonably clear that the topography we are exploring is Stargher's interior construction, a place to which he withdraws as needed and into which both the psychologist and the cop venture. In Stargher's mind, we cannot distinguish between what he is thinking—does he indeed think while in this coma?—and what Catherine sees.

POINT OF AUDITION

Throughout these long sequences, it is impossible to determine the subject position being offered, because there is no physical or psychological boundary between Stargher and Catherine, nor is there any clear separation between Stargher's conscious and unconscious minds. (On the one hand, he is in an extremely shut down state, so perhaps nothing is conscious; on the other hand, the boy Carl and the various monsters seem to represent different parts of him.) One way that *The Cell* highlights the bizarre status of this domain is by problematizing point of audition. Point of audition is an idea that has been promulgated by both Rick Altman and Michel Chion in different ways. Chion suggests that point of audition, like point of view, has two senses, not entirely overlapping: (1) spatial, the way that sound locates one in filmic space; and (2) subjective, the character through whom one hears. In this way, Chion treats point of audition as a generalized phenomenon, like point of view or spectator position. All moments in film, then, have a point of audition; it is an auditory representational or narrative strategy.

For Rick Altman, however, point-of-audition sound is a tactic, one among many in the world of film sound. In his view, point-of-audition sound is sound that clearly articulates a particular spatial and subjective position. So, for a clear and lovely example, there is a moment in *Garden State* (Zach Braff, USA, 2004) when the main character, Andrew Largeman (Zach Braff), meets the character who will be his love interest, Sam (Natalie Portman), in a neurologist's office. She wants him to hear a track from the CD she's listening to, so she passes him her headphones. As she takes them off, we begin to hear the music, increasing in volume as he takes the headphones from her and brings them closer to his ears, slowly replacing room tone; when they are fitted on his head, there is no sound on the sound track except the music; as he removes the headphones, the process is reversed. This is an extreme point-of-audition sound experience of the sort Altman discusses; as is perhaps obvious, in these moments, Chion's spatial and subjective senses will coincide completely.

In narratology, Gerard Genette makes a distinction more similar to Chion's than to Altman's. He offers the term *focalization* as a way to hold apart the knowledge of the narrator and the characters; the narrator can know more than the characters, which he terms *zero focalization*, or the same amount as the characters, that is, *internal focalization*, or less than the characters, that is, *external focalization* (Genette 1972).[3] Internal focalization offers an especially unified perspective and worldview, like Altman's point of audition. Similarly, point of audition in both of Chion's senses can coincide, at which point the distinct terminologies overlap, and sound then locates perceivers in a particular subject position. At least since the rise of the novel, such positioning has been one of the central requirements of narrative and narrativity. Shifts away from clear and consistent offers of such positions, then, indicate an erosion of narrative as we commonly experience it, and thus of many, many of the theoretical insights predicated on it.[4] Many feminist theories of film and of music, for example, begin with the basic presumptions of narrative as we generally think of it in modernity—a linear structure, a central individual character, and a beginning and end. These works consider linear narrative forms as masculine.[5] But they also often rely on theories with highly narrative grounding, such as Marxism and psychoanalysis. Position, then, and more specifically point of audition, is crucial to how films locate film perceivers in a field of distributed subjectivity. In this way, point of audition should be seen as a necessary guarantor of subject positionality and of narrativity, that is, of a film's offer of (the fantasy of) a unified, discrete subject (presuming it makes such an offer; see below).

Point of audition in *The Cell* is a strange phenomenon; it fails us in every sense of the term and therefore fails as a guarantor of subject positionality and narrativity. We are not placed in the film's space by sounds, nor do we have a clear subjective location. Are we in Catherine's head? Stargher's? Peter's? all three at once? Sounds do not provide adequate information about spatial relations—there is no relationship between Catherine's location in the spatial world in Stargher's mind and the volume or placement of the sounds we hear. Moreover, the entire world is located in a single point of audition, within which another character is "moving." Or put another way, the sound materials while Catherine and Peter are in Stargher's mind make it clear that we are hearing a very subjective point of audition; there is no relationship between echo or volume and space. But we can never be clear *whose* subjective point of audition we are occupying; is it that of the host (Stargher) or the guest/intruder (Catherine, Peter)? Thus, not only is sound space constructed according to inconsistent principles, but it is also

indistinguishable in terms of whose point of audition we're being asked to occupy, and in fact whether there is even just one. Insofar as point of audition implies subject positioning, our placement in the sound world of the film is not of much help.

It is revealing, instead, to rethink these moments in terms of affect and distributed subjectivity. Catherine insists on going into the mind of Stargher, the serial killer, in case she can help save the trapped victim. She shares subjective space with Stargher, by choice and design. This is an impressive, even beautiful literalization of distributed subjectivity. Stargher doesn't have the option of saying no: Catherine and her boss and the cops have walked into his mental space without invitation or preparation. This seems to me to be an excellent metaphor for distributed subjectivity: there is structural equality, at least at the level of technology, but other forces coagulate into a differential relationship, perhaps even one in which some figures make shadow shapes on the wall. While some have the power to exit and enter psyches at will, others (like Stargher) have not.

But if the scenes inside Stargher's mind destabilize point of audition, the two scenes of his schizophrenic episodes are even more challenging. When he's watching his next victim from his car and when he's in his bathtub, we hear a garble of sounds. In the first case, a passing motorcycle engine sounds as if it is in the car with him, then it is layered with high whines (possibly synthesized strings) and a distorted male voice that is extremely slowed down. It is clear that the voice (or voices) is speaking, but no words are intelligible. In the second case, when Stargher is in the bathtub—his last conscious moments—we hear a faint high drone, to which the same morphed voice is added, then factory sounds, and a sound like a car starting. On a cut away from his interior soundscape to the police arriving at his house, repetitive string figures are added—the first overtly musical sounds in the cue. But while the audio in this sequence is a combination of noises and sounds, they are clearly treated compositionally—perhaps even instrumentally—as controlled and organized components of a score.

In some ways, this sequence is still more disorienting than the later one I already described. Whereas the scenes discussed above take place in Stargher's mind, this one is filmed from outside his body, but the sounds we hear are clearly internal to Stargher's world. There is a clear mismatch between what we see and hear, between point of audition and point of view. There is, then, no point of audition that can be inhabited by the film's perceiver with any comfort or predictability. Doane's obsessive matching is completely violated. Here, as in almost every other important sequence, the sound track insists on being heard as not only subjective, but troubled,

unreliable, and impossible to locate in relation to either character or physical space.

In such moments and throughout *The Cell*, point of audition loses its reliability as a marker of available or encouraged subject positionalities, suggesting shifts in narrative relations and the failure of a complete, discrete individual body. Through a collapse of sound, noise, and music, point of audition is challenged, disrupted, problematized so that no comfortable subject positionality can be engaged. In this way, *The Cell* is a defining moment among a group of films—science fiction films such as *Hackers* (Iain Softley, USA, 1995) and *Lara Croft: Tomb Raider* (discussed below; Simon West, UK/Germany/USA/Japan, 2001), and self-consciously postmodernist films such as *Run Lola Run* (Tom Tykwer, Germany, 1998), *Pi* (Darren Aronofsky, USA, 1998), and *Tank Girl* (Rachel Talaley, USA, 1995)—in which the sound track, in all its complexities, demands enormous attention and priority, becoming a peer to the visual in every important sense. These films are slowly pulling away from linear narrativity as we know it from most novels and classical Hollywood films; they deemphasize narrative structure and identification processes in favor of a different organizing principle, one in which the moment supersedes the story. The piecemeal, iterative narrativity of video games (and, to a lesser extent, of comic books and graphic novels) is developing a film language of its own. And in this shift, narrativity is subordinated to sensory experiences, with a new emphasis placed on sound tracks created from very different aural and musical materials. Such films—and other works using related principles—demand new theories, based on the loss of boundaries, on the aural logics of dance music, iteration, and sound collisions and on the nonlinear narrative worlds of video games.

Before moving on to other films, I want to return to the question of narrativity and video games that I raised earlier. The narratology-versus-ludology debate, as I suggested above, and as most game scholars have now agreed, needs to be thought of in a more supple, subtle way. There are at least two further questions that need to be considered: are all narratives linear narratives? And is it possible to think of "narrativeness" as a spectrum—like attention, for instance—rather than as an on/off switch? It would make no sense, simply put, to think of *The Cell* as nonnarrative, but it is not only possible but quite productive to think of it as *less* narrative than more classically structured films. I am arguing that *The Cell*, and many films before and since, are not primarily concerned with plot, character development, or even subtext and allegory and other traditional concerns of linear narratives, but rather with sensory experiences.

(This would, of course, explain the return of both 3D film technologies and "smell-o-vision" experiments [see, e.g., reports about the development of Smell-O-Vision for television (Hickey 2010)].[6]) While perspective and point of audition are important components of linear narrativity, this emphasis on the senses makes them all the more central to a film's address to its perceivers.

THE MATRIX AND LARA CROFT

There are many films that proclaim these shifts; two early participants are *The Matrix* (1999, directed by Andy and Larry Wachowski, music by Don Davis) and *Lara Croft: Tomb Raider* (2001, directed by Simon West, music by Graeme Revell). Each approaches this emphasis on the senses differently, taking it in very distinct and gendered directions. There are, however, some striking similarities between *The Matrix* and *Tomb Raider*. Each focuses on an action hero; *The Matrix* generated a series of comic books (Burlyman Entertainment, vol. 1, 2003; vol. 2, 2005), and *Tomb Raider* began as a now-classic computer game, first released in 1996.[7] Each plot demands that its hero save the world, and it hinges on the fact that the hero is uniquely equipped to do so.

It is important to remember that saving the world does not mandate narrative closure. While serials have long been an important part of film history (think *Flash Gordon* or *Indiana Jones*), sequels are becoming more and more expected. For instance, as the newspapers and magazines gleefully reported, all three *Lord of the Rings* films were made before the first was released. Serials and sequels follow the logic of comic books—an unending but nonetheless linear logic. So, for example, the *Star Wars* films are referred to in the order of their chronology in the story world, not the order in which they were produced.

But in the case of *The Matrix* and *Lara Croft: Tomb Raider*, something else, something more, is at work—a logic of endless iteration. They have little devotion to linearity. Even in the stories themselves, moving back and forth through time is thematized. This move away from linearity and between realities is clearly heard in *The Matrix* and *Tomb Raider*, heralding a film form that shares a great deal with video games and dance culture, based on iteration. That form is established significantly through music.

Each film uses contemporary popular music in its score. But there is almost no overlap in the styles and genres. *The Matrix*, with its future technological dystopia, does not use techno, but rather a mix of shock rock (e.g., Marilyn Manson) and rap metal (e.g., Rage Against the Machine)

TABLE 1. *The Matrix*
Sound track albums tracks versus songs listed in film credits

Title	Artist
"Dissolved Girl"	Massive Attack
"Dragula (Hot Rod Herman Mix)"	Rob Zombie
"Leave You Far Behind (Lunatics Roller Coaster Mix)"	Lunatic calm
"Mindfields"	Prodigy
"Clubbed to Death (Kurayamino Mix)"	Rob D
* "Minor Swing"	Django Reinhardt
* "Begin the Run"	(from *Night of the Lepus* aka *Night of the Lepus*, 1972)
"I'm Beginning to See the Light"	Duke Ellington
"Spybreak"	Propellerheads
"Wake Up"	Rage Against the Machine
"Rock Is Dead"	Marilyn Manson
† "Bad Blood"	Ministry
† "My Own Summer"	Deftones
† "Ultrasonic Sound"	Hive
† "Look to Your Orb for the Warning"	Monster Magnet
† "Du Hast"	Rammstein

* song appears in film credits but not on CD
† song appears on CD but not in film credits

(see table 1). *Tomb Raider*'s plot centers on ancient mysteries and the once-every-five-thousand-years planetary alignment, but despite its mythical content, the sound track is techno/electronica (e.g., Chemical Brothers, Fatboy Slim, Moby), full of machine and electronic sounds (see table 2). Moreover, while *The Matrix* released two sound track CDs—one of songs, the other of composed material—it only uses three of the songs noticeably in the film. *Tomb Raider*, however, makes ample use of its techno songs, using them for at least eight cues, to score everything from establishing shots to action sequences. And finally, the musics have very different textures and vocabularies.

Both sound tracks use songs whose musical vocabularies depend on repetition more than on development. Most of Western music, at least since the late 1600s, has been organized by a logic of development, in which some goal is projected and then reached. This is certainly truer of concert-hall music than other forms, but it has some power in describing

TABLE 2. *Lara Croft: Tomb Raider*
Sound track albums tracks versus songs listed in film credits

Title	Artist
"Elevation (Tomb Raider Mix)"	U2
"Absurd"	Fluke
"Speedballin' "	Outkast
"Terra Firma (Lara's Mix)"	Delerium featuring Aude
"The Revolution"	BT
# "Lila"	Vas
# "Piano Concerto in f minor"	J. S. Bach
"Satellite"	Bosco
"Devil's Nightmare"	Oxide & Neutrino
"Illuminati"	Fatboy Slim
"Get Ur Freak On (Remix)"	Missy Elliott featuring Nelly Furtado
"Song of Life"	Leftfield
"Ain't Never Learned"	Moby
"Deep"	Trent Reznor
"Inhaler"	Craig Armstrong
"Edge Hill"	Groove Armada
"Galaxy Bounce"	Chemical Bros.
"Where's Your Head At"	Basement Jaxx

\# song appears in film credits but not on CD

most popular musics as well. This logic of development does not, however, describe the musics used in *The Matrix* and *Tomb Raider*. One might be tempted to say that they are cyclical, as opposed to linear, but the repetitions are different from standard strophic song forms; there is more emphasis on repeated fragments than on a shape and its returns. Overall, in other words, they share a break from more traditional Western musical patterns of goal-oriented motion.[8]

The styles of repetition, however, differ in significant ways. The techno musical world of *Tomb Raider* is almost completely devoid of directionality. The tracks use a number of gestures to create this sense. First, and most obvious, is the omnipresence of sampled loops. In almost every cut, we hear not just repetitions of the same phrase, but iterations of the same performance of the same phrase. There is no development, as there is in restatements of a phrase or theme in concert-hall music or, in different ways, in many forms of popular music (if we consider repetition with

differences, for example, as "development"). Second, and relatedly, there is a very high profile of mechanical intervention. The loops certainly mark that, as do many of the sounds themselves. Moreover, the samples are often cut off at the beginning and end, so that we can only hear the middle of the sound, as it were. All sounds can be described as having a beginning, middle, and end (often called attack, sustain, and decay). Many sampled sounds in *Tomb Raider* songs have clipped off the attacks and decays to leave only sustain—in other words, they are all middle, with no beginning or end. This forecloses the possibility of a sense of narrative or development, replacing it with an insistence on technicity, that is, the technological basis of the sounds themselves and how they came into being. And finally, the rhythmic patterns are often unaccented or less accented, so that they emphasize something like presence or immediacy over drive.

It might be tempting to imagine techno as an opposition to a more phallic, directional model. Much of the writing on music and gender, at least since Susan McClary's *Feminine Endings*, has relied on the notion that narrative is structurally masculine. As Robert Scholes says:

> For what connects fiction—and music—with sex is the fundamental orgastic rhythm of tumescence and detumescence, of tension and resolution, of intensification to the point of climax and consummation. In the sophisticated forms of fiction, as in the sophisticated practices of sex, much of the art consists of delaying climax within the framework of desire in order to prolong the pleasurable act itself. When we look at fiction with respect to its form alone, we see a pattern of events designed to move toward climax and resolution, balanced by a counter-pattern of events designed to delay this very climax and resolution. (as quoted in de Lauretis 1984: 108)

Certainly much music can make the same claims. Tonality itself requires such diversion and completion as Scholes describes. Thus, in comparison to such clear linearity and narrative development as sonata form, for instance, and even in comparison to most rock, techno is certainly not narrative, developmental, masculine. But if techno opposes phallic directionality, is it therefore feminine? It certainly does not offer itself as a cultural expression of care, one thread of contemporary feminist thinking. Nor is it significantly produced by women—men far outnumber women as DJs. Nor is techno circular or recursive in structure, which are the most commonly posited feminine alternatives to phallic linearity.[9]

The very technicity of the musical materials refuses any of the romantic hearkening back to pre-Enlightenment times or matriarchies that often undergird such arguments. Instead, I am arguing, narrativity is no longer

the defining characteristic of gendered cultural forms. Techno is forging a new space of gender, in which directionality is inconsequential.

The Matrix sound track, on the other hand, is full of directionality, but not of a traditional kind. Neither the songs nor the composed score unfolds according to a necessary logic—in fact, most of the songs stop rather than ending at all. "Wake Up" by Rage Against the Machine is one of many songs on this album that kind of fades out at the end. Rather than reaching an obvious developmental conclusion, there are a series of phrases of different textures and tempos that simply stop at some point. Even the fan guitar tablatures online struggle to notate how this song closes:

OUTRO

kind wiggle back and forth on fret

WAH

G:-17-|

Transcribed by: Kevin Dole[10]

BRIDGE 1 (screaching part)

RIFF 1 ("WAAAAAKE UUUP!")

SECOND SOLO (not tabbed)

OUTRO

that's it!

Transcribed by Marcel[11]

The rest of the song is parts that I have written, just put em tagether. Im sorry, I am havin trouble tabbin the second solo. If you write me, ill help ya tha best I can—just use tha harmonizer?[12]

Nonetheless, *The Matrix*'s songs do display much more harmonic motion than the songs in *Tomb Raider*. In other words, they move toward and away from a recognizable center. And while the *Tomb Raider* songs rarely have accented rhythmic patterns, these songs rely on highly repetitive patterns in the bass, percussion, and/or vocals to motor them forward. The melody of Rob Zombie's "Dragula," for example, uses the following pattern:

The pattern repeats throughout the song, creating a sense of direction and expectation. This kind of structure is widespread throughout the songs in

The Matrix. In combination with the lack of closure in these songs, the patterns that motor this music amount to forward motion without a goal or endpoint.

The songs of *The Matrix* comment on existing sound worlds in other ways. First, they betray their own directionality by refusing it a telos. Second, they blur the distinctions between voice and instrument and between noise and music, altering and morphing voices in all kinds of ways. In ways that are reminiscent of Stargher's internal soundscape in *The Cell,* many of these songs alter voices to signify threat and rage; the mutated voices mark affects of alienation and anger that are central to the sound world of *The Matrix*. And arguably, this is an important register for blurring the boundaries between human and machine, which is the central thematic of the film.[13]

The Matrix stops without ending; after the resolution of the plot line, we inexplicably find Neo back in the Matrix. This is the identical gesture that was set up repeatedly by the songs, and is echoed in the songs on the sound track CD that were not used in the film. This is not a closed narrative of the kind to which we are accustomed. Something else is going on here.

What I want to take from these textual details is that some films have found a new vocabulary, one that is not linear but iterative, one shared by techno and video games but not symphonies and novels. In these films, narrative is not primary, but rather equal, if not subordinate, to the sensory experiences of sight and sound. In them, some possibilities are foreclosed, such as traditional character development, in favor of some new ones.[14]

None of these films does a very good job of soliciting identifications from audience members with characters or scenarios in the films. In fact, two of them—*The Cell* and *Lara Croft: Tomb Raider*—were widely perceived as bad films, which I would argue is the direct outcome of their "failure" to encourage and engage identifications. For another, more recent example, *Sucker Punch* (Zach Snyder, USA, 2011), a film that works precisely along the lines I have described above, got a complete thrashing from Frank Kermode in a review on BBC Radio 5 Live. He ranted on about it for nearly ten minutes, insisting on saying the name of the director, Zack Snyder, in an obnoxious high-pitched voice that had listeners calling in to complain. His review was nothing short of pure vitriol, because he fails to understand that his usual standards for the film are inappropriate. He insists that Snyder's only interest is in costumes, without discussing the intense computer-generated imagery or the very dense, thickly designed and familiar sound track, with covers of songs like "Sweet Dreams" and "White Rabbit." He goes so far as to say that a discussion of the sexual

politics of the film would be to give it more credit than it deserves. "He [Snyder] appears to have no understanding of anything below surface and costume.... He is one of the worst storytellers in the world." Unlike *The Matrix* and *Tomb Raider*, but much like *The Cell*, *Sucker Punch* was not a box office or critical success, but it has already become something of a cult classic. And importantly, throughout the dreamworld sequences, the very thick sound world is almost completely without point of audition—all sounds sound as if you are right up next to them, regardless of where they are taking place in the visual field. In other words, identification is simply not the point.

But these are not films that "want" your identification, if films can be said to want. These films are made with a wholly different purpose in mind: where once films traded in character development, these are designed for sensation, both literally and figuratively; where once the story was king, these films focus on setting and scene, on the look and sound of the film. There is no reason to criticize them in terms of what they are not—that would be not one bit better than judging film as a failure because it isn't live theater, or popular music as a failure because it isn't a symphony. These are films designed and created for an entirely different purpose than the ones we're used to in critical language, even though these developments have been in the works for at least the past two decades.

These films are sometimes thought of as spectacles, a naming with which I disagree, both because they must be distinguished from the highly narrative spectacles of, for example, Bible epics, but also because it over-emphasizes the visual in a genre that is very heavily auditory. These films draw on affective responses to keep audiences "on the edge of their seats." That is, they trade on their ability to knowingly extract powerful affective responses from us, pulling audiences together—whether in homes or theaters—into supraindividual units of distributed subjectivity. Around these small networks, or circuits, of affect, responses flow and bounce and become stronger and stronger. Attention is gripped, but not the conscious attention of structural listening. Rather, these films keep audiences in high-attention mode by keeping our neurochemistry on high alert, keeping us engaged and tense and waiting for the next big loud boom. What I am suggesting here is that attention varies not only in quantity, but also in quality, in the sense not of good or adequate versus bad or inadequate attention, but rather in the sense of kind or type. There is the heightened sensory state, with high focus on input events, and there is the intellectual sense of focused thought. The latter is what Katherin Hayles (2007) terms "deep attention," but the former is not really accounted for by her model.

To think of attention on a spectrum, as I do at various points throughout this book (see, e.g., the following chapter on television musicals), is to focus on quantities of attention, which is crucial. But it is equally important to think about the kind of attention that is being engaged in the development of the dynamic subjectivity or field of distributed subjectivity that we could call film-perceiver(s).[15] (See the introduction for a discussion of this idea.)

Since I first wrote about these films, other theorists have also taken an interest in closely related questions, most particularly Steven Shaviro in his *Post-Cinematic Affect* (2010). What he calls "post-continuity" films display, he says, "a preoccupation with immediate effects [that] trumps any concern for broader continuity—whether on the immediate shot-by-shot level, or on that of the overall narrative." Alongside many other writers, this particularly interests him in the editing of action films, as he discusses in his talk at the Society for Cinema and Media Studies Conference (Shaviro 2012). But the question, as I have argued in this chapter, isn't just about editing; this new regime of experience and sensation over narrative and development happens as much aurally and musically as it does visually, if not more so.

There have been a host of films like these before and since the ones I've chosen to focus on here. Some are thought of as art films (*Pi, Requiem for a Dream, Run Lola Run*) and others as entertainment films, including *Sucker Punch*, Tarsem Singh's film *Mirror, Mirror*, and Tom Ford's *A Single Man*, each of which had at best uneven critical fates. And there are, of course, technologies (such as 3D and especially IMAX) that are taking filmmaking much further in these directions. I think something much more interesting is happening in these films. Many such films that have been deemed weak or trivial or gimmicky are, I think, preparing audiences for a different order of filmmaking, in which the next big boom is indeed the next big thing. But even further, they are part of a growing network of cultural objects and activities that are organized around sensation and affect and the production of distributed subjectivities.

4 Musicals Hit the Small Screen
Attention, Listening, and TV Musical Episodes

On the terrain of the terms with which this project is concerned, there was a brief outpouring of events beginning in the mid-1990s that deserves consideration. As I have already suggested, listening has, through its ubiquity, become a frequently less-than-fully-attentive activity. The practices of some potential readers of this book notwithstanding, most people rarely allocate time to listening as a primary focus, and much, if not most, listening takes place somewhere in an attentional field that includes other simultaneous activities. Arguably, we often use music as a parallel to climate control, as Joseph Lanza in *Elevator Music* (1995), Philip K. Dick in *Do Androids Dream of Electric Sheep?* (1968/2007: 3–7), and many other disparate writers have observed.

A similar case can be—and has been—made for television, and by a wide range of authors. As Anna McCarthy shows clearly in *Ambient Television* (2000), the prevailing notion that TV is a domestic sphere activity is patently untrue. Rather, TV has penetrated the public sphere as well through, as McCarthy says via de Certeau, a wide range of complex and intersecting institutional strategies and user tactics. Following her logic, ambient television is nearly as ubiquitous as music.

In *Autoaffection: Unconscious Thought in the Age of Teletechnology*, Patricia Clough argues that television can be seen as the terrain of a different kind of unconscious thought that is not only not limited to individuals, but also not limited to humans or even discrete entities: "Television points to and produces itself in a network of a vast number of machinic assemblages, crisscrossing bodies—not just human bodies—producing surplus value, pleasures, and signs all on one plane" (Clough 2000: 3–4). Her point, which in some way is raising McCarthy's observations about

the place of television in everyday life in the public sphere to a theoretical insight, is that television is the field on which organic and inorganic life collides and colludes.

In his novel *Lullaby*, Chuck Palahniuk writes about television in just this way, but his focus is on television *sound*. The book is about a song that kills, a "culling song." This in and of itself provides an interesting point of entry into his treatment of sound, but leaving that aside, I want to look more closely at some of his more direct ideas about television and sound. Early in the novel, Streator, the protagonist, comes home and is frustrated by the noise coming from surrounding apartments. His thoughts on TV sound are telling, so I will quote here at some length:

> The muffled thunder of dialogue comes through the walls, then a chorus of laughter. Then more thunder. Most of the laugh tracks on television were recorded in the early 1950s. These days, most of the people you hear laughing are dead. . . .
>
> Up through the floor, someone's barking the words to a song. These people who need their television or stereo or radio playing all the time. These people so scared of silence. These are my neighbors. These sound-oholics. These quiet-ophobics.
>
> Laughter of the dead comes through every wall.
>
> These days, this is what passes for home sweet home.
>
> This siege of noise. . . .
>
> These music-oholics. These calm-ophobics.
>
> Old George Orwell got it backward.
>
> Big Brother isn't watching. He's singing and dancing. He's pulling rabbits out of a hat. Big Brother's busy holding your attention every moment you're awake. He's making sure you're always distracted. He's making sure you're fully absorbed.
>
> He's making sure your imagination withers. Until it's as useful as your appendix. He's making sure your attention is always filled.
>
> And this being fed, it's worse than being watched. With the world always filling you, no one has to worry about what's in your mind. With everyone's imagination atrophied, no one will be a threat to the world. . . .
>
> The music and laughter eat away at your thoughts. The noise blots them out. All the sound distracts. Your head aches from the glue.
>
> Anymore, no one's mind is their own. You can't concentrate. You can't think. There's always some noise worming in. Singers shouting. Dead people laughing. Actors crying. All these little doses of emotion.

Someone's always spraying the air with their mood. (Palahniuk 2002: 15–19)

This sound world that Palahniuk is describing, which is substantially but not exclusively created by TV, is one he doesn't completely understand. His point, that the sound colonizes the mind and withers imagination, may be well taken. But he misses that all of that sound is often, perhaps most often, not a primary activity. Rather, it is accompanied by homework, cooking, conversation, newspaper reading, and hosts of other activities. Or, to reverse the logic, someone I know puts on her headphones when she comes home, and she leads her entire domestic life to the accompaniment of TV sound and images. Television and music accompany everyday life, and everyday life accompanies them in return.

Without question, both television and music have taught us a great deal about what many writers (e.g., Chu, Cheung, and Reich 2004; Chong, Kastner, and Treisman 2004) are calling "distributed attention" (of which multitasking is a commonly discussed subset), and they did so before those terms were ever even coined. We should hear "distributed attention" as what Katherine Hayles (2007) calls "hyper attention," I think, and while the questions raised in all these articles seem perfectly suited to thinking of attention on a spectrum (from distributed to focused or from hyper to deep), there are ultimately too many different kinds of attention for this to be suitable. Attention is a field on which multiple types are arrayed: multiple versus single focus, conceptual/analytic versus generative/creative, durational (reading) versus pointillist (watching viral videos, clicking around web pages), and so on.

Given this understanding, then, I want to turn to the question I left hanging at the opening of this chapter—the strange proliferation of musical episodes of TV series in the period from roughly 1995 to 2005, and the place of musical numbers, episodes, and series since then. How do musical episodes enter into this terrain of attenuated attention? What possibilities do musical episodes offer? What are they *doing*?

MUSICAL EPISODES

Perhaps a few observations are in order. First of all, there are surprisingly many musical episodes of successful television series, mainly in the United States. As just a brief and not at all exhaustive list of examples, there were several episodes of *The Simpsons* ("The President Wore Pearls," air date 16 November 2003; "A Streetcar Named Marge"; "Stop the Planet

of the Apes, I Wanna Get Off!"), two *Drew Careys*, three *Hercules: The Legendary Journeys*, two *Xena: Warrior Princess*, *Chicago Hope* (season 4, episode 3, 15 October 1997), *Malcolm in the Middle* (2005—this was an opera), *The Larry Sanders Show*, *X-Play* (5 February 2007), *Daria* (17 February 1999), *Oz* (10 February 2002), *Scrubs* (season 6, episode 6, 18 January 2007), *Two Pints of Lager and a Packet of Crisps* (UK, 15 December 2009) and, of course, *Buffy the Vampire Slayer* (season 6, episode 7, 6 November 2001). Examples in this period range across genres from sitcoms to dramas, animation to fantasy. Robynn Stilwell (2003) and Sandy Thorburn (2004) have shown that the first TV musical episodes of series in the United States were in *The Lucy Show* and *The Dick Van Dyke Show*, that is, the 1950s and 1960s. There were, subsequently, important experiments in the form that succeeded (Dennis Potter's *The Singing Detective*, BBC, 1986) and failed (Steven Bochco, *Cop Rock*, ABC: 1990). But the return of the musical episode in the period, approximately, from 1995 to 2005 is striking in both the number of examples and their variety: there are well over twenty series, across most genres, that tried some kind of experiment with musicals.

Second, while it is clear that there was a new burst of film musicals in this period (think *Moulin Rouge!* (2001), *Dancer in the Dark* (2000), *Chicago* (2002), and even *Charlie's Angels: Full Throttle* (2003), television and the musical had not been comfortable bedfellows in the years leading up to the mid-1990s. The aforementioned *Cop Rock* (eleven episodes from September to December 1990) was a fantastic experiment and almost unanimously perceived as a failure, though it has a cult following, and *The Singing Detective* is perceived as an aberration. This certainly wasn't a history to be looked on with wistful longing.

Thirdly, these musical episodes have generally been regarded as postmodern, primarily because they are such overt parodies of film and stage musicals—many, if not most of the episodes play on past films, plays, and musicals. For example, in *Chicago Hope*'s musical episode, "Brain Salad Surgery" (air date 15 October 1997; the episode shares the title with Emerson Lake and Palmer's fourth album), Adam Arkin sings "Luck Be a Lady" from *Guys and Dolls*. One of *The Simpsons* musical episodes is based on *Evita* ("The President Wore Pearls"), with Lisa in the main role, and another a musical version of *A Streetcar Named Desire* ("A Streetcar Named Marge," air date 1 October 1992). As *TV Guide*, the very popular U.S. television weekly schedule publication, describes this latter episode: "Marge Simpson plays Blanche to Ned Flanders's bare-chested Stanley in a musical version of 'A Streetcar Named Desire.' Otto the bus driver,

police chief Wiggum and convenience-store owner Apu are also in the cast. The director, insolent Llewelyn Sinclair (voice of Jon Lovitz), has three plays—and three heart attacks—to his credit, 'and I care so much, I'm planning a fourth.' Until the opening, Maggie is sent to Springfield's 'only day-care center not currently under investigation.' It's run by Sinclair's sister, who confiscates pacifiers. Maggie and her peers retrieve them in a manner reminiscent of 'The Great Escape.' " Another episode contains a musical *Planet of the Apes* entitled *Stop the Planet of the Apes, I Wanna Get Off!* which manages the unlikely combination of references to the *Planet of the Apes* films and to Leslie Bricusse and Anthony Newley's 1961 musical *Stop the World—I Want to Get Off.* It clearly displays the series' disdain for musicals that Paul Attinello (2010) has discussed—the parody is not gentle, and it is of musicals generally, of the genre as a whole. The finale of the episode (though not the musical within it) begins with the apes' surprise that the human star ("played" by the recurring character Troy McClure, voiced by Phil Hartman) can sing. He responds in a rhythmically precise pattern that rhymes with the last sentence of the apes' ordinary speech, and which is followed by the apes repeating a phrase over and over to lead into the number, which is filled with inane interjections, uttered in this same rhythmic speech, like "Can I play* the pia*no a*ny more*?—Of course* you can*.—Well, I could*n't before*." (The asterisks mark the stressed syllables; the scansion is either one or two unstressed syllables followed by a stressed one.) At this point a piano rolls in so the human can play it. Later in the number, the human sings "I hate every ape I see, from chimpan-A to chimpan-Z." The number is chock full of such vaudevillian humor and delivery, on top of which, Bart and Homer are thrilled by what Homer terms "the legitimate theater" (pronounced, of course, "thee-ā'-ter"). As is the strategy of *The Simpsons* more generally, their point about the stupidity of musicals is made over and over and from every possible corner.

Not all of the parodies and pastiches are so disapproving, however. In one of *Drew Carey*'s musical episodes ("New York and Queens," season finale, season two), there's a dance fight a la *West Side Story* between Drew's *Rocky-Horror*-costumed gang and Mimi's group, who are dressed as characters from *Priscilla Queen of the Desert*. They face off, each group performing a verse and chorus of their song ("Time Warp" for *Rocky Horror* and "Shake Your Groove Thing" for *Priscilla*—originally by Peaches and Herb), then alternating choruses, and finally alternating lines, as the police arrive to a loop of one line of "The Time Warp." (At the end of the episode, Kate wonders why they're constantly being drawn

into musical numbers.)[1] In a parallel scene in *Scrubs,* Leonard Bernstein–style show jazz is used to stage a showdown between the surgeons and the internists. The quotations in all cases abound, especially in the choreography; the residents approach each other in a narrow hallway, snapping their fingers, and they even perform specific modern dance moves and hand gestures from Jerome Robbins's choreography for *West Side Story* (1961). Both of these episodes (and many others) draw on the audience's cultural capital to stage perfectly postmodern parodies that can sometimes seem like a hall of mirrors, where all one sees is reflections of reflections.

And finally, these musical episodes are for the most part examples of high camp. My favorites in this regard are the three *Hercules* episodes: ". . . and Fancy Free" (1997, season 4, episode 8/67), based loosely on *Strictly Ballroom;* "Men in Pink" (1998, season 4, episode 12/71), based loosely on *Some Like It Hot;* and "Greece Is Burning" (1999, season 5, episode 15/96), based, of course, on *Paris Is Burning.* In them, the actor who plays Hercules's sidekick, Iolaus, takes on the drag role of the Widow Twanky (often spelled "Twankey"), "dance teacher extraordinaire." The character is based on the pantomime dame of the same name in *Aladdin,* a staple of the panto repertoire. In two of the episodes, Twanky lip-synchs a song, both written by series composer Joseph LoDuca: in the first she sings in a high soprano while dancing through the air and on rooftops, and in the third she does a tear-jerking down-on-my-luck torch number, "One Dinar a Dance," in a much lower register. But the campiness, to which I will return, and intertextual referencing are throughout both songs and, indeed, all three episodes.

Many of these musical episodes play similarly on past films, plays, and musicals. I've mentioned *Chicago Hope's* musical episode, in which Adam Arkin sings "Luck Be a Lady" from *Guys and Dolls, Scrubs's* use of *West Side Story,* and *Drew Carey's Rocky Horror* and *Priscilla* quotations, and two of *The Simpsons* musical episodes, the one based on *Evita* and the musical *Planet of the Apes;* yet another of *The Simpsons* episodes is the musical version of *A Streetcar Named Desire,* and another is called "Elementary School Musical." In all cases, they are a form of parody, ranging from gentle homages to the rather more brutal *Simpsons* style of mockery. In the Drew Carey dance fight, it isn't just *Rocky Horror* and *Priscilla* that are being parodied, but the fight also refers to *West Side Story,* though less overtly and directly than does the *Scrubs* episode.

But parody of this kind is not addressed to the inattentive consumer. It requires focused attention to recognize the gestures, sounds, and choreography that are being quoted or referred to. If you look away or talk over

something, you stand to miss a good laugh. And once you recognize the reference, you're apt to stay attentive, looking for more. In this way, it becomes clear that television and music, those forms that taught us multitasking and networking as we know them, joined forces in these works to make a bid for our undivided attention. These episodes are chock full of puns, quotations, parodies, and self-referentiality, all of which demand a high level of attention and familiarity with the materials being quoted or referred to.

The *Buffy* musical episode is a perfect example.[2] Joss Whedon, the force behind *Buffy*, trades in these qualities regularly, but he pulled out all the stops for this one. While there has been significant critical engagement with the series, this episode has been particularly commented on.[3] Whedon wrote the script and the music for the episode, and all the actors sang themselves, which makes for an interesting note of realism in a purely fantastic episode and series. Each number parodies a different style and period and song type in the history of musicals. They have the usual winks and nods, like in Buffy's opening number, when she complains that nothing penetrates her heart as she stakes a demon through his. Or when Spike, after a moving rock number begging Buffy to let him "Rest in Peace," peeks out of a grave to say "So, you're not staying, then?" Or when Willow, in the midst of a group number, sings "I think this line is mostly filler."

But "Once More, with Feeling" goes a step further than usual. It plays on, among other things, the qualities of the musical itself. Over and over, everyday events are recast in musical terms; there is a large dance number, for example, on the occasion of learning that the dry cleaners got the mustard out of a man's shirt. Another number is sung by a woman to a cop writing her a ticket; she sings to him that there was no place to park, and "I think the hydrant wasn't there." Right after that, Giles explains to Xander and Anya that the cops are taking witness "arias." The episode repeatedly points out what life would be like if it were a musical—we would all be singing about trivialities all the time. But one needs to attend to the lyrics rather closely in order to get all the jokes.

All of the TV musical episodes are spectacles as well. In *Xena*, for example, Xena and Gabrielle are drawn into the land of Illusia by their hatred for each other. The episode becomes a cross between Brecht and Dada, full of Kurt Weill–ish numbers and visual dreamscapes and unconscious logics. (See, e.g., the songs "What's Still Unwritten" and "Hate Is the Star.") It's genuinely strange television, visually sharing more with Jean Cocteau's *Le Sang d'un Poète* than with any of *Xena*'s usual ancestors.

Each in its own way, these episodes demand visual and aural attention, drawing us—as spectacle so often does—into rapt attention.

And in many cases, as in *Buffy*, the range of musical styles keeps one's attention tightly focused on the show as well. Anya even talks about the disparate styles, complaining that her piece with Xander is a retro pastiche and will therefore never be a breakaway pop hit. But there are also ballads, hard rock, and jazz. Not only is there something for everyone, but the changes hold on to listeners, as they both watch and listen to the spectacle.

By coming together to create programming that one might be tempted to call postmodern, for its pastiche and parody, television and music are attempting to fight against the fragmentation of attention that they worked so hard to teach. Musical episodes of TV series are fairly obvious bids to reintroduce an older form of television spectatorship and music listening, one in which we all sit around the set and watch and listen with dedication and focus. It may not be the attention of an Adornian expert listener—the attention these media aspire to is quite likely to be a similar amount, but of a different kind, than Adorno hoped for. Regardless, however, they are clearly pursuing a level of attention that is no longer commonplace.

CAMPING IT UP

The musical episodes, however, are not simply postmodern parody. In a startling number of instances, they are examples of high camp, as I mentioned earlier.[4] Thinking back to the episodes of *Hercules: The Legendary Journeys* that I mentioned above, the point becomes immediately clear, though I will provide a number of other examples. Such camp practices do not take place only in routinely queer-aware series like *Hercules;* both *Scrubs* and *The Drew Carey Show* have numbers that are unmissable as camp. The case of the *Carey Show* surely requires no further evidence of camp than that the costumes are taken from *The Rocky Horror Picture Show* and *Priscilla, Queen of the Desert*. The *Scrubs* example is from an episode entitled "My Musical" (episode 6, season 6), in which a patient hears everything in song. In this sequence, the main character, JD, and his best friend, Turk, who have been roommates since they first arrived at university many years ago, sing about their love for each other in this song, called "Guy Love":

[J.D.]
Let's face the facts about me and you,
A love unspecified.

Though I'm proud to call you "Chocolate Bear,"
The crowd will always talk and stare.
[Turk]
I feel exactly those feelings, too
And that's why I keep them inside.
'Cause this bear can't bear the world's disdain,
And sometimes it's easier to hide,
Than explain our
[J.D. and Turk]
Guy love,
That's all it is,
Guy love,
He's mine, I'm his,
There's nothing gay about it in our eyes.

The lyrics and the performance gestures all overtly undercut JD's and Turk's denial of their "gayness." Musically, JD's voice cracks and he sings in falsetto at several points, while visually they stare into each other's eyes with gazes usually reserved in mainstream culture for heterosexual romance.

All three examples—*Hercules*, *Drew Carey*, and *Scrubs*—are taken from different genres of shows, with very different audiences, but they share their campiness and their parodic relationship to musicals. In his introduction to *The Politics and Poetics of Camp*, Moe Meyer argues that camp is always queer, and that when it's used in straight contexts, it is an appropriation. He and the other contributors share the following definition: "Camp is political; Camp is solely a queer (and/or sometimes gay and lesbian) discourse; and Camp embodies a specifically queer cultural critique. Additionally, because Camp is defined as a solely queer discourse, all un-queer activities that have been previously accepted as 'camp,' such as Pop culture expressions, have been redefined as examples of the appropriation of queer praxis" (Meyer 1994: 1).

In the case of the *Hercules* episodes, there is no question that they are camp. They include drag. There was a long, ongoing conversation about queer subtext between Hercules and Iolaus in this series (as there is about Xena and Gabrielle in the sister series, *Xena: Warrior Princess*, which also had musical episodes; in fact, the second musical episode of *Hercules* and the first for *Xena* were coordinated to appear in the same week.) And the

performances themselves are high camp. In *Scrubs*, which doesn't have the same queer subtext, the intimate, though sometimes tense, relationship between JD and Turk is brought to the surface and shown to be what Sedgwick would describe as the homophobic homosocial (i.e., social forms engaged by men that exclude women and are nonetheless carefully defended against any hint of homosexuality; see Sedgwick 1985), all in the form of a 1960s Broadway duet. In *The Drew Carey Show*, there are some references to queerness, but they take the form of a hands-off libertarianism, which aligns with Carey's public political statements. Like *Scrubs* and unlike *Hercules*, there is no engagement with queer cultural practices, except in the musical excerpt, which pits two iconic camp and very queer films against each other.

If we follow Meyer's lead, and accept that camp, when not overtly queer, is an appropriation of queer culture, then we find ourselves able to explain much about TV musical episodes and their relationship to attention. By coming together to create programming that has been called postmodern, for its pastiche and parody, but is clearly camp, television and music in this period, from the mid-1990s to the mid-2000s, were attempting to fight against the fragmentation of attention that they worked so hard to teach. And they did so by remembering that nothing draws attention like difference, and by camping it up beautifully.

On some level, however, the writers themselves realize that this is an unsustainable relationship. They can create single episodes that hook participants, but they won't be able to do so week after week. As Sweet, the dancing demon in *Buffy*'s "Once More, with Feeling" says:

All these melodies, they go on too long.

Then that energy starts to come on way too strong.

All those hearts lay open that must sting,

Plus some customers just start combusting.

That's the penalty when life is but a song!

And the demon is right. This strategy, until very recently, has proved untenable for any longer-term viewing and listening relationship.

FAMILY GUY

But I want to move forward in contemporary U.S. television to look at two shows that I argue are outgrowths of the phenomenon I was describing above: first, the musical numbers in *Family Guy*, and second, the series

Glee. These two very different offshoots of the fascination with musicals show what has to happen in order to accommodate the regimes of attention and listening in which most of us in the industrialized world live most of the time.

Family Guy has been on the air for nine seasons so far, so it began right in the period I was describing above. The first fifteen-minute pilot aired on Fox in December 1998; it was picked up and ran for three seasons and was then canceled. From 2001 to 2004 it ran in reruns on Adult Swim,[5] and it enjoyed solid DVD sales, ultimately convincing the network to reinstate it. Seth McFarlane, the series' creator, signed a record $100 million deal with Fox television in 2008, and according to Josh Dean (2008): "Among males 18 to 34, often cited as the most desirable demographic in advertising, *Family Guy* is the highest-rated scripted program in all of television (*American Dad* ranks sixth). It is the second-highest-rated show among males 18 to 49. It is among the most-downloaded shows on iTunes and the most-watched programs on Hulu, and it was the eighth most-pirated show of 2007 on BitTorrent sites." But it has had a complicated history of critical displeasure alongside its financial and popular success. Other animators have reviled the show. *South Park* did an episode (scenes of which Comedy Central censored) in which Mohammed appears on *Family Guy* as a way to pillory simultaneously both *Family Guy* and the Muslim rules against representational art that led to the *Jyllandsposten* comics disaster (Gillespie and Walker 2006). John Kricfalusi, creator of *Ren and Stimpy*, notoriously trashes the show on his blog, with such posts as this one: "Compare this to modern anti-talent cartoons which hang everything on the limited power of the written (or spoken) words alone. For example the Simpsons or Family Guy . . . I never know when to laugh when I watch modern cartoons because they are so devoid of pacing or feeling. Everything is timed the same way, the animation never varies. It's about as fun as watching a spoon stir soup."[6] Kricfalusi, Trey Parker, Matt Stone, and others have derided the success of *Family Guy* over its simple drawing style. But the humor of the series derives from other sources than complex visual gags.

Family Guy takes the model that I have been describing—the postmodern, parodic, explicitly camp quotations of movies and musicals—and turns it into a regular feature of the program, far more so than even *The Simpsons* ever dared. One of the staple forms of humor for the show is the cutaway gag, which is ideal for dropping musical numbers into episodes. (A cutaway gag does precisely what the name implies: on a cut away from the current scene, there is a jump to an unrelated scene such

as a historical moment or a musical number.) It is clear that creator Seth McFarlane has a persistent interest in musicals; as one web article puts it, "a significant percentage of *Family Guy* episodes feature extravagant Broadway-inspired song-and-dance numbers" (Dean 2008). He has gone on record as saying that he is developing a film, and he imagines it as "'an old-style musical with dialogue' in the vein of *The Sound of Music*" (Dean 2008). The numbers tend decidedly toward the offensive, including, for example, a barbershop quartet singing the diagnosis of AIDS to a patient in a hospital bed and a number entitled "Prom Night Dumpster Baby" performed by a chorus of babies who crawl out of a dumpster and use their umbilical cords as props.[7] Among other apparent favorites on various websites, including YouTube, is an extremely popular version of Buddy Hackett's song-and-dance number "Shipoopi" from *The Music Man* and whole episodes parodying the *Road* flicks of Bob Hope and Bing Crosby.

The shocking nature of the lyrics isn't only achieved, though, by crossing boundaries of obvious propriety, such as sensitivity to people with diagnoses of serious illnesses or babies thrown away by partying young parents. "Shipoopi" perfectly illustrates this point, because its lyrics are simply silly and not in any way offensive. (Except, perhaps, to modern-day sentiment on female sexuality—the song opens with the lines "Well, a woman who'll kiss on the very first date / Is usually a hussy. / And a woman who'll kiss on the second time out / Is anything but fussy.") Similarly, "My Big Fat Baby Loves to Eat" is only shocking because people who prefer fat partners remain closeted in our fatphobic cultures; there is not, however, anything inherently offensive or disturbing in the song, even though it is startling to hear. Similarly, the Four Peters' a cappella rendition of *Eine Kleine Nachtmusik*'s opening theme can hardly seem offensive as such, and yet it is jarring. There are many, many such songs throughout the series: "A Bag of Weed"; "Fellas at the Freakin' FCC"; "This House Is Frickin' Sweet" (a parody of "I Think I'm Gonna Like it Here" from *Annie*); and "I Have James Woods" (a parody of "You Two" from *Chitty Chitty Bang Bang*).

While I will readily confess to loving many of these numbers and the episodes in which they appear, my point here is not simply to recommend them to you. Rather, I am suggesting that *Family Guy* has developed a series of comic strategies, among which the musical number is a significant one, that insist that viewers and audiences pay attention to what is happening on the screen. Missing any cue diminishes the overall experience of the show (although there are by and large so many references thrown

around with abandon that it doesn't really matter, for example, if you haven't seen *Annie*). Moreover, unlike *The Simpsons*, the parodies are somehow less dismissive and critical, displaying not only familiarity with but also genuine fondness for the history of musical theater. They are, however, simultaneously more camp—more overblown, more over the top, more showy. And they handle the queerness of camp with a strategy similar to that of *Scrubs;* they acknowledge the presence of queerness rarely, instead preferring to focus on homosocial settings and relationships (the neighborhood drinking group, Brian and Stewie's adventures with Frank Sinatra Jr., etc).

GLEE

The television series *Glee*, however, is a whole other matter entirely. The first successful musical drama series (as opposed to short series such as *The Singing Detective*), it takes a theme for each episode and develops a series of songs around that theme that will both move the plot forward and allow the high school students (played by not-high-school-aged actors) who are the stars of the show to sing and dance every week. All of the numbers take place within the show's world—that is, none are completely fantasy numbers or dream scenes, as was sometimes the case in classic Hollywood film musicals.[8] Rather, most of the songs are sung as part of the routine work of New Directions, the show choir, while a very few are the ruminations of cast members alone onstage, trying to think through their current dilemmas using their favored medium. (The "reality" status of these is quite complicated, since they come with costumes and lighting and props; they seem to be a combination of reality [the character singing the song on the stage] and fantasy [the professional trappings of the performance]. These numbers have decreased over the run of the series to date.) The songs are usually covers or mashups—with a balance among very contemporary pop, classic rock and pop, and show tunes. Most weeks Mr. Schuester, the Glee Club's director, played by Matthew Morrison, assigns the students either a genre, like ballads (season 1, episode 10), or a topic, such as love songs (season 2, episode 12), that has some relevance to the plot and subplots.

The series has been a commercial success in many senses. While it has had mixed reviews from critics, it has been wildly successful in product sales—primarily CDs but also DVDs and tour tickets. It won the Golden Globe award for Best Television Series—Musical or Comedy in both of its

first two years; Jane Lynch has won a Best Supporting Actress Emmy and a Golden Globe for her portrayal of Sue Sylvester, the evil cheerleading coach and arch-nemesis of the glee club; Chris Colfer (as choir member Kurt Hummel) also won a Best Supporting Actor Golden Globe; and there have been scads of other award nominations, including Best Actor for Morrison and Best Actress for Lea Michele (Rachel Berry, lead female singer in the choir).

It is crucial to any discussion of *Glee* to note that there is a musical sensibility of a sort that runs throughout the whole series. Everything is slightly, if not extremely, overblown: Principal Figgins is an idiot on a spectacular scale; Sue Sylvester, the thirtyish cheerleading coach played by fifty-year-old Jane Lynch, is the most evil villain Disney could ever have imagined; she convenes Will Schuester's ex-wife, his predecessor, and his fiercest rival as the League of Doom to destroy Will and New Directions, giving them all superhero names (the Honey Badger, the Pink Dagger, and Sergeant Handsome, respectively). There is a running gag throughout every season so far of the singers being given a "slushie facial," usually by a member of the football team; a slushie facial takes place when one person dumps the contents of a large slushie frozen drink into the face of another in the school hallways. Jacob ben Israel, the editor of the school newspaper (whose media format is very unclear, since we never see a print paper and he frequently shoots video), is very stereotypically Jewish and nerdy, both in appearance and in behavior. All of these and many other details contribute to the slightly surreal, strange, overblown feeling of the series, trading on many of the features that are most frequently criticized in musical theater.

Strangely, however, the show does not work with the language of camp. As quirky and surreal as it is, it doesn't seem to lean in the direction of camp. Many commentators call it camp or campy, based on the show tunes content, the style, and its gay and lesbian themes, which are substantial. The character of Kurt Hummel (named after Kurt von Trapp from *Sound of Music* and the Hummel figurines) had terrible experiences of gay bashing that were a major story arc for season two. He moves schools and falls in love with the lead singer of the show choir of Dalton Academy, Blaine Anderson. Blaine doesn't share his feelings at first, but then reciprocates a few episodes later, and they have become a very popular romantic couple among U.S. television audiences—not only is there fan fiction about them, but they have their own fan website, fan blog, and LiveJournal community page,[9] and they were finalists in a "Favourite TV Romantic Couple" poll on spoilertv.com. But they are not even the only gay characters on the

show. The major bully of the show, Dave Karofsky, is revealed in one episode ("Never Been Kissed," season 2, episode 6, 9 November 2010) to be gay when he responds to Kurt's confrontation of his bullying with a kiss, and he has seen been seen at a gay club, where he makes a romantic overture to Kurt. And Santana, one of the cheerleader-singers, is in love with Brittany, who is bisexual, and when she comes out as a lesbian (with great encouragement from her fellow singers), she is tragically rejected by her *abuela* (grandmother). Brittany and Santana continue to be treated as a couple by the series.

But none of this makes the show camp. It shares terrain with camp programming, such as *Scrubs* and *Family Guy*, but it isn't the same thing. None of the gay characters are over the top, for instance, and, as Chris Colfer, who plays Kurt, says of his character in an early interview, "In the original script, they were leaning on him being overly flamboyant and I didn't want to do that because it's so overdone. So I made him more internal and superior" (Fernandez 2009). Freya Jarman has argued about musical camp that one of its most salient features is long, drawn-out phrasing (Jarman 2010). In *Glee*, we hear this kind of styling in the numbers from the musical theater repertoire, where it is a part of the genre's performance style (and where it is often associated with camp), whereas it is utterly absent from the rock and pop songs, which is also appropriate to those genres' conventions, and a big part of the program's musical world.

In other words, while the words *camp* and *campy* come up from time to time in writing about *Glee*, the journalists are quite correct in not following those throw-away lines through. *Glee* is a show about teenage singers and it has a thick, saturated style and several gay plots and subplots, but it is not an exercise in camp. It is, however, like all the other programs and episodes discussed in this chapter, an utterly shameless bid for our listening and viewing attention. Given how complex a matter attention is, I want to turn now to some perspectives on attention that stretch from Herbert Simon's 1971 positing of the term "attention economy" to Jonathan Beller's *The Cinematic Mode of Production* (2006).

HERBERT SIMON AND THE ATTENTION ECONOMY

Simon gave a talk in 1971 at the Brookings Institution entitled "Designing Organizations for an Information-Rich World."[10] In it, he argued that attention is a new kind of commodity: "Now, when we speak of an

information-rich world, we may expect, analogically, that the wealth of information means a dearth of something else—a scarcity of whatever it is that information consumes. What information consumes is rather obvious: it consumes the attention of its recipients. Hence, a wealth of information creates a poverty of attention, and a need to allocate that attention efficiently among the overabundance of information sources that might consume it" (Simon 1971: 6–7). He goes on to argue that in order to understand and allocate resources effectively, they require measurement, suggesting that a simple way of measuring attention would be in time spent consuming something. He then proceeds to argue that the cost of information needs thus to be understood not only in terms of the production costs, but also the consumption costs: "In an information-rich world, most of the cost of information is the cost incurred by the recipient. It is not enough to know how much it costs to produce and transmit it; we must also know how much it costs, in terms of scarce attention, to receive it" (41).

Simon proceeds to build a compelling argument about not only what processing systems should do (withhold information by filtering out the unnecessary or overly detailed) and what we need to know (not facts but how to access them: "That is exactly what science is all about—the process of replacing unordered masses of brute fact with tidy statements of orderly relations from which those can be inferred" [Simon 1971: 45]), but also technology assessment (he argues for less focus on an attempt to know everything beforehand, and more for assessment mechanisms as processes take place). He concludes by stating that we need to understand what we need from computers—not just information storage and retrieval, but intelligence (though he uses the word *processing*). He concludes: "And that understanding will enable us to build for the future organizations far more effective than those we have been able to operate in the past and present" (Simon 1971: 30).

Essentially, then, Simon is making a twofold case: as information increases, we have a scarcity of attentional resources, and computing should be designed to address that problem so that we have nonhuman resources to apply to the problem of human attention scarcity. This is a stunning understanding of the problem that would be generated by waves of e-mail and web pages and blogs and UPC codes and store cards and scanned data collections at a moment a good decade before the marketing of the desktop home PC, when the prevalent technologies were phones and photocopiers. But clearly Simon saw something that strikes a chord with us today.

Many contemporary thinkers and business people are fascinated by the problem of the attention economy. It is behind discussions of the rate of information growth and an ever-expanding range of products and services such as personalized social network and news sites, push technologies, data mining services, collaborative filtering, and so on. Academics like Thomas Davenport (President's Distinguished Professor in Information Technology and Management at Babson College) and public intellectuals like Michael Goldhaber (a former theoretical physicist turned Internet thinker whose trail on the Internet vanishes in January 2010, with his last attention economy blog post at http://goldhaber.org/) have argued, following Simon, attention is the scarce resource that will define a new economic system.

Alex Iskold, a start-up entrepreneur (founder and CEO, Adaptive Blue; founder and CEO, GetGlue) and IT thinker, puts it this way: "Both implicit (clickstream) and explicit (bookmarks) attention is captured and stored in a database. The users have control over what attention-capturing system to use. For example, AttentionTrust has created a Firefox add-on called AttentionRecorder which captures clickstream and redirects it to a vault. The user also has a choice of where to store the data. A standard protocol between the attention-capturing software and storage software ensures that users have the choice" (Iskold 2007). The point here is that as early as 2007—and it wasn't new then—it was possible for our web browsing patterns (clickstream) and bookmarks to be used by businesses to whom we gave such permissions to track how and what we view and to develop technologies that help us get to what we want or are interested in more quickly and directly. These are attention economy technologies.

Such insights have not escaped media scholars. As early as 1986, in the groundbreaking anthology *Studies in Entertainment* (Modleski 1986), Rick Altman discusses the kind of attenuated attention frequently given to television. He summarizes the body of empirical literature on the topic, saying that there is a persistent presumption that "active viewing is the exclusive model of spectatorship, yet there is a growing body of data suggesting that intermittent attention is in fact the dominant mode of viewing" (Modleski 1986: 42). Richard Dienst draws on this passage to argue that Altman, like many others writing on television before and after him, takes Raymond Williams's idea of televisual flow too uncritically: "Depending on the choice of model, different visual/textual units will be carved out and presented for analysis. That flow works on the scale of the message, the enunciation, or the subjective interpellation is taken for granted. But this emphasis on segmentation domesticates and normalizes the concept

of flow, reconstituting a stratum of sense exactly at the point where its appearance is most radically uncertain and contingent" (Dienst 1994: 31).

TELEVISION VIEWING AS LABOR

Dienst, and several other thinkers after him, want to reconceive television viewing as labor. He argues that just as factories reorganized labor time, so too do televisions reorganize leisure, family, and household time. Patricia Clough describes his argument: "Dienst imagines the watching viewer as a worker at work, the work of watching. . . . The viewer produces surplus value when he or she watches, that is, when a unit of viewing time and television image, having already been capitalized, is used up. . . . It therefore appears that television networks make value out of nothing, when in fact they ' "buy" (with images) and "sell" (as ratings) this socialized time' " (Clough 2000: 98).

Clough connects Dienst's analysis with Jonathan Beller's positing of an "attention theory of value," a position that draws him into conversation with a number of theorists thinking and writing about immaterial or affective labor, including most obviously Michael Hardt (1999) and Hardt and Antonio Negri (2000), but also Tiziana Terranova (2000) and others. These arguments are intricate and not directly pertinent here, but I want to make two points in this regard. Firstly, not only is television, or even "cinema" as Beller uses the term (by which he problematically means all moving-image technologies), affective labor, but so is radio, Internet radio, music composition, music producing, and, above all for my purposes here, listening. Second, it remains puzzling that all of these theorists, and most particularly Beller, pitch their arguments in relation to visual media, or even worse, audiovisual media that they write about as if there were no sound present. As I argued in the introduction, sound, in the form of radio and Muzak, was the first sense to be engaged in processes of distributed attention.

This raises a number of questions in relation to the use of musicals—as an episode form or for cutaways—for gathering attention.[11] The episodes were certainly heavily advertised; *Buffy*'s episode was the talk of all media watchers in the run-up to its broadcast, and (as mentioned earlier) a pair of the *Hercules* and *Xena* episodes was scheduled in the same week to provide cross-advertising for each other. Clearly they are gathering attention as a form of labor in the sense that Dienst and Clough and Beller are interested in (although I will return to Beller below). But that raises a

much more difficult question: if the point of the mass media is to gather attention to produce surplus value, what is music doing when it's in the attentional background?

MUSIC WHEN WE'RE NOT PAYING ATTENTION

There are several models that people have proposed to explain what music does in the background of attentional fields. The literature from marketing and other business studies fields and from social psychology tends to be fairly mechanistic:

> The tempo of the music can speed or slow shoppers' walking speeds, thus having an effect on buying patterns (Milliman 1982).
>
> The national associations raised by certain musical styles can affect consumer choices (North, Hargreaves, and McKendrick 1999).
>
> The perception of waiting time in queues is varied by musical tempo (Oakes 2003).
>
> Sonic branding can be used to rise above the routine din (Fulberg 2006; Powers 2010).
>
> Correctly chosen music can lessen preprocedure anxiety in ambulatory surgery patients (Lee, Henderson, Shum 2004).

But these arguments hardly explain the profound ubiquity of listening that pervades everyday life in the industrialized world. There is an Adornian explanation, and it is indeed inviting. One could argue, as Adorno did, that our constant bombardment by the culture industry's musical products leads to pseudo-individualization in the form of, for example, iPod playlists, which can help us believe we have made choices that reflect our uniqueness when we are actually being fed predictable product, and that filling our experiences with such product reduces our capacity to think, as Palahniuk was suggesting in *Lullaby*.

As a scholar, I cannot accept this theoretical position, for reasons I will outline below. But as a listener, I often find myself drifting in this direction—I cannot think while listening to music, and not because I am some superior form of being who listens only attentively. Far from it. Rather, I hum along, and when I hum, I lose my train of thought. So throughout the more than ten years that I have worked on this project, I have struggled with such ideas. Moreover, I am convinced that the constant presence of music in retail and domestic spaces and on headphones

has shifted the range of modes of listening that many listeners can call on toward the less attentive. As a musician, and as someone who grew up in a very different auditory regime, I find these shifts sad.[12] But my nostalgia for a less auditorily dense time is not the ground on which I have written this book and developed my theoretical position. I tell you this now only to say that I have done my best not to indulge my sense of loss, and so that you can consider for yourselves whether or not I have succeeded in setting it aside.

Jonathan Beller's *Cinematic Mode of Production* (2006) is a very sophisticated critical theoretical perspective on the ubiquity of images, and he makes some arguments about the economy and attention that bring to the surface many issues swirling around in this chapter and throughout the entire book. Like Dienst, he argues that looking is a laboring activity, and therefore that it produces value: "By some technological sleight of hand, machine-mediated perception now is inextricable from your psychological, economic, visceral, and ideological dispensations. Spectatorship, as the fusion and development of the cultural, industrial, economic, and psychological, quickly gained a handhold on human fate and then became decisive" (Beller 2006: 2). In this way, Beller argues that relatively quickly after their inventions, the mass-mediated image technologies became the means through which we perceive the world around us. He then goes a step further to argue that a whole other layer of abstraction has developed in which the image is the medium of sociality, not unlike money (understood as the general equivalent in Marxist terms) once was.

> What I will call "the attention theory of value" finds in the notion of "labor," elaborated in Marx's labor theory of value, the prototype of the newest source of value production under capitalism today: value-producing human attention. . . . At once the means and archetype for the transfer of attentional biopower (its conversion into value and surplus value) to capital, what is meant today by "the image" is a cryptic synonym for these relations of production. The history of the cinema, its development from an industrial to an electronic form, is the open book in which may be read the history of the image as the emergent technology for the leveraged interface of biopower and the social mechanism. (Beller 2006: 4–5)

There is much to say about Beller's ideas about the image, the new layer of abstraction that he posits, and the attention theory of value. As with the theorists and critics of affective labor, I want to refer to Beller's work and ideas for some very specific reasons relating to my project here, although I think there is a larger critique that I will not draw out fully here.

Two aspects of Beller's theory concern this project: first, that his is ultimately, as I suggested earlier, a neo–Frankfurt School position in which the world of complexities and possibilities that arise alongside of and fully imbricated in the horrors he describes is shut down, and second, that it is in silencing the processes he describes that this totalizing perspective becomes possible. He begins by taking what is ultimately a technologically determinist position, in which mass mediation of the image leads to, if not totalitarianism (as was thought in the immediate post–World War II period), then certainly a form of colonization of thought: "This production vis-à-vis the cinematicization of society has become increasingly dematerialized, increasingly sensual and abstract, to the point that it occupies the activities of perception and thought itself" (Beller 2006: 296). From there, he proceeds to suggest that nearly everything—"linguistics, psychoanalysis, structuralism, and post-structuralism, like so many architectural styles"—shows the complete occupation of both thought and production by the visual (289).

But there remains a question of what is sometimes conceived, especially in the literature on globalization, as reverse flow. While Alexander Galloway's argument in *Protocol: How Control Exists after Decentralization* (2004) is in many ways like Beller's—that any participation on the part of those of us who do not own the image-making (Beller) or code-generating (Galloway) technologies is tightly controlled—there are also digital utopians (possibly the WikiLeaks founders?), and perhaps more importantly, a wide range of thinkers, like Peter Lunenfeld (2011a) and Peter Ludlow and Mark Wallace (2009), who see a more complicated picture of possibilities as well as problems.[13]

CONCLUSION

As I suggested in the introduction, hearing is a very different sense than vision, and it has different capacities and possibilities. Commentators frequently note that it is slower and less information-dense than vision, but it is also more creative and less containable. It can go around corners and through walls. It can become vibration or pain—or perhaps it always is both, and only sometimes passes over the thresholds of our perceptions of vibration or pain (see Goodman 2010). While I will not dwell too long on the possibilities of audition over vision—the senses are better thought in contiguity than in distinction—it is nonetheless crucial to remind ourselves that the bleakness of Beller's vision not only ends in a violent

revolutionary clash between wetware (human beings) and the forces of capital but also is expressed in sound. Following a long quotation from "The Poverty of Philosophy," a work by Immortal Technique (a Latino spoken-word poet and hip-hop artist), Beller concludes by saying: "Binary code may transmit the mp3 files that disseminate 'The Poverty of Philosophy' and thousands if not millions of similar encodings, but running the program requires wetware and organizes zones that are beyond the reach of the project and projection of capital. Or so we must assume. And, perhaps, it is there in the shadows, that the poverty of philosophy may be seen to express Our new power. This time, here, now, it is capital that will have to catch up or fizzle out. Either way, there will be blood" (Beller 2006: 312). In Beller's view, then, the only possibility is a violent revolution, not least because his analysis of the visual regime that was put into place over the course of the twentieth century and that he describes compellingly has completely banished sound. So it should come as no surprise that it erupts in the final moment, to express the response to this visual exploitation machine, to, as the many old sayings go, speak out, speak up, speak truth to power.

It is, as I have argued, through sound that we sense ourselves and each other. And since, as Peter Lunenfeld (2011b) writes, "Nobody uploads more than a tiny percentage of the culture they consume," listening is clearly central to sociality. What is important, theoretically, is to notice that the range of listenings—from attentive to distracted and everything around and in between—has, over time, become the informational web over which a sensation of subjectivity is distributed. In other words, when we listen, we hold open channels that connect us to the network of listeners, over which contemporary sociality is produced. (This is why "quiet" is so widely perceived as eerie, both as a discursive trope—just try googling "eerie"/"eery"/"eerily" and "quiet"—and as an experience.) More importantly for the peculiar question of musical forms on television, it offers a way to explain why, when television gets tired of its audiences engaging in the distributed forms of attention that it helped to teach us, it goes to music to try to recapture our focus.

5 Improvising Diasporan Identities
Armenian Jazz

In the early 1980s, when I went back to university for the fourth time to finish my undergrad degree, I was a journalism student, looking to concentrate on music journalism. I proposed a story to *DownBeat*, probably the preeminent U.S. magazine about jazz and its musical extensions, on fusions of jazz and Middle Eastern music, which they summarily turned down, despite the fact that I placed the piece in the context of works by Ornette Coleman and other serious jazz icons. I assumed at the time that it was because I wanted primarily to write about people they'd never heard of, like Souren Baronian and his group, Taksim, though I knew that it could just as easily have been because I was a new writer and hadn't worked for them before.[1] I certainly could not have imagined coming back to the topic more than twenty years later.

This chapter is an account of my listening to Armenian diasporan jazz fusion projects over the course of those years. It is fragmentary, shards of memories and thoughts, a journey that includes my coming-of-age as a music scholar, leaving behind Armenian music (at least as a subject of thought) for many years, and coming back to it, slowly, tentatively, to reconnect those important pleasures with my work. An earlier version of this chapter was commissioned for a collection on jazz and world music, and it raised many questions as it went through various readings by friends and editors, which I will comment on throughout.

I am interested in the place three particular Armenian-jazz fusion albums had in the history of negotiating my diasporan identity. This was a difficult process for many reasons, not least the many complications of Armenian diasporan movements and cultures that I began to describe in chapter 2, but also for all sorts of other reasons; perhaps the most vivid for me was the clash between my development as a feminist and what seemed to me

to be the rigidity of gender roles and representations in the Armenian-American communities from the 1970s to the 1990s. (While feminism hasn't accomplished nearly as much as I would like, in any community, diasporan Armenian communities seem much more open to women now than in those years, thankfully.) During those challenging years, these albums were very important—dear, even—in helping me find a way to be an Armenian-American feminist political mother, friend, partner, and scholar of music and media. I want to consider here, on the one hand, my relationship to the three albums in question, and the place they held and hold for me—and perhaps for some others—in suggesting that genuinely complex, not-simply-assimilated, diasporan being is possible, and on the other, the process of writing and rewriting this chapter.

One of the first issues is terminology. What history does the phrase "Middle East" bring? It was the term I used in my query letter to *DownBeat*, and it is still in common currency—for example, the study group attached to the Institute for Musical Research, University of London, is called the Middle East and Central Asia Music Forum. But the term has a strange and inconsistent history, originating in colonial British and U.S. military usages in the nineteenth century. Musically speaking, however, I hear strong connections among the musics of territories in this area, so I have long looked for a way to express this. I have tried "West Asian" in the past, though it doesn't seem to stick, even for me, and readers have not responded well. In the past few years I have settled on "post-Ottoman" as a way to express the shared practices within and across the territories of the former Ottoman empire.[2]

Post-Ottoman music was an important feature of my childhood; I grew up in a musically multicultural household. My father ran a small semiprofessional Italian opera company in New York City, my mother wrote community musical theater revues based on songs from musicals and Tin Pan Alley, my brother and I took classical piano lessons, and my parents ran a performing Armenian folk dance troupe. They, along with others, went to older community members, collecting songs and dances, and versions of dances, teaching them to dancers who rehearsed for several hours each week, year-round, to learn the dances and prepare for performances. So, there were lots of kinds of musical traditions in my childhood, Armenian folk music being one important one.

When I was in high school, I decided to sing in church, and I acquired yet another Armenian musical vocabulary—one that has been strangely morphed and westernized over the twentieth century in particular. From an essentially Eastern Orthodox liturgical tradition (this is terrible

shorthand, but it suffices for these purposes, I hope) without harmony, *sharagan* (hymns) have been harmonized in very unimaginative, schoolish ways, into the standard Armenian liturgy as we now know it. I remember even then disliking the most choral parts of the liturgy, preferring the far-less-altered morning services and Lenten *sharagan* to the main body of the mass.

In my early twenties, I left the Armenian community, finding it (as many did) too restrictive politically and culturally, too unforgiving of my ideas about art, gender, class, and nationalism in particular. But it was too much a part of my world, and especially my musical world, to stay away happily. So in my late twenties, when I went back to school, I began to find others like me who were experimenting with Armenian music and other forms. My childhood friend Mark Kyrkostas was studying classical Arabic music and trying to find ways to play it on the piano, despite the instrument's inability to allow subsemitonal divisions.[3] And one night, Mark and I went to hear Souren Baronian and his band, Taksim, play.

It's trite, but not untrue, to say that that performance changed my perspective on music. My parents, most especially my father, had been intent on preserving Armenian folk music as they had collected it, and so their patience for fusions was limited. And my displeasure with the harmonization of the liturgy seemed to be more of that same impulse. But in Taksim, I heard something that demanded I reconsider that position—a genuine blend of two musical practices that made something new and worth listening to.

The current lineup of Taksim is Baronian on clarinet, Haig Manoukian on *oud*, Mal Stein on drums, Sprocket Royer on double bass, and Lee Baronian on *darbukkeh/doumbek*.[4] As I recall, however, when I first heard them, Rowan Storm Hicks was the percussionist. That was important for me, because I'd never before seen a woman playing an Armenian instrument. My mother played the piano for the dance group, but all the *oudis* and *kanounis* and *dumbeg* players were men, though I had heard stories of *Shakar* (Sugar) Mary, a respected oud player in New York City in the early twentieth century.[5] And not only was Rowan a woman—she was a kick-ass percussionist. One of the reasons I wanted to write that article for *DownBeat* was because I thought Taksim was revolutionary in so very many ways—its sense of musical possibilities and its lineup of musicians among them.

Formed in 1975, Taksim began at the height of the fusion era (often understood to have begun in 1969 with Miles Davis's *Bitches Brew* and best represented, perhaps, by the work of Weather Report, Return to Forever,

and Mahavishnu Orchestra), and it is a very, very early attempt to bring together post-Ottoman sounds and jazz.[6] The group has recorded two albums: *It's About Time* (Carlee Records, 1995) and *Ocean Algae* (Carlee Records, 2002). *It's About Time* is quite literally about time; each song is listed with its meter next to its name, and many are in uneven meters such as 9/8 and 11/8 that are much more historically rooted in dances in post-Ottoman regions than in jazz, in which metric experiments were then taking hold.[7] But while meter is central to this album, making it an ideal fusion project for the period, the melodic materials and instrumentation are interminglings of jazz and Ottoman sounds—for example, oud and scat singing, and the two very different traditions of improvisation—also bring related musical practices that developed by parallel evolution into conversation with each other.

The second CD, *Ocean Algae*, brings the two traditions into even closer conversation. The improvisational traditions are brought together, worked over, so that post-Ottoman melodic fragments get jazz treatments, jazz melodies and processes are played on oud and *dumbeg*, and so on. Some tracks are actually called *taksim;* however, rather than being given the title of the *maqam* they use, for example, *Hijaz Taqsim*, as in the classical Arabic and Turkish traditions, they are named by the instrument, as one would label a jazz solo. The album is a much more integrated and developed work, by a group of musicians who've been playing together a very long time—three are original members of Taksim, and one is Baronian's son.

In the world of post-Ottoman jazz fusions, Taksim is still singular in its approach. In researching this article, I have listened to a lot of projects, and Taksim stands out among them as the most focused—the group forges a consistent language of jazz and post-Ottoman sounds that brings them together and reshapes them to create a genuinely new kind of music.

I can still remember the physical feeling of listening to Taksim that first night. There was something so extraordinary happening, and in retrospect, especially in writing, what I felt can only sound corny. But I believe, genuinely, in the importance of trying to capture and understand our relationships to significant cultural moments, so I will continue to try despite my great trepidation. I felt like something had been lifted—like a cover or an obstacle—that made it possible to hear myself for the first time. I felt a world of possibilities unfolding, a world that has been a part of me ever since in the music I listen to and the works I write about.

It was more than ten years before I had that experience again. Ara Dinkjian founded Night Ark in the mid-1980s, composed of himself on oud, Arto Tunçboyaciyan (percussion), Armen Donelian (piano), Marc Johnson

(bass).[8] By this time, Ara was already a major Armenian-American oud player; he is now perceived as a world-class performer and writer.[9] Night Ark recorded four albums with RCA/BMG and Polygram/Universal over the course of about fifteen years together, creating the first serious sustained Armenian jazz project with widespread international distribution.[10]

Night Ark was a crucial moment in the history of Armenian jazz music—it brought Armenian music to the attention of the jazz world, and vice versa, because the members of the group were all so very highly accomplished in at least one, and in several cases both, of the forms involved. Their output is polished, professional, drawing not only on Armenian music and jazz, but also other post-Ottoman traditions, rock, pop, and classical musics. Dinkjian is widely recognized as a top international oud player. Tunçboyaciyan, who was born and raised in Turkey, went on to form Armenian Navy Band (see below); he is an unusually creative, even visionary, percussionist. All members of Night Ark brought to it such a range of experiences that Night Ark's discography is relentlessly innovative. Tunçboyaciyan has played with Al DiMeola, Joe Zawinul, Paul Winter, Maria Pia De Vito, and others; among Donelian's credits are gigs, tours, and recordings with Mongo Santamaria, Sonny Rollins, Chet Baker, Paquito D'Rivera, Anne-Marie Moss, and others; Johnson has worked with, for example, Woody Herman, Bill Evans, Pat Metheney, and Eliane Elias.

My introduction to Night Ark was another watershed moment. By then, I was back in New York, finished with graduate school, teaching, totally alienated from any Armenian community or activities for many years. Night Ark, like Taksim, threw me a lifeline of a very particular kind. I came across *In Wonderland*—I think my aunt showed me a review of it in an Armenian newspaper—and it offered me a world of possibilities I'd given up on. Perhaps I should backtrack and take another path to this point.

The Armenian communities internationally, with the exception of the Republic of Armenia and perhaps one or two other very small places, are small minority communities. For the most part, these communities are very nationalist, struggling hard to maintain identities in the face of invisibility, lack of political recognition, dwindling numbers of fluent speakers, intermarriage, and all the threats that face small diasporan communities.

We learn from very young to scan lists of names (e.g., film credits) for Armenian names, and we can all list off important Armenian artists and inventors. (In the case of music, that list would include Aram Khachaturian, System of a Down, and Cher, but perhaps also Shahan Arzruni, who was for years Victor Borge's sidekick; Gomidas Vartabed, one of the founders of the International Musicological Society and an ethnomusicologist

as well as a composer; and Cathy Berberian, Luciano Berio's wife and collaborator.) One absorbs the desperation, and for some of us, me included, it inverts into a peculiar kind of self-loathing. Any group so willing to list every third-rate poet, painter, and singer among its luminaries must not be *able* to produce much of worth, right? I still scanned lists, but felt vindicated when we only turned up as sound editors.

Hearing *In Wonderland* changed that. It gave me evidence of another world of possibilities—beautiful, smart, creative, interesting music that made a genuine contribution not just to Armenian music, but to the whole world of music. Many reviewers talk about Night Ark as a world music project *avant la lettre*—the fusion of different musical materials to create something new, which it certainly was. Some tracks sound like straight-up jazz with a new instrument or two added. For instance, the first track of *In Wonderland*, "Very Nice," is that—a kind of duet between Dinkjian and Donelian that recalls Bill Evans in particular. The second track, "They Love Me 15 Feet Away," has a little more pop sound, and much more clear influences from Armenian roots. "Is That How Loving You Goes" (track three) sounds quite a bit like a Weather Report–style fusion piece, and track eight, "Keesher Bar" ("Night Dance"), is very traditionally Armenian and folk in its sound.

I don't know what happened to Night Ark, why they stopped recording together, but they were quite successful in the roughly fifteen years they were together. For me, they were the beginning of a slow, careful return to the Armenian community in New York. Like Taksim, it meant to me that there were other people like me, other Armenians hoping to create diasporan culture to reflect and support, produce and project our mixed identities in thoughtful and thought-provoking ways.

Shortly after this point, and through Thea Farhadian, another alienated Armenian whom I knew from the San Francisco new music scene, I got involved in organizing and curating an Armenian film festival. Slowly, I met filmmakers, writers, and artists who thought and felt like I did. About diasporan identity, about Armenianness, about art and politics. It is, perhaps, easier to express those ideas in obviously representational forms like film, but after Night Ark, I didn't hear music that did what the films we were showing did for a long time.

Some years later, in 2000, I was at the University of Newcastle to give a lecture, and Goffredo Plastino asked me if I had heard of the Armenian Navy Band.[11] I had not, and I was concerned that it would be something I didn't like and I'd have to be polite. (Another instance, of course, of my perverse hope/fear that things Armenian will be inadequate.) What he

played me took my breath away. The driving force behind Armenian Navy Band is Arto Tunçboyaciyan, and when I heard that CD, I didn't register that he was part of Night Ark. The Band is a project Tunçboyaciyan began in 1998 in Armenia, with twelve then-young musicians who play both jazz and traditional Armenian music:

1. Arto Tunçboyaciyan: percussions, vocals, *sazabo* (a stringed instrument not unlike the oud)
2. Anahit Artushyan: *kanun* (a multiple stringed zither of twenty-six courses with three strings per course, with *mandal*, levers, to create altered tones)
3. Armen Ayvazyan: *kemanche* (three- or four-stringed fretless or fretted bowed instrument, played upright, usually on the knee)
4. Armen Hyusnunts: tenor and soprano sax
5. Ashot Harutiunyan: trombone
6. David Nalchajyan: alto sax
7. Tigran Suchyan: trumpet
8. Norayr Kartashyan: *blul, duduk, zurna* (all wind instruments)
9. Vardan Grigoryan: *duduk, zurna*
10. Arman Jalalyan: drums
11. Vahagn Hayrapetyan: piano, keyboards
12. Artyom Manukyan: bass[12]

By any reckoning, that's a very cross-cultural line-up of instruments. And while Tunçboyaciyan took with him his jazz influences from Night Ark and before, the others brought with them the classicisms that were so ingrained in Armenian music-making in Armenia in the Soviet period. They have recorded three albums so far: *Bzdik Zinvor* (*Small Soldier*, Svota Music, 1999); *New Apricot* (Imaj Müzik, Universal, 2001); *Sound of Our life—Part I: Natural Seed* (Svota Music/Heaven and Earth, 2004). Their sound is the most classically oriented of any of the groups discussed so far and obviously farthest from the jazz quartet style of both Taksim and Night Ark.

Winner of the 2006 BBC World Music Audience Award, Armenian Navy Band is more like the world music version of a large jazz band: thicker textures, careful arrangements, less overt jazz vocabularies than the other groups discussed above. In fact, Tunçboyaciyan calls what they

do "avant-garde folk"; this is also the name of a club in Yerevan, where an impressive range of classical, folk, rock and world acts (such as the National Chamber Orchestra of Armenia; "Dhoad" Gypsies of Rajasthan, India; Aly Keita, Mali; and the Armenian Navy Band) have played or play regularly.

The Armenian Navy Band's version of "They Love Me 15 Feet Away," originally written by Tunçboyaciyan and recorded by Night Ark, appears on the *New Apricot* album. Since it was recorded by both Night Ark and Armenian Navy Band, it provides an interesting point of comparison. Night Ark's version is stylized, a jazz quartet playing a folk-inspired tune. It begins with a bit of wordless singing that could be taken as a kind of post-Ottoman scatting, and it includes passages on the oud that sound not unlike Al DiMeola's fusion guitar work in Return to Forever, and some quiet passages of conversations between oud and piano. Armenian Navy Band's version, on the other hand, has a horn section with passages that sound straight out of Tower of Power or Earth, Wind, and Fire; their version is faster, poppier, and a bit funkier. Tunçboyaciyan's notion of avant-garde folk shows itself clearly here—while Night Ark's version is safely within a jazz idiom, Armenian Navy Band's is fairly far from jazz, with the possible exception of the presence (though not the vocabulary) of the horn section. It is, rather, an unpredictable combination of folk and pop and funk.

In 2004, a group of music promoters and lobbying organizations put together Armenstock 2004 and the "Kef for Kerry" tour, a series of fundraisers and get-out-the-vote efforts for John Kerry's presidential campaign.[13] For a number of reasons, this was a surprising event: the Armenian-American community has historically preferred to maintain close ties to both political parties, and to the extent that it has preferred one party, it has often been the Republicans. Moreover, the community has been conservative musically, but this event advertised "Armenian Jazz, Progressive KEF, Traditional Folk, Alternative Folk and Armenian Pop." It was a huge success, with people in attendance from all over the Northeast, including a big group of my friends and family.[14] There was an all-day lineup of artists such as Gor Mkhitarian (the lead guitarist of Lav Eli, whose solo career as a singer-songwriter mixes folk and rock idioms), Cascade Folk Trio (which mixes Armenian folk music with R&B, jazz, and rock), John Bilezikjian (a respected folk oud player). In other words, the program was a mix of both traditional folk and more contemporary sounds, and all of my friends, like me, were incredibly moved by the experience (even if some older women did ask one of my friends to put a shirt on

her baby girl, the kind of old-fashioned thinking we thought we'd escaped for this one day).

Another interjection: I certainly associated the woman's comment with the traditional notions of gender and propriety that drove me away from the community. But what do I actually know about this? Would an older woman in Armenia be likely to say the same things? Would a woman my age be likely to object? Am I transporting very Western liberal notions of the politics of the body into this interaction? This is the first question in the list I can answer—yes. Am I sorry? No. Am I disturbed? Yes. The day—for my friends, for me, and I think for many of the participants—was about making new combinations of traditional Armenian diasporan values with those of the local context. Arguably, at least, neither I nor the woman in question can lay claim to correctness.[15]

In the evening, the featured act was a solo performance by Arto Tunçboyaciyan. In a mix of philosophy and virtuosity, he played the drums, told stories, and captivated the audience with a solo performance on a soda bottle and plastic paint bucket. (This last part was very similar to his performance at the BBC awards, and both are very easy to find on YouTube.) Once more, I was spoken to and for by an unexpected performance. Tunçboyaciyan says in performance, in liner notes, and on his website that his musical mission is to bring people together, to bring "Love, Respect, and Truth" (the title of the "soda bottle" song). Perhaps it is unfashionably idealistic to imagine that music can change people, but his ideas and the music that expresses them are powerful and powerfully engaging. The audience at Kef for Kerry, including my seriously cynical cohort and I, were swept away by his vision of what might be.

There are, of course, many other Armenian jazz acts throughout all these communities: Armen Donelian's important solo piano and composition career, the Armenian-born singer Datevik Hovanesian (who now lives in New York City), the Armenian Jazz Band, Tigran Hamasyan (winner of the 2006 Thelonius Monk International Jazz Piano Competition), and Vardan Ovsepian, who also played at Kef for Kerry. My effort here was in no way meant to be exhaustive or definitive, and there are a host of other Armenian jazz musicians, both in diaspora and in Armenia, whose music deserves attention. It remains to be seen (and heard) if music, including projects like the Armenian Navy Band, can help to close the very real and very vast historical, ideological, and philosophical gaps among various diasporan communities, and among those disparate communities and Armenians in Armenia.

Rather, this is an account of my own relationship to these artists and their importance to me, personally and professionally. Each group—Taksim, Night Ark, and Armenian Navy Band—stepped into my life at a crucial moment to remind me that all (Armenian) is not lost. That I don't have to choose between tradition and independence, between being Armenian and being a scholar of music cultures. That I can hear myself in a CD. This is a gift I'm sure none of these projects had in mind when they began to play and record, but it is of enormous importance. As "undisciplined" diasporan subjects, people like me rarely hear or see ourselves, and that is an unenviable state indeed. Whereas ethnicities often attach themselves to affects of inclusion, for us the affect can more frequently be frightening. When groups like Taksim, Night Ark, and the Armenian Navy Band express their worlds through fusion projects like these, they may or may not understand their work as a healing balm for the scars of fragmented identities, but it is exactly that. When we can hear ourselves so beautifully sung, some of the strangeness of living diasporically becomes, itself, beauty.

Before I had heard the albums discussed above, I experienced myself, as I have been trying to describe, as an impossible creature—both a feminist and a lover of the oud, both able to teach film theory and to make what my mother's family called *khadaif* and my father's *knafa*, both Westernized and Armenian.[16] I didn't know there were diasporan Armenians who shared my feelings. Once I encountered these albums—each, as I have described, at important moments in my life—I was part of a distributed subjectivity again. Not alone, but connected; not isolated, but embraced; not silent, but full of sound.

Put another way, I felt like a bunch of parts that wanted to be whole but couldn't. Once I shared events and experiences with other "bunches of parts" like me, I didn't feel like something was missing. But what I felt was a temporary sharing of a host of things: the sounds, the ideas, the prior dissatisfaction and discomfort, the feelings of deficiency and excess, loss and joy. Kef for Kerry didn't make me whole—it made me part of a field of subjectivity that was made of all of those things at once. In that room, for a brief while, we were a small unit of distributed subjectivity that shared something very particular: not Armenian-American identity, which is, in Massumi's terms, a stasis, but rather a process in motion, the process of being diasporan/Armenian/American/hopeful/democrats-leftists-anti-Bush-ites.

In listening to these albums (over and over, as I was doing other things and with focus, in a variety of places in the attentional field), I experience

myself as part of a field of distribution, as part of a process that comes into being through listening. Listening, before these albums, meant for me a kind of excision—you can bring this part of you into the endeavor, but not that part. Engaging albums like *It's about Time*, *In Wonderland*, and *New Apricot* is, on the other hand, not a process of exclusion.[17] Quite the opposite. In drawing on various musical practices, they offer inclusion, a broad reach around the network of distributed subjectivity. In projects like these, affective listening can do its most important work, offering ways *in* to new experiences and perspectives and events and processes that open up a whole new world of possibilities.

6 Would You Like Some World Music with Your Latte?

Starbucks, Putumayo, and Distributed Tourism

RETAILING WORLD MUSIC, RETAILING LIFESTYLE

In this last chapter, I want to turn to the most obvious form of ubiquitous music—music in stores. One of the ways we referred to ubiquitous musics in general for decades was by the term *Muzak*, the name of the corporation that arguably developed many of the practices this book is about. (For a history of Muzak, see Lanza 2004.) Several features of that music have undergone radical changes in the past twenty-five years. First of all, it now mainly—although not exclusively—consists of songs by original artists, whereas it once was almost all popular songs and classics rearranged for lush strings. Second, it can often include percussion and vocal tracks, which were long considered undesirable in music in retail space—vocals were thought to demand too much attention from listeners, and percussion was perceived to work in opposition to the relaxing effect that was being sought. Third, the range of materials has stretched well beyond the local and familiar. Fourth, in the United States at least, it was for a period an important stage for branding activity. During the 1990s and early 2000s, retail chains from Sunglass Hut to Jiffy Lube (where you can get a quick and reasonably priced oil, lube, and filter on your car) to Victoria's Secret (which offers infamously provocative lingerie) produced compilation CDs to sell in their stores.[1] While this is less common now, sonic branding is a whole, highly developed world of activity (see Goodman 2010; Powers 2010; Meier 2011), and the choices of music in stores is still a matter of significant economic activity for businesses.

It is these latter two phenomena with which I am concerned in this chapter. How should we understand stores choosing what has come to be called "world music" for their sound tracks? What are stores selling and

what are listeners buying when they purchase such compilations? "Ethnic" restaurants have for years now played "ethnically appropriate" music; for example, Olive Garden, a North American chain of Italian restaurants, had, as of the mid-2000s, specially tailored music provided by DMX Music that combined Italian folk songs, Italian-American singers like Frank Sinatra and Perry Como, and opera. (I haven't been in one of these restaurants in a long time, and DMX, which at one time tried to purchase Muzak, has now been bought by a Canadian company, Mood Media, which had previously purchased Muzak. Nonetheless, I assume that regardless of the provider, the mix of genres in Olive Gardens everywhere remains much the same as when I researched it approximately ten years ago.) Such a representational matching does not seem to me to be the same issue as world music in coffeehouses and health food stores, which is less about representation as such than about engaging a particular aspect of distributed subjectivity in a particular kind of listening. (As an aside, it's also worth mentioning that, at least in New York and San Francisco, more and more restaurants began playing "mismatched" music some time ago; I have heard the Gypsy Kings, for example, in my favorite local Thai restaurant in San Francisco, Rat Pack evergreens in an Indian restaurant, and Buena Vista Social Club almost everywhere when Wim Wenders's movie about the group was released in 1999.)

STARBUCKS AND PUTUMAYO

Two paradigmatic cases in the United States are, I want to suggest, Starbucks, the coffee chain, and Putumayo, a world music record label. One is a business that has throughout its history to date included music in its strategies, and the other is a label that grew out of a business, and that has included selling in nontraditional retail outlets as a significant part of its business strategy. Let us begin with Starbucks. In April 1995, Starbucks premiered its first for-purchase CD, entitled *Blue Note Blend*. Since then, it has released dozens more, often focused on jazz, but including *Café* [sic] *Cubana* and *Mas Café Cubana, Rendezvous à Paris*, and *Sentimento Brasileiro*. (On 31 July 2011, the two world music CDs Starbucks had on sale were *Jamaica: Island in the Sun* and *In a Bossa Nova Mood*, both compilations. In January 2012 Malaysian singer-songwriter Zee Avi was featured.) The first Starbucks CDs were produced in a partnership with Sony Records, after which Starbucks had a brief relationship with the WOMAD (World of Music, Arts, and Dance) festival and Peter Gabriel's

Real World Records label, which produced the album "WOMAD: Starbucks World Music Volume One" in 1998.[2] But, as the Starbucks website said in 2002, "In 1999, Hear Music, a music company dedicated to guiding curious, thinking adults to great music, joined the Starbucks family. We invite you to listen to hundreds of CDs, explore music you've never heard, and discover your next favorite record at www.hearmusic.com."

Hear Music's site said, "In 1999, we joined Starbucks to enhance the discovery of music in their coffeehouses worldwide." Hear Music's tag line was "Live More Musically," and the company specialized in helping people "discover all the great music out there beyond the Top 40." *Elle* magazine wrote of Hear Music: "Imagine a record store that arranges its inventory by mood, history and taste, guides you through whole genres, and makes grown women feel just as welcome as teenage boys. Cruising into Hear Music is like dying and going to music heaven" (as quoted on *www.hearmusic.com* in 2002).

Hear Music, in other words, offered a lifestyle-oriented approach to music marketing that is very much in synch with the Starbucks approach. Alongside Hear Music albums, Starbucks sells Kenyan, decaf, French roast, and fair trade beans, jungle print mugs, and chocolate covered dried cherries. Oh yes, and venti nonfat no-foam lattes. ("Venti" is Starbucks-speak for "large." For a longer discussion of the similarities between Hear Music and Starbucks, see Simon 2009, chap. 5.) In 2007, Hear Music became a partnership of Starbucks and Concord Music Group; their current output focuses on "emerging artists with inspired vision and extraordinary talent and also serves as a home for established artists with timeless resonance."[3] In May 2012, that quotation still appeared on the home page, where the featured artists were Clarence Milton Bekker (listed as World and Latin), James Taylor, Paul McCartney, the Chieftains, Carole King, and Linda McCartney. For a handful of years, music was projected to be a significant income stream in its own right, especially after the massive success of the 2004 Hear Music album of Ray Charles duets, *Genius Loves Company*. But Starbucks has scaled back that vision considerably; stores sell a small number of both Hear Music products and albums made by other labels, and music has returned to being seen as part of the overall service provision of the Starbucks experience.

Putumayo's story is slightly different but equally intriguing. Dan Storper founded the Putumayo clothing company in 1975. He began with a small clothing and craft store in Manhattan that featured products he found on trips to Central and South America and grew to include more

stores and a wider range of merchandise. He played Andean music in the stores, because, as he put it, "It helped to create an environment that made you feel as if you were escaping the city and traveling to South America" (Putumayo 2003). In 1991, while traveling in San Francisco, he heard Kotoja, a Nigerian and American band that plays a mix of highlife, juju, jazz, and world music. Somehow, this African fusion sound inspired Storper to understand that he needed different music in his Latin clothing and craft store. He began working with an in-store music company to create mixes of music from around the world. Customer response was great, and very quickly Putumayo developed a partnership with Rhino Records. They began putting out compilations like *The Best of World Music: African;* by 1993, Storper had started his own label, Putumayo World Music. In 1997, Storper sold the clothing business to focus entirely on the label (which had produced over one hundred CDs by its tenth birthday). The company has experimented with signing artists and releasing single-artist albums, and it has also rereleased a Miriam Makeba CD, *Homeland,* which received a 2001 Grammy nomination, but the core business remains putting together compilations according to region and what could be called "vibe," that is, the "Lounge" and "Groove" and "Beat" series.

One could presume that Putumayo, whose tag line is "Guaranteed to make you feel good!" is just another world music label, but there's a crucial difference. Based on its roots in the clothing store, Putumayo has aggressively pursued a marketing strategy that includes arrangements with retail stores. As its website stated in 2005: "Putumayo is considered a pioneer and leader in the non-traditional retail area. Putumayo has built a network of more than 2,500 book, gift, clothing, and coffee retailers that sell, play and display its CDs. Putumayo also retains a strong presence in record stores around the world. It has developed retail promotions including Travel the World with Putumayo trips to Martinique, Senegal and Ireland, in-store events, and consumer gift with purchase promotions utilizing calendars, beach balls, journals and notecards featuring Putumayo cover art."[4]

The same paragraph now says: "Putumayo is considered a pioneer and leader in developing the non-traditional market. A large portion of its target audience consists of 'Cultural Creatives,' sociological terms for 50 million North Americans and millions more around the world with an interest in culture, travel, and the arts. To reach these consumers, Putumayo has built a proprietary network of more than 3,000 book, gift, clothing, coffee and other specialty retailers in the US and thousands more

internationally that play and sell its CDs, in addition to maintaining a strong presence in record stores."[5]

This is clearly a lifestyle marketing approach as well, but with a slightly different orientation. Starbucks and Putumayo are addressing the same market group, which they share with the *New York Times* and National Public Radio in the United States. This is the group that Putumayo calls "Cultural Creatives" and that Simon calls the "creative class" (Simon 2009: 150).[6] But Putumayo prides itself on its social responsibility. It gives to a number of nonprofits working in the countries where the music comes from, including Coffee Kids, Music Maker Relief Foundation, and its own nonprofit project, Putumayo Cross-Cultural Initiative, aimed at bringing arts and music from all around the world to children. While Starbucks also seeks to cultivate this part of its image (see Simon 2009: chap. 6), it is nowhere near as significant a component of its branding as it is for Putumayo. This puts Putumayo firmly in a lifestyle configuration that is particularly appealing, for example, to natural foods stores and gift shops that specialize in crafts from underdeveloped nations. It means that people like me see Putumayo CDs everywhere we go.

One reason I see them everywhere I go is another important feature of the Putumayo brand, which is the cover art of Nicola Heindl, whose style is immediately recognizable, and full of people having lots of fun. As the website says, "Putumayo's CD covers feature the distinctive art of British illustrator Nicola Heindl, whose colorful, folkloric style represents one of the company's goals: to connect the traditional and the contemporary. By combining appealing music and visuals with creative retail marketing, Putumayo has developed a unique brand identity, a rarity in today's artist-based music industry."[7] Each cover focuses not on landscapes but on people in a medium field of vision (i.e., torsos with some background, what filmmakers would call a medium shot) of happy dancing people and icons of local color. In 2004, Putumayo began to market note cards and calendars with Heindl's art as well, and now the company sells art prints and sticker books and Christmas cards and coloring books. Moreover, the nature of the CD packaging will be expanding. On the home page of the site is this quotation from Storper: "We look forward to offering great international music digitally. Our physical CDs will remain unique and include multilingual liner notes, photos and often recipes, glossaries and more which will not be included on the digital collections."[8] Like many labels, Putumayo is trying to find a way to offer value added in the physical product, rather than abandoning it altogether, and the idea of recipes and glossaries points to opportunities available particularly to world music labels.

DISTRIBUTED SUBJECTIVITY AND WORLD MUSIC LISTENING

It's not only the art that has a "feel good" focus, however. Throughout Putumayo's materials, there is an emphasis on "fun" and "upbeat," the adjectives Storper uses to describe his first experience of Kotoja in Golden Gate Park. In the same interview with him quoted above, which is contained in the liner notes to the Tenth Anniversary Collection, the interviewer asks him about Putumayo's A&R strategy.[9] He replies: "We look for melodic, upbeat music that's accessible, that we feel is universally appealing" (Putumayo 2003: 7). And the company takes this part of its mission very seriously; it even has a "feel good guarantee": "Putumayo's products are protected by our Feel Good Guarantee. If you are unhappy with any purchase of a Putumayo CD, you may return it to Putumayo for a full refund." This is an unusual musical strategy,[10] pursued not only by Storper, but also by Jacob Edgar, an ethnomusicologist and former vice president of A&R, who joined Putumayo in 1998, and all the staff.[9] And it is very clearly effective; the press talks about how Putumayo has taken world music from dry field recordings to the domain of the fun and marketable.

Putumayo's strategy raises hosts of questions about whose aesthetics are being reflected in music that is presumed a priori to express another culture. But it does work quite well for the company—its sales continued to increase through some of the recorded music industry's worst moments. In fact, the caption to the photo of Storper that appeared in a 2003 *New York Times* article reads "Dan Storper, founder and president of Putumayo World Music, has found success with his compilations of upbeat global grooves."[11]

While Hear Music does not have the same kind of mission to distribute world music that Putumayo does, it nonetheless regularly includes world music in its offerings, which generally comprise jazz, blues, African, Caribbean, and Latin American music; more recently there's been a focus on singer-songwriters and stars of the 1960s and 1970s. For example, one compilation, "Hear Music Volume 8: Between Stories," includes artists such as Wilco and Nina Simone, but also Quetzal (an LA Chicano band) and Henri Dikongue (a guitarist from Cameroon), and *In a Bossa Nova Mood* includes tracks ranging from Frank Sinatra and Tom Jobim to Bossa-CucaNova, an electronica/bossa nova group. Generally, it seems that the CDs focused entirely on world music are based on musical practices in countries associated with coffee, such as Brazil and Cuba. While perhaps

a bit unsubtle—despite rejection of coffee-themed tracks as "too clichéd" (Simon 2009: 158)—it does maintain a kind of clunky coherence among the products in the Starbucks shop. And the company appears to be unencumbered by musical details. For example, here is the description for *Cafè Cubana:* "Our first and most popular Latin music CD. One of our most requested CDs, Cafè Cubana is an exciting blend of Latin sounds from Cuba, Argentina, Cape Verde and the south of France. This hot collection showcases the different musical influences that make the Cuban sound unique. Some of the finest artists in Cuba share the marquee with world artists whose musical styles helped shape these hot sounds. The lights are up and the beat has started. Welcome to Cafè Cubana, a Starbucks exclusive." Despite the ad copy, there is nothing about the way this compilation is put together that provides insight into influences on Cuban music—in fact, the subtitle is "a flavorful blend of Latin sounds," and the track list includes the Gypsy Kings playing "Una Rumba por Aqui" and Gidon Kremer playing Astor Piazolla's "Oblivion".[12] The other musics are there, in other words, simply because they make a good blend, with no concern for the relationship between the title and the tracks. But the CD does sound good in a coffee shop.

AFFECTIVE MARKETING

Starbucks/Hear Music and Putumayo have both created focused lifestyle-oriented marketing strategies based on the insertion of world music sounds into the contemporary gift and coffee shop retail landscape.[13] In *Everything but the Coffee: Learning about America from Starbucks,* Bryant Simon opens his chapter on music, "Hear Music for Everyday Explorers," with this anecdote (to which I referred in passing above):

> In 2006, *New York Times* columnist and linguistics professor Geoffrey Nunberg published a book called *Talking Right: How Conservatives Turned Liberalism into a Tax-Raising, Latte-Drinking, Sushi-Eating, Volvo-Driving, New York Times–Reading, Body-Piercing, Hollywood-Loving, Left-Wing Freak Show.* Nunberg's long list captured the attention of NPR [National Public Radio] media reporter Brooke Gladstone. "Hmm," she thought, "this sounds like a profile" of her listeners. She set out to see if, in fact, it did fit. Using internal documents, she discovered that while NPR listeners refrained from body piercing, they did like movies and sushi. They were 173 percent more likely than other Americans to buy a Volvo and 310 times more

> likely to read the Sunday *Times*. They liked *West Wing*, not *Fear Factor*, and yes, she determined, they really did go to Starbucks.
>
> Perhaps this shouldn't be surprising.... Both sell, actually, what Gladstone called a desire to "understand how the world works." Indicating once again the expanded meanings of buying, they offered their customers an easy way to absorb and project a sense of learning and discovery.... Both promise to take customers to new and different places, and the customers in turn get to use the knowledge they gain from these adventures as a kind of currency—as yet another way to make distinctions and show that they are, in the words of a Starbucks marketing representative, "everyday explorers." (Simon 2009: 149–50)

But there is something more than the addressing of this particular lifestyle cluster—the cultural creatives, the creative class, bobos (bourgeois bohemians)—going on in the way both Starbucks and Putumayo present their music. In his 2004 article "Intensities of Feeling: Towards a Spatial Politics of Affect," Nigel Thrift argues that urban spaces are being repoliticized through design. They are being designed, he argues, to invoke affective response, and while he recognizes that this has always been the case, he suggests that something different is happening now:

> But what I would argue is different now is both the sheer weight of the gathering together of formal knowledges of affective response..., the vast number of practical knowledges of affective response that have become available in a semi-formal guise (e.g. design, lighting, event management, logistics, music, performance), and the enormous diversity of available cues that are able to be worked with in the shape of the profusion of images and other signs, the wide spectrum of available technologies, and the more general archive of events. The result is that affective response can be designed into spaces, often out of what seems like very little at all. (Thrift 2004: 68)

I want to emphasize the word *seems* in the last sentence of that quotation. It does indeed seem as if the Starbucks affect formula is "very little at all," but everything from the obvious, like sofas and fabrics and wood and color schemes, to the subtle, like how few CDs to have available or font choices for signs, is carefully selected to create a particular affective response—a complex of feelings around relaxation/comfort/security. While the response can obviously not be guaranteed, it certainly can be, and is, carefully engineered to produce a particular relationship between the customer and the shop (and, by extension, the brand).

While Putumayo has nowhere near the same level of control over the stores in which its products appear, the release of the *Yoga* CD is one among many clear signs of how the label hopes to be perceived. In Liverpool at the moment, for example, I most routinely see Putumayo CDs in a small shop called Shared Earth, an eco-friendly shop that sells recycled and imported gifts, often with a hint (or more) of non-Western origin. The shop sometimes plays Putumayo CDs, and it always plays world music. I have also seen Putumayo CDs in alternative health practices that offer various forms of massage, Reiki, and so on. The first time I saw a Putumayo CD in a record store, which was before I began this research, I was startled—I had presumed that the company only stocked businesses with some sort of non-Western theme or content. As I will discuss below, this may not seem like a question of affect, but on the contrary, I think it is precisely that.

DISTRIBUTING SUBJECTIVITIES

While I find the questions of the economic structures and practices of Hear Music and Putumayo fascinating, they are ultimately not my focus here. As I have already pointed toward, most scholarship on world music as a phenomenon (as opposed to particular artists or genres of music that might be categorized as world music) remains focused on one of the persistent problematics of popular music studies and cultural studies more generally—commodification. Rather than interrogating commodification, however, I want to ask a series of questions, ones that have always been central to my work, and that are ultimately the focus of this book. How can we understand the relationship between listening processes and moments of subjectivities? What fields of distributed subjectivities might the Hear Music and Putumayo CDs engage in their listeners? Who are we and what are we hearing when we enter those spaces? When we purchase these CDs? I want to suggest that the answers might not be containable by the terms of the debates around commodification, globalization, and cultural imperialism; as I will insist, the alternative is not simply celebratory rather than critical, but might instead introduce different kinds of questions and vocabularies that could have far-reaching implications for these debates.

I have been arguing throughout this book that ubiquitous musics engage us in distributed subjectivities that exceed, or perhaps ignore, the apparent boundaries of the individual, that operate rather on a model more like distributed computing than like early desktop computing. As

I argued in the introduction, desktop computing takes the computer as a discrete entity, like the Enlightenment subject; it relies solely on the processing power contained in the desktop unit. I talked about research that uses thousands of computers, rather than a single one or a few massively powerful computers. But there is an important distinction to make: I am not suggesting that distributing computing is a metaphor for subjectivity. Rather, the operations, engagements, and processes that we perceive as being between "us" as discrete individuals and "objects" in the world around us, including "objects" of culture, *are* distributed subjectivities. The development of these subjectivities is, I believe, the condition of possibility of distributed computing having been developed. It works so well as a metaphor for subjectivity because subjectivity was, unconsciously, the model—the metaphor, if you will—of distributed computing. As people and things and people and things became increasingly interdependent, the thought of networks and interdependencies and distributions became possible, appealing, necessary. Then, the concrete operationality of distributed computing becomes available as a way to comprehend the kinds of subjectivities-processes that made them possible.

So, distributed computing aggregates the unused processing power of many small computers to make enough power to address very large-scale questions; each computer, then, is a dense node in a network, neither discrete nor flattened. This helps to make sense of subjectivity; each object, each person, each organ, and so on is a dense node in an enormous network that addresses and engages each other in various ways and with varying degrees of power. Distributed subjectivity, as I am conceiving it, is related to technofeminist notions, beginning perhaps with Donna Haraway's cyborg manifesto, but also to, for example, Deleuze and Guattari's (1987) rhizome and Alexander Galloway's (2004) protocol.[14]

As I will elaborate on in the conclusion, the centrality of listening to distributed subjectivity is not only important for those of us interested in sound and music. It has a range of important ramifications for all students of culture. One such salient feature is the absence of focused attention, or more appealingly, the presence of a multilocated attention, and the understanding of attention as having multiple qualities as well as a range of quantities that I have been arguing throughout this book. I understand distributed subjectivity in this sense as undermining a series of entrenched ideas: our received notions of both the individual and the social, and particularly any notion of the conflict between the two; the centrality of vision in almost all stories of all kinds of subjectivities, and particularly the repression of all the other senses in such discussions; and the notion of

each body as a discrete and presocial entity. Instead, distributed subjectivity is movement and flow, through and across diasporas, as in chapters 2 and 5, in our furniture, wallpaper, clothing, and phones, as in chapter 1, and through the affective responses that Starbucks and Alternatively Better (where I go for massages) engineer.

* * *

This notion of subjectivity has wide-reaching ramifications for our understanding of technologies, repetitions, capital flows, and much more. In the context of this discussion, to begin with a fairly small example, if subjectivity is distributed, as I have suggested, what is being evoked across that particular field of subjectivity when world music is played in coffee shops? What does the "far away" or "not here" sound suggest? What is musical tourism, and what are the possible relationships between it and physical tourism? In the quote from Storper above, Andean music produced a sense of escape and travel. What does that mean? To begin approaching that question, a brief survey of world music scholarship is in order.

Many scholars have argued that multiculturalism, rather than being a critique of contemporary capitalism, is/was an extension of multinational capital into its cultural form. In other words, the insertion of more and different cultural practices would not necessarily disrupt relations of power, and particularly not economic relations. This kind of argument was the basis of much of the first scholarship on world music, such as works by Veit Erlmann and Steven Feld.

Erlmann's approach is strongly influenced by a sophisticated poststructuralist Marxism, most clearly Fredric Jameson. In his 1993 introduction to a special issue of the journal *The World of Music*, he makes this position clear: "Perhaps the assumption does not seem wholly unfounded then that the nostalgia for the totality celebrated in 'world music' answers an old-fashioned, residual desire in the West for a unity and coherence of worldview that has for ever been lost" (Erlmann 1993: 8). Erlmann's concern is exactly that of multiculturalism's Marxist critics; rather than introducing difference into homogeneity, world music is one more expression of a "global ecumene." "The idea of a world community is, in the first place, the result of a double process of global commodity production with its homogenization of specific local qualities and life worlds, and functional rationalization" (Erlmann 1993: 9). In other words, he argues, we would not have the "one world" fantasy so dear to many world music projects without transnational capital flows, without neocolonial relations, without a notion of a universal humanity that erases difference(s).

In his 1996 *Public Culture* article, entitled "The Aesthetics of the Global Imagination: Reflections on World Music in the 1990s," Erlmann makes the case even more strongly: "World music is a new aesthetic form of the global imagination, an emergent way of capturing the present historical moment and the total reconfiguration of space and cultural identity characterizing societies around the globe" (Erlmann 1996: 468). While Erlmann shows an unusual sensitivity to questions of subjectivity and listening, one consequence of his approach is a focus on questions of production and distribution.[15] In "The Politics and Aesthetics of Transnational Musics," the journal introduction quoted just above, he explicitly argues for a focus on production: "Musical ethnographies will increasingly have to examine the choices performers worldwide make in moving about the spaces between the system and its multiple environments. Rather than casting these moves in dichotomic terms as choices between the West and the rest, between hegemony and resistance, these circuits of global musical production must be seen as having numerous loops, highly changeable 'border-zone relations' that allow performers to constantly evaluate their position within the system" (Erlmann 1993: 6–7). Erlmann offers this focus on production as an antidote to naive celebrations of world music in which the entry of some non-Western materials in the marketplace will lead the way for a serious engagement with the cultures that produced them. And in 1993 and 1996, one could come away from reading or listening to discussions about world music with just such a naive, celebratory sentiment.

Feld shares this emphasis on the questions of production of world music. Two essays from his important body of work on this topic are included in *Music Grooves*, which he coauthored with Charles Keil (1994). The volume is divided into two sections: "One: Participation in Grooves" and "Two: Mediation of Grooves." Both of Feld's essays on world music—"Notes on 'World Beat'" and "From Schizophonia to Schismogenesis: On the Discourses and Commodification Practices of 'World Music' and 'World Beat'"—appear in part 2, under the sign of "Mediation." The placement of the essays is an emphatic mark of their concerns; Feld is not writing about world music or world beat as a participatory practice, but as a mediated one. At the end of "Notes on 'World Beat'" he says:

> I'm suggesting then that the revitalizing cycle of Africanization/Afro-Americanization in world beat comes to be increasingly entangled with issues of power and control because of the nature of record companies and their cultivation of an international pop music elite with the power to sell enormous numbers of recordings. These forces tend to draw upon and incorporate African and African-American

materials, products, and ideas but stabilize them at the levels of labor, talent, or "influences," levels at which they can be continually manipulated for export and recirculation in made-over forms. The politicized aesthetic of a record like *Graceland* then looks more and more like an ink-blot test whose projection is a much too literal map of the black and white of world music. (Feld 1994a: 246)

Feld's concerns in this passage stand in here for the issues he raises throughout these essays and in his other publications on "world music" (see, for another example, "A Sweet Lullaby for World Music" (Feld 2000). He aligns himself with the interests of those who, from the perspective of economic power, are marginal, which in the present case are the non-Western musicians and cultures who provide the substrate of world music. His diagnosis is that schizophonia, the separation in time and space of musical production from consumption, leads to schismogenesis, the escalating process of differentiation between two cultural entities, to the detriment of the less powerful.

Jan Fairley, Jocelyne Guilbault, George Lipsitz, Tim Taylor, and many others have addressed these very tensions in world music. They all agree that it is a complicated phenomenon about which they are ambivalent. As Guilbault succinctly says: "World music should not be seen as simply oppositional or emancipatory. Neither, however, should world music be viewed as merely the result of cultural imperialism or economic domination. To understand world music fully, we must look at its place within the complex and constantly changing dynamics of a world which is historically, socially and spatially interconnected" (Guilbault 2001: 176). Or as Reebee Garofalo (1993) puts it, the "cultural consequences of the emerging world system include challenges and opportunities as well as destruction and defeat" (13). Throughout the literature, in these and many other cases, the authors are attentive to the possibilities and problems of the production and distribution of world music, expressing, on the one hand, great concern over the rights of musicians, and, on the other, hope for the power that music can bring to attempts to understand unfamiliar issues and cultures.

Two more recent works on world music bear brief discussion here. The first is David Clarke's (2007) "Beyond the Global Imaginary: Decoding BBC Radio 3's *Late Junction*," in which he struggles with the demand to "ponder again music as consumed in everyday life and the question of its commensurability with a critical analysis of the politics of the lifeworld" (paragraph 81). He concludes by saying that these two elements—the critical and the pleasurable—may well be incommensurable, but they might also serve as a critical resource when trying to understand, for example,

World Music with Your Latte / 97

the complexities of our engagements with Alan Lomax's recordings of several songs in the penitentiary:

> In a song like "Black Woman" heavy hammer blows—the sounds of the prison workers' tools—are the only accompaniment to the singing. This is simultaneously a musical and non-musical accompaniment. Downbeat in every sense, the mallet blows sound as both an index of hard labour and an element of the music. If they're an aural translation of the force of the law on the bodies of the prisoners, the singers resiliently claim its rhythm for their song and in the process resist subjugation to law's authority. But the very sonic materiality of the blows resolutely ties the singing back to the occasion. The blows won't entirely assimilate to the singing, not even as a sedimented part of the musical material; and it's perhaps this fact above all others that forestalls hearing the music as an artefact, as something that can be universalised. It chains the singers into *this* context; but this also makes the singing *theirs* only—definitely not for appropriation by sippers of Cabernet Sauvignon. Lomax's sleeve note tells us that the prisoners were working on state cotton plantations, engaged in the same activity as non-imprisoned black labourers on the other side of the fence. It would not be fanciful to understand their common situation here—seen by some as a form of internal colonisation—as part of the *longue durée* of the same geopolitics that continues to operate in our own times. (paragraph 96)

Clarke's argument is that some music is more difficult to hear in the pleasant, enjoyable, multicultural mode of consumption of most world music; in fact, he calls such a possibility an "obscenity." And this is only one of the significant points he makes in this essay, but I want to reiterate it here: both Hear Music and especially Putumayo are working very hard at excising, beyond the realm of our vision and hearing, anything unpleasant or critical. If Clarke's concern is that we lose the sharp edge of Marxist critique at peril of underwriting multinational neoliberalism, then we need to find some way of escaping from that, or of working around it, or perhaps within it, which is very much what he seems to be suggesting; he ends his essay with only these lines after the above quotation: "Such are the flights of thought that can be released from these kinds of musical encounter, making a political turn that eclipses and destabilises pleasures of a more culinary kind. Potentially. Only connect." If we accept the glib fusions of global food (where Clarke's essay began) as pleasant and enjoyable, perhaps we can sometimes encounter music like that in Lomax's recordings at the Mississippi and Louisiana State Penitentiaries, music that refuses us the comfortable pleasure of the other, insisting instead on

sounding its conditions of production in the musical materials themselves in a way that makes enjoyment in any traditional sense impossible.[16]

The second work is Keith Howard's 2009 "Live Music vs Audio Tourism: World Music and the Changing Music Industry." Howard makes a crucial argument there; while many have noted the shift of profits and attention away from recording and toward live music, he considers the relevance of that for the field of ethnomusicology, which has always had a very complicated relationship to the world music industry. In this essay, he argues that "with live music . . . consumerism can be subsumed beneath the excellence above popularity mantra" in four ways. First, music is used as a form of cultural diplomacy, to be put on display at state functions and so on. Second, folk festivals make it possible for audiences to come into contact with musics they would otherwise not have heard. Third, various initiatives such as UNESCO's "Masterpieces of the Oral and Intangible Heritage of Mankind" shine a spotlight on live folk music practices. Fourth, there has been substantial growth in the teaching of folk instruments to students in higher education institutions. For all of these reasons, the focus on making music has remained absolutely central to the world music market. Howard takes, in other words, a different angle on the problem than Clarke; from Howard's perspective, the return of live music-making to a central position in the industries reinforces a very strong aspect of world music's—or perhaps (mostly non-Western) folk music's—communities, which is their frequent focus on collection, transmission, and accuracy rather than profit.

Keir Keightley's criticism of this body of scholarship offers an important different entry into the debate. Keightley begins from the hearpoint of the 1950s and suggests that, while Erlmann and others consider world music as a product of globalization beginning in the early 1980s, there are ample examples from the 1950s of what he calls "around-the-world" music. Record series such as Capitol's "Capitol of the World" and RCA-Victor's "Dinner in . . ." (e.g., Havana or Rio) not only suggested musical tourism, but also tied in to various campaigns for gastronomic and literal tourism (which might return us to Putumayo's plans to include recipes in CD packages).

Keightley identifies these recordings as early forays in globalization. On the one hand, he shows how some of these materials came into the possession of the major record labels through corporate acquisitions. On the other hand, these recordings are, as he puts it, a kind of "proto world music," in which we see what is sometimes called a "reverse flow" of culture from the margins to the center. He suggests that this reverse flow

is in the service of a global tourism that "offers a signal means of imagining and in turn experiencing the complex universe of modernity" ("Around the World": 11). This "complex universe" necessarily involves travel and tourism, it would seem, in ways that lay the groundwork for the invitations to distributed tourism that Hear Music and Putumayo deliver.

HERE, THERE, AND EVERYWHERE:
DISTRIBUTED TOURISM

I have deep intellectual and political sympathies with each of these arguments. For me, the history of world music should probably begin even further back than Keightley's project. It must include, for example, the several waves of Latin invasion in the United States (think Carmen Miranda, Xavier Cugat, Desi Arnaz) and should probably stretch back to the musical orientalisms of the nineteenth and early twentieth centuries in Europe. (Think *Turandot, Carmen*, Brahms's *Hungarian Dances*.) (There is some wonderful work on these topics; see, e.g., Jann Passler's 2000 article, "Race, Orientalism, and Distinction in the Wake of the Yellow Peril," on Albert Roussel and Maurice Delage in *Western Music and Its Others*; or Philip Brett's 2009 "Queer Musical Orientalism".) With Guilbault and the others, I simultaneously detest the exploitation of musicians as so much fodder for the industry's mill and welcome, even celebrate, the circulation of musical vocabularies that are new to me, not least on the grounds that they produce and reproduce different social orders than those I routinely participate in.

But all of these critiques, while powerful, fail to extend into the engagement of listening and subjectivities. (Keightley's work actually makes some strong hints in this direction in his discussion of tourism, but as in Erlmann's, it never quite surfaces to the level of a topic in its own right.) How are listeners located in the world by world music? What affects are set into play?

On the one hand, as we well know, collectors of world music accrue unto themselves a kind of discoverer's authority, or, as Simon's Starbucks informant put it, they become "everyday explorers," cultural Columbuses, if you will, "discovering" new continents of sound. Anthropologists and ethnomusicologists have interrogated this authority for themselves (although I think the questions remain very much unsettled—and unsettling). Nevertheless, the more salient point is that world music producers have no such qualms about their colonialist positions, at least not as far as

I can tell. Dan Storper was named a Goodwill Ambassador of the World Association of Former United Nations Interns and Fellows; no one seems to be concerned about questions of cultural or economic appropriation in his activities (which appear to be, in the grand scheme of things, at least not simply unethical), nor of the position of authority he occupies in relation to the musical cultures he chooses to disseminate.[17] This position of authority is deeply rooted in the same terrain as all discourses of musical authenticity—art in opposition to profit, fan in opposition to consumer, and so on. The one who actually physically *goes* to the field accrues authority, though he (the always masculine adventurer) who has heard what was brought back has "been to places" the rest of us haven't.

On the other hand, however, ubiquitous world music enterprises like Starbucks/Hear Music and Putumayo bring together a different set of relations of authority and tourism for their consumers. They set into motion a distinctly different form of space relations and subjectivities. Let me explain.

I own a few dozen of these CDs, almost all from Putumayo, but definitely Hear Music as well. I want to invoke them now to offer you what physicists call a thought experiment. I'm listening to one of the CDs in question as I write this—a Putumayo release from 1999 called *Samba Bossa Nova*. It includes cuts from a range of contemporary Brazilian artists of that period; this one is called "Preto, Cor Preta" by Jorge Aragão. Aragão is renowned among Brazilian musicians as a samba songwriter and performer with a funk/soul sound. By a small shift in sonic space—the addition of Aragão's funky samba—I am no longer just at my desk. This tune, and in fact the entire CD, makes focus a challenge for me. It pulls me away from here, to motion, to dance, to "there." Here. Let me do it again.

Out with *Samba Bossa Nova*. In with *Women of the World—Celtic 2*, a 1997 Putumayo release. This song is "Ta Se 'Na La" by Eithne NiUallachain. The difficulty of being a writing person accumulates as the link between me and this cut again moves me elsewhere. Thanks to artists like Enya and Loreena McKennitt, Celtic sounds have become perhaps the quintessential marker of elsewhere, though Irish music was familiar to many in the Anglophone world through the music-making and listening of the Irish diaspora before the advent of world music. In this case, I've been drawn into a party, a pub session, a ceilidh. There is something simultaneously very here and now, in my body, about this listening, and also something very "there" about it.

One more time, now.

Out with the Celtic women, in with *Music from the Tea Lands*, a 2000 Putumayo release with ten cuts from Tatarstan, China, Pakistan, India, Japan, Turkey, Iran, and Indonesia. I love this CD, at least in part because it produces for me the same spatial transports within one CD. Some cuts sound like my childhood to me, especially the one from Turkey called "Gerizler Basi" by Okan Murat Öztürk. Others, especially the east Asian cuts, sound as oriental/exotic to me as I envision the Putumayo staff imagine they will sound to the buyers.

So, what is this field of subjectivity I'm moving in and around, or that moves in and through me, or that the music and I create/uncreate/re-create together over and over? Leaving aside for the moment the fact that I'm listening more attentively than I usually would, when I sit here in my office at home in Liverpool and listen to music from Aleppo or Lagos, where am I, and what am I doing? And when I hear these cuts in my grocery store? my coffeehouse? These are all distinct settings with different listening practices, certainly, but they share certain features.

One might be tempted to call what I'm experiencing postmodern tourism. It's a compelling idea. That's what Daveena Tauber called it in her article in *Passionfruit: A Women's Travel Journal*. It's entitled "What I did on my Summer Vacation; or, the Politics of Postmodern Tourism," and she describes it thus:

> This past summer in a café in Guatemala, I heard a woman at the table behind me complain, "I like the goods here, but they look like they're straight out of Cost Plus, and I know I can just buy them at home." Her lament echoes precisely the predicament of the tourist in the postmodern era. The custom of bringing home exotic objects of curiosity is, after all, one of the long-standing customs of travel, handed down from colonist to tourist. . . . But in a globalized market . . . it is hard to find something that is "out of context," because everything is everywhere. (Tauber n.d.)

According to Tauber, Dan Storper's project—collecting exotic objects of musical curiosity—is embedded in old-fashioned tourism, and when he makes it possible for them to be *in* context in *all* contexts, he offers his listeners postmodern tourism.

I prefer the term distributed tourism, however, highlighting as it does the presence of a network, many places at once. Sitting in my office, listening to Putumayo CDs, I am a distributed tourist. I move from place to place without changing physical spaces. I occupy conflicting spaces—my car and Tatarstan, New York City, and Newfoundland—with the fluidity of electrons. My location at any given moment is only a statistical

probability, nothing more. My tourism is immediate and constant, iterative and only partially predictable.

My audio touring, in other words, is not about transport, which distinguishes it from musical tourisms of the past. For months, I was puzzled by the body of music Keightley described as "around-the-world music." I wondered what distinguishes Putumayo's *Italian Musical Odyssey* from 101 *Strings Presents the Love Songs of Italy*. I considered where they were purchased, how they were consumed, everything I could think of. And finally I realized that 101 Strings and other such international collections are the material culture of *modern tourism*; they are meant to evoke for consumers a different space and time through the wonders of modern technology. The basic idea seems to have been to create a sense of another place, even if only in fantasy for the moment. One turned one's home into someplace like Italy, for a brief moment, through the confluence of cuisine, place settings, and music—spread a blanket on the floor, put the album on, stick a candle in a Chianti bottle, and feed each other forks full of pasta. (I do not, of course, imagine that this was the routine material practice of 101 Strings' listeners, but rather that this was the fantasy structure in place.) One's attention, in this fantasy, was not split between Italy and one's living room; rather, one's speakers and so on made one feel *as if* one were in Italy. Such recordings operate this way at least in part because their basic musical structures—from instrumentation to harmonic language to recording technologies—are local and familiar, flavored with just enough markers to transport their listeners effectively to the destination of their fantasy.

The *distributed tourism* that Putumayo markets, however, offers a quantum effect—that is, entanglement. Just as Schrödinger's cat is both alive and dead, and light is both a particle and a wave, so too am I, as a Putumayo listener, both here and there, wherever there may be. Whereas many writers of postmodernity argue that the distinction between "here" and "there" is collapsed, rendered meaningless, I am arguing quite the contrary. Distributed tourism, as a postmodern cultural activity, depends on maintaining the difference between "here" and "there" while making it possible to inhabit both spaces simultaneously. Musically, these recordings are the verso to 101 Strings' recto: the musical structures are nonlocal, while a layer of pop/rock/electronica material is mixed in for comfort.

Jan Fairley (2001) describes this, as many writers do, in terms of the disappearance of geography-based communities. She recounts a point made by Paul Oldfield and Simon Reynolds in *Melody Maker*: "Identifying two groups who enjoy world music—non-Western musicians, Western

fans—Oldfield and Reynolds suggest that each group is attracted to the other because they are both disillusioned with their own societies in crisis and project onto the other culture a 'vicarious sense of belonging, of community, *wherever* it is to be found.' . . . There is a postmodern point here about the forging of non-geographical, non-spatial, imaginary societies." (Fairley 2001: 274).

Fairley goes on to develop her point in another direction, but she is right to suggest that so-called postmodernist theory went quickly to "non-space-based" communities. The problem with that model, as I suggested above, is that it can imply that space becomes inconsequential, and that cannot possibly describe the appeal of listening to world music. In particular, it doesn't account for the wild popularity of the feel-good Putumayo product.[18]

The notion of distributed subjectivities, however, offers the possibility of what I propose we should think of as a quantum effect; if I am a dense node in a lumpy network, I can *in fact* be both here and there at once. Not non-space-based, but entangled. While entanglement is fragile, it is nonetheless real and observable; similarly, this coffee-shop entanglement I'm proposing is fragile, too, but very real. It can be disrupted by the slam of a door or a scrap of conversation, but it is quite possible to be—as I described in the thought experiment above—both embodied and moving to the music in the coffee shop, and "in" another place, whether a ceilidh or a *souq*. This is, I think, the brilliance of Putumayo. Heindl's cover artwork, the company's A&R, its engineering, and its choice of track order all guide you through an apparent naïveté and recognizability to a sense of being "t/here."

Entanglement is a feature of quantum physics that many, beginning with Schrödinger himself, argue marks its radical departure from classical physics. According to Michael Nielsen in the November 2002 *Scientific American*: "The members of an entangled collection of objects do not have their own individual quantum states. . . . Entangled objects behave as if they were connected with one another no matter how far apart they are—distance does not attenuate entanglement in the slightest" (Nielsen 2002: 73). In a distributed world, places can be and frequently are entangled objects. Entanglement is fragile, and like most quantum phenomena, disappears under direct observation. But its consequences can clearly be noted.

Distributed tourism is a perfect example. It can take place anywhere, at any time, under the right conditions, but the slightest shift returns the two places to their separate and distinct states. Certainly, as I suggested with the musical excerpts, distributed tourism is a feature of particular

contemporary spaces, for example, homes, buses, trains. And, lest we lose sight of Starbucks' core business or Putumayo's nontraditional retail strategy, it also takes place in retail space and coffee shops the world over. The experience of drinking a grande soy no-whip mocha is startlingly similar in Fresno, California, and in a Sainsbury's (supermarket) in Greenwich, London. Or at the Starbucks one block south of my former office, or the other one a block east of it. Or in central Cairo. The "heres" are the same—the same décor, the same objects for sale, the same coffee. And the "theres" are the same as well—the same Count Matchuki cuts playing. They have succeeded in creating an often entangled space we might think of as "t/here."

But the distributed tourist still relies on the modern colonial tourist, Dan Storper and Jacob Edgar, in the case of Putumayo, to make her distribution possible. Here, it's important to make a quick note of the inseparability of time and space. As Nielsen puts it in *Scientific American*, "If dice could be 'entangled' in the manner of quantum particles, each entangled pair would give the same outcome, even if they were rolled light years apart or at very different times" (Neilsen 2002: 72). Thus, time simply offers another parameter across which objects can be entangled.

In this sense, the time between a modern tourist (e.g., Dan Storper) and a distributed tourist (e.g., me) is something of an aporia, a founding gap; my spatial multiplicity as a distributed tourist, in other words, depends on the physical mobility of the modern tourist, the collector as such, who gives new meaning to the role of scholar, director, *metteur en scène*. Yet my very engagement as a distributed tourist depends on erasing the presence or notion of the modern tourist, just as classical Hollywood film erases the presence or idea of the director, its own *metteur en scène*. Storper doesn't have the power of, for example, Hitchcock to control the paths and contexts of our consumption, but he certainly does choose what to offer me for sale, in what order, with what packaging, in what stores, and so on.

Distributed tourism is a fundamental feature of distributed subjectivity; in order to be nodes of subjectivity in a vast array, we must be able to inhabit multiple locations simultaneously. On the one hand, it is a rupture in the fabric of tourism as a colonial enterprise, a project of modernity. On the other hand, it maintains certain unassailable relations to late-modern capitalism: the erasure of its own production, that is, the invisible hand of the *metteur en scène*, and the bringing home of riches from elsewhere.[19] And, as Simon Frith points out, it reinforces particular relations of authenticity between "there" and "here": "As a rock critic in the late 1980s on most world-music mailing lists, I was always more aware

of the authenticity claims of the music sent to me than of its exoticism. The difference at stake wasn't between Western and non-Western music but, more familiarly, between real and artificial sounds, between the musically true and the musically false, between authentic and inauthentic musical experiences" (Frith 2001 307). In this sense, then, "here" becomes false, virtual, the simulacrum, the infinite Starbucks shops of *The Simpsons'* episode, while "there" maintains an innocent, untainted relationship to authenticity, easily pictured by Putumayo's cover art.

Distributed tourism, and therefore distributed subjectivity, depends on the oxymoronic quality of this dichotomy: in order to bridge it through entanglement, to produce the distributed tourism I'm describing, the distinction must be maintained. Or, rather, it must simultaneously be maintained and erased. One must hear the "authentic" music of "there," produced by local musicians; one must hear it "here"; and one must hear the difference between the two spaces in order to be able to occupy both simultaneously and be "t/here."

Let me be absolutely clear. What I am arguing here is not a monolithic, singular, universal listening practice, but rather a modality of engagement. Not all listeners hear the same music the same way—in part, that was my point in the example of the *Music from the Tea Lands* CD. For some listeners, the music that is presumed to suggest "there" will suggest, instead, "home." Or something else. For some listeners, or some parts of some listeners, or some listening groups, the sounds will be recognizable, but not for others. These differences are certainly important, but they are tangential to my point. Rather, my concern is to understand something about the entanglement of places, and how that can be invoked in the experience of listening, the microcreation of fields of distributed tourist subjectivities. And it is in the musical qualities of the recordings, the attention we give to the listening, and the settings in which we listen that entanglement takes place.

DISTRIBUTED LISTENING

It is impossible, of course, to declare with any certainty anything about listening in general. But it is clear to me, beyond doubt, that something different and specific happens in ubiquitous listening that demands careful attention and study. In the setting I am considering here, the question is: Who are we, and how do we listen, when we hear world music in coffee shops? In particular, when we hear Hear Music and Putumayo products?

One answer, of course, would be to say that we are many different listeners engaged in many different ways, and that would be undeniable. Perhaps we might even say within one apparently discrete being, we are many different listeners. But I am proposing an answer of a different order: in all our differences, there are perhaps some similarities, some processes we share. I am arguing that we are all, or nearly all, distributed tourists . . . or at least parts of us are. Just as one would understand there to be multiple kinds of tourism, and yet understand tourism to be a general phenomenon, so, too with distributed tourism. We may all travel "t/here" differently, but we travel.

As I have been emphasizing, listening is a significant terrain for the summoning and engagement of distributed subjectivities. It is a central, defining feature of life in the industrialized world in postmodernity. It is not simply a commodity exchange, nor is it simply a production of subjectivity in the sense that, for example, early psychoanalytic film theory posited. Nor is it simply an aesthetic experience. It is a simultaneous, coextensive condition of almost every act and activity, a constant flow. One of its features, as I have described here, is to reshape our relationship to space itself. This, I am convinced, is a constitutive feature of distributed subjectivity.

Living in distributed subjectivity is, of course, a precarious business in precisely this sense. It is both/and; neither/nor. It is both a rupture and a continuity; neither purely modern nor purely postmodern. And like everything else, it bears differently on its components. Distributed musical tourism is a feature of hyperintellectual upper-middle-class industrialized life—it takes place in Starbucks and gift shops and health food stores, after all, where only people who can afford a three-dollar cup of coffee, which won't pay its grower a living wage, shop. My former local supermarket in New Jersey, where the working class and labor aristocracy Latinos and South Asians buy their groceries, or my current one in Liverpool that serves labor aristocracy and middle-class professionals, are not playing Putumayo CDs. They're still distributed; they're just living in different network neighborhoods, where oldies radio, nostalgia, and time travel prevail.

World music is not simply a matter of the circulation of capital and culture. It is that, certainly, but as scholars we cannot afford to stop at the questions of appropriation and hybridity, a terrain beautifully articulated in the introduction to Georgina Born and David Hesmondhalgh's *Western Music and Its Others* (2000). If we return for a moment to David Clarke's essay (2007), he addresses this problem quite directly. He

describes Meaghan Morris's critique of David Harvey, in which she argues that all of politics is not available to be subsumed to the single grand narrative of commodity relations. This is, of course, a very long, protracted, ongoing debate between Marxists of various kinds, from Jameson to Eagleton to Harvey and a whole range of interlocutors, including feminists, postcolonial theorists, critical race theorists, poststructuralists, and others. Writers such as Gayatri Chakravorty Spivak, Judith Butler, Jacques Derrida, Patricia Ticineto Clough, and many others have argued similar or related positions from a wide range of different perspectives. Clarke's article itself, however, struggles with this problematic, as, indeed, have I on many occasions. How does one hold on to the compelling arguments made about the commodity form and the commodification of knowledge and culture and thought, and yet at the same time recognize that the commodity form does not exhaust all of the engagements we have with moments of culture?

Clarke begins his epilogue by saying: "A conclusion is what cannot be reached here. I have not been able to bring the contradictory panoply of musical enjoyment offered on *Late Junction* (in part a proxy for what's on offer in culture at large) and the heterogeneity of possible valid critical perspectives on it to resolution; the purities are mixed. If this uncomfortable position were authentic, then perhaps the best way to end would be to reinstate the tension" (Clarke 2007: paragraph 81).

I both agree and disagree. First, it is important to note that thinkers from the Marxist tradition are always quick to point out when someone is insufficiently attendant to matters of production, but not so matters of consumption. And when they treat consumption, it tends to be in economistic terms, rather than trying to understand something more complex about the interaction between art, subjectivities, and economy/ies. But there is a larger problem: for all the commitment to social, collective forms within Marxism, it still, with some few exceptions (most famously Hardt and Negri), thinks of agency—and thereby subjectivity—in purely individual terms. One of the reasons to turn to a theory of distributed subjectivity is to get away from such thinking, to find another terrain on which activity occurs, across which connections are held open. Clarke's critique of an earlier version of this chapter is intriguing to me, because he reads my notion of distributed tourism as celebratory. He says: "Unlike Harvey in his negative critique of space–time compression, Kassabian here puts a positive spin on the collapsing of space. For her this connection of disparate spaces need not, it seems, be an ideological or illusory perception, but may represent an imaginative and sophisticated act of postmodern

consumption, infused by the world of quantum space–time." (Clarke 2007: paragraph 72). I would not put it that way. I would characterize this chapter, and the book as a whole, as an observation, or perhaps a theorization of the audible. Distributed subjectivity, and its subset, distributed tourism, is neither to be celebrated nor reviled. Or perhaps both celebrated and reviled and something altogether different again. Distributed subjectivity requires a rethinking of all of these categories, in ways that many different theorists are calling for: scholars studying the senses, theorists of affect, work on digital culture, and much, much more.

In the conclusion, I will point toward some of what I think might come next. I will bring together the perhaps apparently disparate strands of these chapters—though they all seem very obviously connected to me, by activity rather than by object—into a theoretical approach to the complex we might call listening—distributed subjectivity—ubiquitous music.

Conclusion

Ubiquitous Listening: Some Conclusions and Beginnings

This book may have seemed an idiosyncratic journey. From music at home to experimental video art to sensory films to TV musical episodes to Armenian jazz to Putumayo albums, what holds these items together is far from obvious, when inventoried by object. But that is, as I hope has become clear along the way, my point. There are very few kinds of music that are not listened to as ubiquitous music, and in fact listened to frequently in that way. From classical music in restaurants and cars to techno in clubs and on condo websites, very little music escapes this fate. Generally speaking, if this observation is made, it is often accompanied with a sense of loss, but is it such a terrible fate, after all? Is less attentive listening really a diminished experience, as it is characterized so routinely by the likes of Daniel Barenboim and his pals? Does it diminish our experience of all music? of that music? Are we lessened by it somehow? In short, is music, or are we, diminished by its ubiquity?

I have been arguing throughout for a different set of questions and a different perspective. Through listening to ubiquitous musics across an array of qualities and quantities of attention, distributed subjectivity is constituted as a field across which dense nodes (people, technologies, organizations) shift and move, sometimes appearing to come together in static groupings (in which case they are often called identity formations, lobbying groups, etc.), but they are never actually standing still. On this field, human, nonhuman, subhuman, and suprahuman units aggregate, interact, and drift apart, creating what Deleuze and Guattari called assemblages: "There are lines of articulation or segmentarity, strata and territories; but also lines of flight, movements of deterritorialization and destratification. Comparative rates of flow on these lines produce phenomena of relative slowness and viscosity, or, on the contrary, of acceleration and

rupture. All this, lines and measurable speeds constitutes an *assemblage*." (Deleuze and Guattari 1987: 3–4). An assemblage, in this sense, can be understood as an agglomeration of what in other theoretical vocabularies are thought of as subject and object (or media critic and text), on the one hand, or as an identity on the other. (There are multiple other possibilities, not just these two.) That is to say, any assemblage is in motion, so static critical language is a deterrent to thought. I will say more about this in a moment, but I want to enumerate here the most important subsidiary conclusions I hope readers will take away from any encounter with this book.

First, theories of listening to date have presumed, in various ways, that listening is attentive. Because of this, studies of music reception need to reconsider their baseline assumptions, and scholars, musicians, and writers might want to contemplate what difference a presumption of inattentive or less attentive listening would make to their analyses, theories, and models. To the extent that some kinds of music analysis (or, in the United States, music theory) are concerned with listening rather than only "the text itself," analysts and theorists have a challenging question in front of them—how do we conceive of musical processes when those processes are only intermittently engaged consciously? How do musical events relate to other events—what is development, or harmonic motion, or a Schenkerian background, if listeners may or may not have noticed earlier events that define a current one? And on the far opposite end of the spectrum, in terms of ethnographic research on music and identity, does it matter what level of attention is paid to the music? Are musical features important, and if so, how can we know whether or not they are being perceived? The ramifications of my arguments may be less for purely textual approaches and for economic and industrial analyses, but to the extent that British cultural studies in particular have succeeded in pushing us not to keep those categories so radically divided, there may be issues to be thought through there as well.

Second, the centrality of listening to the formation of distributed subjectivity that I have argued for throughout this book demands a rethinking of theories of subjectivity. While most have had language (Lacan, literary theory) or visual materials (film and media studies) at their center, it should be clear from the preceding chapters that any serious discussion of subjectivity has to listen for the sounds and music that constitute it. Without a consideration of sound and music, subjectivity, too, will remain out of reach as a sociocultural field of study. In fact, this is the insight that began my career as an academic, a story I have told in print a few

times—as an undergraduate student, I was completely taken with feminist psychoanalytic film theory for a host of reasons, but both surprised and disappointed to realize that it had no interest in sound or music. (And in fact, when people tried to intervene in that arena—most notably Kaja Silverman in *The Acoustic Mirror*—their well-received works had very little effect on subsequent scholarship.) One hope for this book, then, is that it will add an insistent voice to the work in sound studies and in music that calls for theorizing subjectivity aurally as well as visually.

Finally, this book argues for a nonindividual, nonhuman, aurally constituted subjectivity. The first two parts (nonindividual, nonhuman) put my work in a long and august line of thought; the second, however, makes this book fairly unique. Distributed subjectivity, as I have theorized it, is constituted significantly (though by no means exclusively) through sound and music, is not nearly fixed, and is certainly not individual, as theories of subjectivity and identity have been. Distributed subjectivity is a field of ebbs and flows that can appear and be engaged at any expanse, from the molecular to the social, from pipe organs to ethnicities. In this sense, it is not as predictable as identity, and it also renders identity less predictable. For example, an Armenian arts organization in New York City had as its first event a theremin concert, in which the program included a number of Armenian folk songs and composed works. The performer, Armen Ra, challenges gender in many ways, appearing visibly male while wearing lots of makeup, rhinestones, big jewelry, and highly stylized clothes.[1] While many Armenian-Americans felt included and invited "in" by this performance in a host of different ways, some of those who never have to question their Armenianness were put off by it. I overheard someone talking about not being interested in watching clowns play music, but it was clear that he felt very isolated. In that moment, the flow of the category "Armenian" was far less heteronormative than it usually is, and the boundaries of inclusion and exclusion were quite different than at most Armenian community events.

I am arguing, in short, that a serious consideration of listening and ubiquitous music, through an inquiry into their relationship with affect, attention, and the senses, leads to a new theory of distributed subjectivity that challenges what we think about reception and about subjectivities and identities. That's a pretty big claim, I know. I imagine your disbelief—"She says what? based on thinking about TV musicals and Armenian jazz?" At this point, I think it would be useful to go back through the chapters to review the theoretical arguments, rather than the materials they engage.

In the introduction, I suggested that the book would be centered around six terms: *ubiquitous musics, affect, the senses, attention, listening*, and *distributed subjectivity*. Each subsequent chapter focused on theoretical issues raised in consideration of one of these terms, and together they formed the field on which I theorized and on which I contend we live out our (aural) lives. My purpose in each chapter was not to analyze the "object" described—not least because I tried to reconceive such subject-object distinctions. But more than that, this book is not a critical project; it is a theoretical one. The chapters worked with various kinds of texts to develop a theory of listening to ubiquitous musics.

Chapter 1 laid out the central ideas of ubiquitous musics and distributed subjectivity. Through a discussion of (a) turn-of-the-millennium fantasies of what future homes would look like, (b) what newly built homes-of-the-future look like today, and (c) what technologies might supersede thinking of architecture as the appropriate medium for one's sound life, I argued that ubiquitous musics engage us in processes of distributed subjectivities, allowing us to hear ourselves as part of something very much current and alive and flowing. Ubiquitous musics create space; they articulate what we think of as internal and external to each other, creating a dynamic relationship that takes place without regard to any discrete, individual subject. And yet it is a process of subjectivity, of distributed subjectivity, and it relies on a highly fluid and variable process of listening with unpredictable scales of attention and only potentially regulated affect.

Chapter 2 considered works by three very different Armenian-identified video artists: Tina Bastajian, an American-born artist now living in the Netherlands; Diana Hakobyan, an artist in the Armenian Republic; and Sonia Balassanian, an Iranian-born artist now splitting her time between New York City and Yerevan. Their works each invoke and evoke very different sound worlds, calling up different affective responses on the parts of listeners, responses that will also differ according to the ethnic and national histories of listeners. Through the specificities of small sounds— mechanically repeated sounds, sharp knives on wet flesh, the pop of a flashbulb—they draw us into relationships among ourselves, the works, the artists, and other listeners that are small temporary pockets of shared becoming. In these distributed subjectivities, the relationships of the various Armenian diasporan communities will ebb and flow, recognizing each other and not in moment-by-moment shifts that make identity. Identity, as I argued in chapter 5, in this light becomes a much less stable and predictable attribute than many critics have presumed (this lapse is less true of theorists).

In chapter 3, I discussed films that have a different relationship to the usual values of Hollywood filmmaking. Where Hollywood preaches drama, plot, and character development, these films take the sensory moment, the extraordinary explosion, and the chilling costume as their basic unit of value. While all have plots and big-name stars, the focus of these films is not on subtlety and fine acting, but a behind-the-scenes crew who creates creatures and situations, sounds and music that keep audiences glued to their seats and begging for more. This address to the senses is connected to later chapters in important ways—these films are no different than Starbucks or an alternative health practice, insofar as all of them are creating as replete and integrated a sensory environment as possible for their customers. Each of these films produces, particularly in moments of extravagant sensory experience, a distributed subjectivity across the audience and across audiences who share the film.[2]

In chapter 4, the problem of attention and listening was considered through the grid of musical episodes of TV programs; attention, the commodity sold by television to advertisers, is collected through the unusual event of a mini-musical. I discussed the idea of an attention economy, the case for seeing attention as a form of labor, and the perpetually increasing challenge of information, or what's coming to be known as "big data." According to the *Economist:* "The amount of digital information increases tenfold every five years. . . . A vast amount of that information is shared. By 2013 the amount of traffic flowing over the internet annually will reach 667 exabytes [1 EB = 1,000,000,000,000,000,000, or 10^{18} bytes] according to Cisco, a maker of communications gear. And the quantity of data continues to grow faster than the ability of the network to carry it all."[3] Clearly, it is no longer humanly possible to "keep up." One of the challenges of thinking about ubiquitous music is centered around the question of attention, that is, does it matter what's playing if we're not listening to it? But I have argued throughout that we are indeed listening to it, even if it isn't the object of focused conscious attention, and that the gathering of attention is for the most part no longer a requirement for affective and sensory marketing approaches.

Chapter 5 traces a very personal journey through three different albums by Armenian folk/jazz fusion bands that at varying times entered my life when I was feeling especially lost to the Armenian world. I argued that while everyday life announces over and over again that you are one or the other, but never "both . . . and," listening is able to articulate the shards of diasporan life. That specific, important kind of connection may be temporary, fleeting, but it is also readily available at the push of a button.

Chapter 6 discussed developments in world music, including nontraditional retail strategies, lifestyle "feel-good" marketing, and happy, upbeat, lounge and dance mixes to discuss a new kind of tourism in distributed subjectivity, which I called "distributed tourism." Through these CDs, listeners can find themselves in "entangled" places, where here and there temporarily share states. Entanglement in this metaphorical sense is quite similar to the phasing in and out of distributed subjectivities. In this way, fields we usually think of as steady and stable, like places (say, Italy, for example) or identities (e.g., Italianness), are shown as unsteady and unstable, fluid, always in process of becoming and unbecoming. The sound track of that chain Italian restaurant, Olive Garden, that I mentioned earlier doesn't only include people who were born Italian; instead, for an hour or so, everyone's Italian together, and we're all partly in Italy. I don't generally share an identity with the people around me, but for a brief time in Olive Garden (or the coffee shop, or the fair trade goods store), we are definitely in something together. Sensory branding, affective marketing, all of these tools are sharing our means of thought.[4]

Distributed subjectivity ebbs and flows with the sounds and settings and components available to it. It developed as a form of nonindividual subjectivity through the increasing presence of sound and music in all settings, and the growing interdependence of people and things in modernity, as the opportunity to include ubiquitous music, and eventually other ubiquitous media, especially television, became first possible and then affordable. And the changing forms of new media, especially handheld devices and smart phones, will be provoking those developments even further.

This suggests, as I have been arguing throughout, that we need to change scholarship about sound and music in several ways, and that these changes pertain across the various disciplinary boundaries. First, it is crucial that researchers begin to consider the relationships between ubiquitous listenings and attentional fields when writing about music in general or particular pieces in specific. As I have argued, listening to ubiquitous musics in various attentional modes and degrees is one of the main sensory components of how distributed subjectivities come into being and recede. Through affect, evoked aurally through many different arrangements and agglomerations of organs, bodies, and sounding objects, subjectivities can be called into being—quite intentionally, as is the case for Starbucks and Putumayo and the films and TV shows, or less intentionally, like our own uses of music at home. In those moments, a field of subjectivity (made

up, for example, of a video, a group of people watching it and listening to it, one person's hearing aids, another's glasses, another's video maker mind, another's ethnic shard, and so on) becomes what we might once have called an identity, or an audience. From my perspective, however, this is a subjectivity, a shared being that crosses parts and wholes, alive and inert, and much more. That video-perceiving subjectivity is a new and very different thing to study than either a perceiver, or a video, or a notion of an individual subject.

Second, the book argues strongly that mass and digital media forms, like sound and music, require a different kind of scholarly attention. It is there that most of us learn what we know about music, that we choose our objects of study and leisure, and that we figure out who we are. From the discussion of smart phone apps in chapter 1, video art in chapter 2, contemporary films in chapter 3, or the musical episodes in chapter 4, much of this book has been about audiovisual musics, and that's not happenstance. I believe, strongly, that this field will grow in importance. Where we once thought about representation and subject positions, or identities and histories, we are now confronted with the task of understanding new ways of addressing our senses (both new uses of old technologies and new technologies such as, for example, 5.1 sound, or Smell-O-Vision) and collecting (and collectivizing) our attention. The subjectivities I've been theorizing have implications for thinking about, for example, media industry studies as well as reception studies, about other senses as well as audition, and about developing media forms that are themselves events of distributed subjectivities, such as multimedia art forms like the works of dance company Chunky Moves. On its website one piece, "Mortal Engine," is described like this: "*Mortal Engine* is a dance-video-music-laser performance using movement and sound responsive projections to portray an ever-shifting, shimmering world in which the limits of the human body are an illusion."[5] In addition, there are still viral videos (on which several young researchers are working, including Áine Mangaoang), video games (the topic of a quickly burgeoning field of sound and music studies; see, for some examples, the works of Karen Collins, and Mark Grimshaw, and look for work from younger scholars such as Timothy Summers and James Barnaby), smart phone apps (on which I've given several papers and lectures), and the many other new forms of aural and audiovisual activities.

Finally, I wrote this book with the hope of encouraging certain areas for development in the study of sound and music. There is a powerful

emphasis, especially in popular music studies, on certain methodologies to the exclusion of others. So, for example, there is a plethora of ethnographic work—though by some definitions of ethnography much of it falls short of expectations by, for example, substituting interviews for the real work of participant observation. There is also a significant body of analytic work that looks to explain textual processes. And yet there is almost no work theorizing reception and listening.

This is not entirely without parallels in other areas. While listening is a growing area of study in musicology, it is still quite underdeveloped. In film studies there are a few outstanding works, the most important among them by Janet Staiger. Literature alone can claim a long history of reception studies; recent incarnations include Constanz School *Rezeptionsästhetik* and American reader response theory, but even there, it is an often ignored arena of scholarly activity. There is a new Reception Studies Society, a very welcome development, which attempts to bring scholars from various disciplines who are working on reception into contact and conversation with each other. The problem with reception studies is that it can only be a speculative, theoretical endeavor, while it looks as if it should be an empirical, positivist terrain. It is impossible, however, to capture empirically all the complexities and nuances of the many different aspects of listening, and that makes industry studies, ethnography, and textual analysis, each with an array of accepted methodologies, more "study-able" than reception. I believe, however, that as more and more new media forms come into being, as music penetrates ever further into everyday life, thinking about what we are experiencing, and who we are in those experiences, will become ever more important.

I embarked on this project in the late 1990s as an outgrowth of my work on film music. At that time, I thought about discrete subjects listening to music they hadn't chosen and weren't attending to consciously. Over the course of these ten-plus years, I have come to see the problematic very differently: distributed subjectivities are the processes set in motion by the affects that listening to ubiquitous (and other) sounds and musics with varying kinds and degrees of attention evokes. I continue to be fascinated by the problems that arise in studying ubiquitous musics—all the kinds of music that are not a primary activity, not listened to with full attentive focus. I hope that all of these challenges—to understand subjectivities as processes within and across discrete bodies and objects, to think a range of listenings in any form of scholarship on sound and music, to study seriously new media forms that include music as they arise, to consider the wide range of attentions and sensory addresses, and

to apprehend affect as it snaps across gaps (between neurons, between objects and organs, between bodies)—are taken up in future scholarship. It is crucial that we stretch our methodological and disciplinary boundaries enough to include more speculative work of the kind that listening and reception studies need most, so that we begin to understand who we are and what we're doing when we're listening, whenever and wherever that listening happens.

Notes

INTRODUCTION

1. Massimo De Angelis, Professor in The School of Law and Social Sciences at University of East London, in a conversation at the conference "Measure for Measure: A Workshop on Value from Below," organized by Stefano Harney, 20–21, September 2007.

2. "Ski Jackets 'lead the way in wearable technology, with built-in radios, microphones, earpieces and "push-to-talk" technology for hands-free communication. Even if an MP3 player isn't built-in, an MP3 pocket and understated portals for earphones have become a winter essential. On the more practical side of high altitude style, jackets are now controlling how hot you feel and how well you can see'" (http://1skijacket.com/#2Safety, accessed 30 May 2012). In addition to these existing products, there have been many ideas that have been scrapped or set aside for the time being. The context-aware iPod is one: "XPOD (http://ebiquity.umbc.edu/paper/html/id/280/) is a prototype portable music player that can sense a user's context—what she is doing, her level of activity, mood, etc.—and that to refine its playlist. The device monitors several external variables from a streaming version of the BodyMedia SenseWear (www.bodymedia.com/) to model the user's context and predict the most appropriate music genre via a neural network." (Tim Finin, "Xpod Senses What Music You'd Like to Hear," UMBC Ebiquity, 28 January 2006, http://ebiquity.umbc.edu/blogger/2006/01/28/xpod-senses-what-music-youd-like-to-hear/, accessed 3 March 2009).

3. I would certainly argue that thoughts and feelings are also bodily, but that is not the issue here.

4. Ian Gardiner founded this journal before I arrived at University of Liverpool, and we served as coeditors for the first five years of the journal's existence. Ian continues to edit the journal with Jay Beck and Helen Hanson. There are more journals in the field: *Music and the Moving Image* (University of Illinois Press), *The Soundtrack* (Intellect), *Journal of Film Music* (Equinox).

5. Very large organs, like the grand organ in the Liverpool Anglican Cathedral, will occasionally have sixty-four-foot pipes that give a low frequency of

8.2 Hz. Such a frequency is well below the standard hearing threshold, which is approximately 20 Hz. These will be felt rather than heard, which suggests that this experience is neither inherently electronic nor inherently recent.

6. I take *auditory* here to mean distant and observational in the same sense that *optical* does for Deleuze and Guattari and others, but this is not a simple decision. On the one hand, vision and hearing are often lumped together in thinking about the senses, often because they are understood to be "distance senses." But hearing does not have the same relationship to observation, science, and Enlightenment rationality that vision has, making the choice quite difficult.

7. Although Freud's second topography, id/ego/superego, is the better known, his first one, unconscious/preconscious/conscious, seems to me to be much more useful for the study of ubiquitous listening. We might think of most ubiquitous listening as "preconscious," but sadly this is not a term that has been used much outside of psychology and psychoanalysis. While I will argue in this book for a nonindividual model of distributed subjectivity, I also argue that there is a persistent individual-subjectivity-function, much like Foucault's (1979) "author-function," and were I to theorize it, the preconscious would figure prominently in my approach.

8. The fact that we think about music in terms dependent on linear narrative doesn't necessarily mean that music is organized that way. Most music—from many kinds of popular music to minimalism to a great deal of non-Western music—is organized according to different logics, often, though not always, in circular or recursive forms. This may be one reason why critical musicology has had less effect outside of the Western tonal canon.

9. To be fair, many theories of ideology attempted to treat it as a constant, dynamic process.

CHAPTER 1

1. Intriguingly, I have not been able to find any recent studies of similar questions. It should be self-evident, however, that data production has only increased over the time since the study.

2. I could not find more recent data expressed in terabytes. While music sales have slumped significantly since the *Economist* article was written, I feel

Earlier versions of chapter 1 were presented at UCLA Department of Musicology in March 2001 and at Carnegie Mellon's Center for Cultural Analysis in April 2001. My deep thanks to the graduate students and faculty who invited me and engaged in wonderful, provocative discussions of this material, and to the Ames Fund at Fordham University for supporting this research. Earlier versions were published in *Echo: A Music-Centered Journal* (vol. 3, no. 2) and in *Popular Music Studies*, edited by David Hesmondhalgh and Keith Negus (London: Hodder Education, 2002), but this chapter is substantially updated.

safe in suggesting that both piracy and self-production contribute to keeping the circulation of music in terms of quantities of data from decreasing.

3. Cisco, "Internet Home Briefing Center: Entertainment," www.cisco.com/warp/public/779/consumer/internet_home/. This page no longer exists but can be found in Internet archives up to and including 18 December 2003.

4. See later sections in this chapter for a brief discussion of how ubiquitous computing has changed over time into other areas of computing research.

5. Companies like DMX and, for example, Mood Media in Denmark, are extending their businesses from music to scent. While this is not directly pertinent to this book, it certainly strengthens the argument about affect and the senses becoming significant contemporary terrains for marketing and for cultural production, and therefore for thinking.

6. One of the challenges of this perspective is how to talk about value, as the revival of the field of aesthetics indicates. Another is a viable criterion, or criteria, for curriculum development if familiarity with the canon is removed as a governing logic. (This problematic pervades the arts, from music to literature to film studies.)

7. Definition from *Merriam-Webster's Dictionary of English Usage* (1994).

8. "Fabric Speakers (various coil materials)," YouTube video, posted by "Plusea," 15 February 2011, http://youtu.be/h6P8DzEG_7A.

9. "The Gadget Show: E-Home," YouTube video, posted by "thegadgetshow," 10 December 2009, http://youtu.be/9R5ddAeP4a4.

10. "Living Tomorrow: house of the future," YouTube video, posted by "Wannahaves," 8 January 2010, http://youtu.be/9DJr8QwgLEA.

11. "South Korea's home of the future," YouTube video, posted by "AFP," 19 August 2008, http://www.youtube.com/watch?v=2mxocMgUrvo.

12. Sonic Chair, www.sonicchair.de, accessed 12 October 2010.

13. Since I have an iPhone, which I originally bought to research the app MoodAgent (see below), I will be using examples from its world, but to the best of my understanding, most apps for all smart phones are either being released simultaneously or following very soon after releases on their native platforms. There are variations in pricing.

14. The Economist Group, "Winner: Consumer Products and Services: Steve Jobs," www.economistconferences.co.uk/innovation/consumerproductsawardwinner2010, accessed 13 October 2010.

15. "1 Billion Angry Birds Downloads!" YouTube video, posted by "RovioMobile," 9 May 2012, http://youtu.be/tdTZOFeWiTI; Mike Isaac, "Android Market Hits 10 Billion Downloads, Kicks Off App Sale," *Gadget Lab*, 6 December 2011.

16. Apple iPhone 4S, App Store, www.apple.com/iphone/from-the-app-store/.

17. Spotify: www.spotify.com/uk/mobile/iphone/, accessed 12 October 2010; Last.fm: http://itunes.apple.com/us/app/last-fm/id284916679?mt%20=%208, accessed 12 October 2010.

18. Moodagent on iPhone, www.moodagent.com/mobile-apps/iphone, accessed 5 March 2011.

19. iTunes Preview, SoundHound, http://itunes.apple.com/app/id284972998?mt%20=%208, accessed 13 October 2010.

20. iTunes Preview, Dance Remix, http://itunes.apple.com/us/app/3dj-dance-remix/id351290052?mt%20=%208, accessed 13 October 2010.

21. 5minLife Videopedia, www.5min.com/Video/Balls-iPhone-App-Review-iApplicate23–134622236, accessed 17 July 2011.

22. "iPhone App by Smule: Ocarina [Zeldarian]," YouTube video, posted by "smuleage," 3 November 2008, www.youtube.com/watch?v=RhCJq7EAJJA, accessed 12 October 2010; Music Ally, "10 of the Coolest iPhone Music-Making Apps," *Music Ally* (blog), 6 March 2009, http://musically.com/2009/03/06/10-of-the-coolest-iphone-music-making-apps/, accessed 10 October 2010; "Live iPhone musical performance—Kids by MGMT played on iPhones and iPod Touches," YouTube video, posted by mentalistsuk, 27 February 2009, www.youtube.com/watch?v=rjx5_-SPhk0, accessed 12 October 2010; Dean Takahashi, "Enthusiasts Keep Pushing Smule's Ocarina iPhone App to Higher Numbers," *Venture Beat*, March 5, 2009, http://venturebeat.com/2009/03/05/enthusiasts-keep-pushing-smules-ocarina-iphone-app-to-higher-numbers/, accessed 10 October 2010.

23. Chris Taylor, "The 4 Best iPad Apps That Can Make You a Better Musician," *Music Think Tank*, 26 May 2010, http://www.musicthinktank.com/blog/the-4-best-ipad-apps-that-can-make-you-a-better-musician.html, accessed 18 July 2011.

24. "Bloom (Create mode) by Brian Eno," YouTube video, posted by "gotetsu777," 11 October 2008, http://youtu.be/BM_bOfTJVGY, accessed 13 October 2010; "Trope in action! Generative Audio Video iPhone app from Brian Eno and Peter Chilvers," YouTube video, posted by "eterogenus," 24 September 2009, http://youtu.be/dlgVoX_GMPw, accessed 13 October 2010.

25. iTunes Preview, Bloom, http://itunes.apple.com/us/app/bloom/id292792586?mt=8, accessed 13 October 2010.

26. Synthhead, "New iPhone App by Brian Eno, Trope," *Synthtopia*, 20 September 2009, www.synthtopia.com/content/2009/09/20/new-iphone-app-by-brian-eno-trope/, accessed 13 October 2010.

CHAPTER 2

1. It is important to note here that I will not refer to subjects, since that notion would simply take us back to the discrete individual. Rather, what I am proposing is a field of subjectivity, distributed over and across many minds, body parts, machines of all sizes, and other forms of life.

2. With the exception of film studies, the standard terms for this field are all visual: visual cultures, moving image studies, screen studies, and so on. While it has the scent, for me, of long-gone days of purple mimeographs and instructional films—on film!—in my elementary school, audiovisual studies

is the only one that will do to describe the (at least) bi-sensual experience of moving images with sounds and music.

3. Video art is a form that began in the 1960s and that has, as technology has become more affordable and the form has gained recognition, grown exponentially. Often shown at festivals or in galleries, the works are usually short and generally don't work with familiar gestures and vocabularies from, for example, Hollywood or MTV. See Rogers (2013).

4. Marc Nichanian (2002) has elaborated a compelling argument for using the term *Aghed* (meaning "catastrophe" in Armenian), which is the word frequently used in Armenian, instead of the juridico-political term *genocide*.

5. Dickran Kouymjian has long operated with the broadest definition of "Armenian" film possible, including in his courses Hollywood films with Armenian actors, for example. It is one noteworthy solution to the knotty problem of a how to define the boundaries of the cultural output of a diasporan community.

6. There have always been entertainment films produced as well, but these more symbolic, more self-consciously "art" films have always had a high-profile presence.

7. As compared, for example, to Eisenstein, whom Pelechian sees as having produced something more like a chain (MacDonald 1998; thanks to Tina Bastajian for this reference).

8. The Nagorno-Karabagh war was a bloody armed conflict in the late 1980s and early 1990s in the southern region of Azerbaijan, where there were a majority of ethnic Armenians. This was in some sense a legacy of Stalin's national minorities policy, in which the boundaries of the Soviet Socialist Republics were drawn to keep them from being ethnically homogeneous. Coming just at the time of national independence, the conflict gave the new Republic of Armenia a nationalist focus, and the plight of the Karabagh Armenians galvanized support from diasporan Armenians around the world.

9. The running time—nineteen minutes and fifteen seconds—is significant because 1915 is the year of the first attacks by the new government of the Committee of Union and Progress (CUP, Young Turks) against Armenians. While there had been massacres in the 1890s, and many Armenians held out great hope for the new CUP, the April 1915 killings were the inauguration of a documented and conscious extermination policy. See, for one account of the events, their context, and the aftermath, *The Great Game of Genocide: Imperialism, Nationalism, and the Destruction of the Ottoman Armenians*, by Donald Bloxham (2005).

10. Armenians in the republic do, of course, think of themselves as postcolonial, but the legacy of colonization has yet to be theorized.

11. The credits list this instrument as a *saz*, but it will be heard as an oud by most listeners. The *saz*, which is also Turkish, is a less common instrument.

12. I will discuss the concept further in chapter 5, but in brief, the areas formerly within the Ottoman Empire share cultural practices in ways that can't

be predicted by religion, language, or any of the more routine parameters by which we organize thinking about culture(s).

13. That the Armenian case is, at this moment, particularly instructive for diaspora studies—not only does it trouble the notion of "diaspora," but it puts on very materialist display the absence of a "homeland." Or, to put it differently, if the term *diaspora* means "a dispersion of a people from their original homeland" and derives from the Greek for "to scatter apart," what vocabulary do we have for a group that insists on imagining that its members share a homeland when every historical, linguistic, and cultural trace suggests otherwise?

14. Ultimately, the two are not unrelated. Theories of affect will have to be able to account for why some images and sounds trigger more specific bodily processes (like shivers and shudders), and this can only be explained, as I am suggesting throughout this book, by the articulation of images and sounds to the distributed experience of affect.

CHAPTER 3

1. The music is actually a very old form of Moroccan Sufi music, particular to the village of Jajouka, which was introduced to the West by Brian Jones in his posthumous 1971 release *Brian Jones Presents the Pipes of Pan at Jajouka*. It has since drawn a wide range of European and North American artists, including the Rolling Stones, Ornette Coleman, DJ Talvin Singh, and Howard Shore.

2. According to the film, Waylon's Infraction is a form of severe schizophrenia that presents as catatonia. It does not appear in DSM-IV.

3. For a useful summary of these ideas, see "Focalization," in *The Living Handbook of Narratology*, http:hup.sub.uni-hamburg.de/lhn/index.php/focalization, accessed 1 August 2011.

4. This is one of the major points of departure between, for lack of better terminology, "entertainment" and "art" film critics (and our counterparts in literature and other arts). Whereas first-run theatrical releases are almost exclusively traditional linear narratives, many other kinds of films are not. This difference has had enormous influence on the development of theoretical work; as one small example, most theorizations of film music, my own included, have focused on narrative, "entertainment" films.

5. For two defining moments in feminist theory in relation to nonliterary narrative, see de Lauretis 1984 and McClary 1991.

6. Smell-O-Vision was the name of the 1960s technology to introduce synchronized scent into movie theaters.

7. The products for both films—as is generally the case with successful films of the past decade or two—are seemingly endless, from the Lara Croft official costume to the Wii Game, from the Ultimate Matrix Collection (Limited Edition with Figurine and Collector's Book) to the 10 Disc Boxed Set.

The scholarly literature on transmediation is in the process of articulating the distance between such examples and direct adaptation.

8. The discussion of linear narrative in music that follows is certainly a large-scale generalization. There is repetition in most musical forms, and there are always works that depart from the general practice of a particular historical period or a musical form. The debates about the usefulness or viability of critical musicology have in no small part depended on the writer's willingness to accept the level of abstraction in use; for example, if one is interested in speaking about nineteenth-century practice or sonata form, then what follows may well be recognizable. For critics who are more interested in particular composers or specific works, however, specificities are quite likely to belie generalizations.

9. For readers unfamiliar with feminist theory, it may be helpful to remember that in general, *female* tends to be used to describe qualities that have to do with women, whereas *feminine* is used to describe qualities that belong to widely perceived gendered roles and norms of behavior.

10. Rage Against the Machine, "Wake Up," guitar tablature by Kevin Dole, www.ratm.net/tabs/guitar/selftitled/wake_up_tab.html.

11. Rage Against the Machine, "Wake Up," guitar tablature by Marcel, www.ratm.net/tabs/guitar/selftitled/wake_up2_tab.html.

12. Rage Against the Machine, "Wake Up," guitar tablature by byrnes@elmo.nmc.edu, www.musicfanclubs.org/rage/tabs/guitar/wakeup.htm.

13. Donna Haraway (1991) identifies this boundary as one of those central to the cyborg in her classic essay "A Cyborg Manifesto."

14. In an earlier version of this part of this chapter, I argued that since most feminist theories rely on narrative, the dissolution of narrative poses difficult and challenging questions for the development of feminist theory. While that question certainly still interests me, it does not align with the larger project of this book. For that earlier version, see my essay in *Popular Music and Film* (Kassabian 2003).

15. I want to use distributed subjectivities both in the sense of one large theoretical field, and also in the sense of temporary flows and agglomerations of events, objects, organs, and humans, both individual and collective. So, in this case, a film and its perceivers attach to each other and for the course of the duration of the film, plus some time before and after, and some small moments for long durations of time after that, there is a field that I am calling "film perceiver(s)." While I would wish the name to be more appealing and less contrived sounding, it nonetheless does the best job (of any phrase I could think of) of pointing to what I am thinking here.

CHAPTER 4

1. Drew Carey sings and dances in a surprising number of episodes; it is difficult to get a good count, but they include "What Is Hip?" by Tower of Power and a fully (over)produced version of "L.O.V.E.," the first half of which

seems to be sung by Carey, while in the second half he is clearly lip-synching to Sinatra's version.

2. When I presented an earlier form of this chapter as a paper at the "IASPM (International Association for the Study of Popular Music) Study Day—Genre, Format, Stereotype: Cinema, Radio, Television, and Popular Music as Factories of Meanings" conference at the Department of Music and Performing Arts, University of Turin, Italy, I was met with absolute lack of familiarity with TV musical episodes and with this type of parody from the audience. I don't take this to mean much, except that musicals are a very Anglo-American form, and that as a source of and for parody, they are not shared, not even across Europe.

3. As many have commented, the series spawned an academic industry. There were a number of conferences devoted to it, an online peer-reviewed journal entitled *Slayage* (http://slayageonline.com/, accessed 22 July 2007), and a surprising number of books, including Rhonda Wilcox, *Why Buffy Matters: The Art of "Buffy the Vampire Slayer"* (2005); James B. South, ed., *"Buffy the Vampire Slayer" and Philosophy: Fear and Trembling in Sunnydale* (2003); Anne Billson, *Buffy the Vampire Slayer* (2005); Gregory Stevenson, *Televised Morality: The Case of "Buffy the Vampire Slayer"* (2004); Rhonda V. Wilcox and David Lavery, eds., *Fighting the Forces: What's at Stake in "Buffy the Vampire Slayer"?* (2002); Lisa Parks and Elana Levine, eds., *Red Noise: "Buffy the Vampire Slayer" and Critical Television Studies* (2003). There is even a volume on sound and music in the series entitled *Music, Sound, and Silence in "Buffy the Vampire Slayer,"* edited by Vanessa Knights and Paul Attinello (2010).

4. While I will not be analyzing any specific musical numbers, Freya Jarman's "Notes on Musical Camp" (2009) offers the first opportunity to begin to think along those lines.

5. Adult Swim is an adult-oriented cable channel that can be seen in much of the Anglophone world and as programming blocks in Latin America, India, Pakistan, and Russia. It includes a wide range of animation styles and techniques in its programming, including shows like *Robot Chicken* (stop motion), *Harvey Birdman: Attorney at Law* (Flash animation [except first season]), *Cowboy Bebop* (Japanese anime), and many more series that contributed to the rebirth of animation as a form for adult audiences.

6. John Kricfalusi, "Good Direction VS Turning the Furnace On and Off," *John K Stuff* (blog), 17 October 2010, http://johnkstuff.blogspot.com/2010/10/good-direction.html, accessed 30 May 2011.

7. The song refers to the case of a teen mother in 1997 who hid her pregnancy from everyone, delivered her baby during the prom, and then threw it out in dumpster in the back of the hall and went back in to the event. Slightly less directly, it also refers to a couple who, the year before, delivered their baby in a motel room a state away from where they lived and also threw it out in the dumpster. Both babies were found dead, and both led to murder trials that received national news coverage.

8. This is true for most of the musical episodes discussed above, although *Scrubs* "My Musical" and *Xena: Warrior Princess* "The Bitter Suite" are exceptions.

9. "Missing Puzzle Piece: The Kurt and Blaine Fanlisting," www.kurtandblaine.com; "Fuck Yeah Blaine Kurt: A Blaine/Kurt Fan Fiction Archive!" fuckyeahblainekurt.tumblr.com; "A Community Dedicated to Kurt/Blaine on LiveJournal," www.fanpop.com/spots/kurt-and-blaine/links/16864557/title/community.

10. The Brookings Institution is a nonprofit entity in Washington, DC, that presents itself as a nonpartisan think tank for governmental policy. It is strangely difficult to find a mission statement anywhere on its website, although there is a theme of "growth and renewal" currently being pursued through a set of "all-Brookings priorities": energy and climate, growth through innovation, global change and opportunity and well-being. The institution is generally perceived to be center-liberal, although it is sometimes described as conservative, especially in foreign policy arenas.

11. While it is not related to the line of thought I am pursuing here, one thing that is important to note about the musical numbers is that they make permissible the expression of thoughts or ideas that might be disturbing otherwise. JD and Turk's "Guy Love" duet is a perfect example of this.

12. Age is no small matter in this area. It is widely recognized that in industrialized urban settings, we hear more music per capita per day than at any other time in history, but there are big differences along demographic lines. According to a study published in January 2010 by the Kaiser Family Foundation (a health care nonprofit based in the United States), "Today, 8–18 year-olds devote an average of 7 hours and 38 minutes (7:38) to using entertainment media across a typical day (more than 53 hours a week). And because they spend so much of that time 'media multitasking' (using more than one medium at a time), they actually manage to pack a total of 10 hours and 45 minutes (10:45) worth of media content into those 7–1/2 hours" (http://www.kff.org/entmedia/entmedia012010nr.cfm, accessed 6 July 2011). This means that, while we cannot be certain given the way the data are represented, it is quite likely that most of those hours (all of the time devoted to music listening, television, film, online short videos (e.g., YouTube), and video games) will include some kind of ubiquitous music. While I have not been able to locate a similar study on adults or elderly media users, I have no doubt that while their media use is increasing significantly over time—I know my own is!—it is surely not equaling the amount of time that younger people spend in contact with mass- and computer-mediated forms. Many adults, and especially musicians, and even more particularly classical musicians, object to the ubiquity of music in contemporary urban industrialized everyday life. I have been told, for example, that the League of American Orchestras, at least until some years ago, routinely asked for the ubiquitous music in the conference hotel to be turned off, and not just in meeting and display rooms. For another example, see Daniel Barenboim's BBC Reith Lecture number 2 on this topic

(Barenboim 2006), and discussions of his position on the BBC news website (Westcott 2006) and an Open University forum (Open University 2006). On a purely anecdotal level, I have not encountered this attitude among younger classical musicians. Moreover, as we discussed in my 2011 Music, Technology, and Society class, it is less likely as life goes on that one will be shopping and doing errands alone; in the presence of partners, housemates, and children, one is less likely to be listening to music on earphones.

13. While I do not fully share Lunenfeld's (2011b) critique of what he has called "the junk culture of broadcasting," his larger point may be an important one. In his book *The Secret War between Uploading and Downloading* (2011a), he argues that we need to try to find a balance between creating and consuming digital culture, which is an argument I think may be well worth a serious conversation.

CHAPTER 5

1. *Taksim*, or more usually *taqsim*, is an improvisation in a particular *maqam* (roughly, a mode) in Arabic and Turkish music. Very briefly, musicians learn a set of figures, rhythms, moods, and so on that are associated with each *maqam* and then use them in solos, with percussion, or less frequently with another instrument (which might be a drone). Each *taqsim*, thus, conforms to a set of conventions particular to that *maqam*. There is, perhaps obviously, an intriguing parallel to be drawn between *taqsim* and jazz, as suggested by the name of Baronian's band. (See, for two starting points, Sadie and Tyrell 2001 and http://www.maqamworld.com/maqamat.html.)

2. Much of the shape of this chapter is owed to the deep interrogation and conversation that I had over it with my colleague and friend Steve Rubenstein of the Research Institute of Latin American Studies at the University of Liverpool, who died just before I submitted the final manuscript of this book. I owe thanks to him for so much, beginning with the question about the term "Middle East." The loss of Steve in my intellectual and personal life is profound. Steve was, of course, right: "Middle East" is no solution, though it is part of the prevailing fashion, which is "Middle East and North Africa," abbreviated as MENA. I've tried many different terms—including West Asian, as I mentioned—over the years, but none has seemed as apt for my purposes as post-Ottoman. Its one flaw is the lack of connection with Persia/Iran, which is also crucial in Armenian political and cultural history. Moreover, I have no doubt that my choice would not meet with the approval of most Armenians, for whom our distinction as a Christian culture is more important than our similarities to other cultures in the region.

3. Mark was an incredible pianist, a teacher of Arabic, and a friend. He died of AIDS in 1990. Information on Mark's music is available at www.artistswithaids.org/artforms/music/catalogue/kyrkostas.html. His mother, Marge Tellalian Kyrkostas, is his musical executor; she performed in the dance group my parents danced in and later directed; Marge later became an

anthropologist. She is curator and director of the Anthropology Museum of the People of New York at Queens College, New York. We went that night with another dear friend, Kevin McKinney. One of the immediate memories of those years in New York City was how frighteningly like a battlefield it began to feel like, strewn with the bodies of wonderful, talented, vivid people who came into contact with the strange life form we know as HIV. Like Mark, but many years later, Kevin too died of AIDS. We've stopped talking about those years and those experiences, but remembering them for me cannot exclude all the fear and loss—and bravery and joy—that swirled around us.

4. The oud is the main stringed instrument of Western Armenian music (and much of the post-Ottoman), along with the *kanun*. The oud is the progenitor of the lute (*al'oud*) and the *kanun* is a kind of zither. The *doumbek* (*dumbeg* and so on) is a bell-shaped drum, also called *darbouka* (with various roman alphabet transliterations) in Arabic and *doumbeleki* in Greek.

5. *Shakar* Mary can be seen on YouTube: http://www.youtube.com/watch?v=Th1T_Fmk97Q (accessed 27/6/11). She is over ninety in the video, and she's singing and playing a hand percussion instrument rather than an oud. The quality of the recording is less than ideal, and it is difficult to hear her, but it is still a record of an unusual and important musician in the history of the Armenian-American community. (Souren Baronian can be seen behind her playing clarinet.) The video was taken at Club 27, a monthly dance at St Illuminator's Cathedral, an Armenian church on East 27th Street in New York City. Most Armenian musicians in New York play at Club 27 now and then. All of my mother's family lived in the apartment building next door to this church for eighty years.

6. There is one project that might qualify as earlier: Herbie Mann recorded three albums that I could find with New York oud player Chick Ganimian and Detroit clarinetist Hachig Kazarian, two of the most important Armenian-American musicians of their generation. The albums, *Our Mann Flute* (1966), *Impressions of the Middle East* (1966), and *The Wailing Dervishes* (1967) were rereleased by Atlantic in 2001 in a series called "Collectable Jazz Classics."

7. The most well known of such experiments is, of course, *Time Out*, the Dave Brubeck Quartet 1959 album, and "Take Five," the hit song from that album. The album was composed of songs written in unusual meters; "Take Five" is written in 5/4. The compositional credit for that song is given to Paul Desmond, the quartet's saxophonist, but stories often say that the quartet was experimenting with 5/4 improv before the tune was written. By the 1970s, of course, both progressive rock and jazz, especially fusion, had taken to these kinds of experiments with meter. (My thanks to Steve Penfold, formerly of the Bicycle Thieves, for pointing this out to me.) *It's About Time* was, therefore, a very ripe project in that period for a band with one foot in post-Ottoman musics and the other in jazz.

8. It is very difficult to find Night Ark's albums, with the exception of a kind of "greatest hits" compilation released by Traditional Crossroads, an important independent world music label run by Harold Hagopian, a

Juilliard-trained violinist and son of renowned oud player Richard Hagopian. In a review of that compilation, Srajan Ebaen says: "The core ensemble of Ara and Arto includes Shamira Shahinian on various keyboards and Ed Schuller on bass. Armen Donelian joined the group at a later date and takes Shamira's place on a few tracks" (www.soundstage.com/music/reviews/rev269.htm, accessed 17 April 2007).

9. See www.aradinkjian.com for more information.

10. This, of course, depends on definitions of an Armenian jazz project; mine would not consider Herbie Mann's releases to fall under that rubric, but one might, given that the "ethnic" musicians were Armenians. See chapter 2, note 5, of this volume.

11. The name is something of a wink—Armenia no matter how or during what period one draws the boundaries, is landlocked. To the best of my knowledge it has never had a navy.

12. For an example of Armenian *kanun* playing, see Ara Topouzian, "Rampi, Rampi," www.youtube.com/watch?v=AXyGHM2r9zE. A picture of an Armenian *kemanche* can be seen at www.aramasatryan.com/Arm-music-ins/Qyamancha/index.html. Pictures of the wind instruments—*blul*, *duduk*, and *zurna*—can also be found online.

13. The word *Kef* in Turkish means a positive altered state, often induced by music, or more recently, by drugs. In some areas of the former Ottoman empire it is slang for marijuana. Among Armenian-Americans, it is the name of a style of music that was perceived by some as controversial because it acknowledged the place of Turkish music in the lives of *Aghed*-generation diasporan Armenians.

14. Our group included my partner, Leo Svendsen, and my child, Maral K. Svendsen; Robert Dulgarian, a friend of mine from graduate school; Janice Okoomian of RitualWorks and her family; and Marsha Odabashian, a painter. Both Janice and Marsha were part of a history-making Armenian feminist group in New England in the 1990s.

15. I do, however, still feel good that my friends and I do not ask or expect our children to hide their bodies or be ashamed of them. Again, my thanks to Steve Rubenstein for asking me to think about this moment further.

16. This is a dessert made from very, very fine pastry, baked in layers, and it can be filled with walnuts or sweetened cheese or a kind of cream. Most Armenians use the word *khadaif*. It is also the word used in Turkish, which is why the Armenians in the diaspora use it. Wikipedia tells me that there are recipes for it recorded as early as medieval Arab cookbooks. *K'nafa* is the word more frequently used by Arabs; it was used by my father's family because the city they were from, Dikranagerd/Diyarbekir, had a significant Kurdish and Arab population in addition to Turks and Armenians (and probably some other ethnic groups, including perhaps Jews and Yezidis). Diyarbekir now has a majority population of Kurds, and it is widely perceived as the home of the PKK (*Partiya Karkerên Kurdistan*, Kurdistan Workers' Party).

17. One might, of course, be excluded by one's own taste. I am not talking about exclusion in that sense: taste is an extraordinarily complicated interaction that could, perhaps, yield important insights if approached from the perspective of distributed subjectivity. I am, however, talking about less conscious processes here, about how, when I don't have Armenian music to listen to, I might be feeling something not unrelated to the fear of silence, that is, the absence of reassurance of the network of distribution (see chapter 6). I want to point out, too, that if this chapter has focused on the political and affective possibilities that music can offer, I am by no means some naïve cheerleader, as some critics of, for instance, my work on world music have suggested. Rather, I want to insist on hearing the possibilities that musical events and various parts of us can engage together, not all of which are exhausted by the analysis of labor practices or the circulation of money, or even value. For related discussions of these issues, see not only the next chapter, but also Clough et al. 2007 and Guilbault 2001.

CHAPTER 6

1. Sunglass Hut was purchased in 2001 and the CD program was stopped. Jiffy Lube produced a CD series that was part of a lounge project; the CDs sold for $9.99 in the shops only. That program has been suspended "for the time being." Victoria's Secret was well known in the late 1990s for selling classical music CDs, which they stopped doing some time ago. They now sell CDs associated with the wildly popular fashion show, including, for example, a Sting release. All of this information comes from communications with the companies' marketing departments. See also Kaufman 2001.

2. Mysteriously, there is no account of the business relationship that produced this CD, at least not that I have been able to turn up. Simon simply mentions it in passing in a single sentence (2009: 157). It seems obvious by the name, that is, "Volume One," that at least one more such recording was intended, but I have not been able to find any CDs or to identify release years.

3. Concord Music Group, "Hear Music," www2.concordmusicgroup.com/labels/Hear-Music/, accessed 31 July 2011.

4. www.putumayo.com/about.html. Interestingly, this paragraph appeared on a separate page about "retail" when I first began this research, but has since been "promoted" to the "About Us" section.

5. www.putomayo.com/en/about_us.php, accessed 31 July 2011.

6. The term originates with economist Richard Florida in *The Rise of the Creative Class: And How It's Transforming Work, Leisure, Community and Everyday Life* (2002). The idea and Florida's arguments about the role of the

Chapter 6 is enormously improved as a result of the generous input of faculty and students at McGill University, University of Newcastle (UK), Università La Sapienza, University of North Texas, and the participants in the La Caixa Forum in Barcelona on Background Listening in 2003.

creative class have been controversial academically, but also widely taken up in popular writing.

7. www.putumayo.com/en/AboutUs, accessed 31 July 2011.

8. www.putumayo.com/en/index.php, accessed 31 July 2011.

9. A&R means Artists and Repertoire, the department of a music label that decides to whom it will offer contracts.

10. This strategy, along with certain aspects of Putumayo's nontraditional marketing, puts the company into proximity with new age and alternative health music labels. A simple search for "music yoga" yields millions of hits, with titles such as *Yoga Sunset Chill* and *OmStream;* "music massage" gets one to the label AtPeace Music, and to titles such as *Across an Ocean of Dreams* and *Ancient Echoes.* It should come as no surprise, then, that in 2011 Putumayo released a CD entitled *Yoga.*

11. Tanya Mohn, "Private Sector; Stumbling into a World of Music," *New York Times,* 21 December 2003.

12. The Gypsy Kings are French-born Spanish Romani musicians; Gidon Kremer is a Latvian violinist; Astor Piazolla was a renowned Argentine tango composer and *bandoneón* player. The relationship of any of them to Cuban music is unclear.

13. And in a sad but unsurprising irony, this at a time when coffee growers around the world cannot feed their families. The connections among these facts are beyond the scope of this book, but they are there to be thought. See, for some examples of attempts,; Clough et al. 2007; and Dienst 2011.

14. I do not mean in the least to suggest that these are not each very different ideas. Rather, I want to suggest that, for instance, while Haraway (2003) and Galloway (2004) share a concern with power that Deleuze and Guattari (1987) treat in an entirely different (and to me less satisfying) manner, the real issue is the absence of sound and listening in their theories. This is not because sound and listening are more important than power. It is, rather, because sound and listening are crucial vehicles for power, and their absence is part of why Galloway ultimately seems like a Frankfurt School pessimist and Deleuze can be read as apolitical.

15. This is absolutely not true across the entire body of Erlmann's work. In fact, he has recently published a cultural history of listening that is a milestone work in the study of sound and music in all disciplines.

16. The ethical controversies that have surrounded Lomax's work might make this a rather more complicated example, but it is perhaps not central to the issues of this chapter. See the review of *Lost Delta Found,* a book that challenges a number of long-held beliefs about Lomax, in the *Boston Phoenix* at www.bostonphoenix.com/boston/arts/books/documents/05051911.asp, accessed 10 August 2011.

17. The Wikipedia entry on Putumayo points out: "The company claims to be committed to helping the communities in the countries where the music they profit from originates, resulting in donations to non-profit organizations including Oxfam, Mercy Corps, Make-A-Wish and Amnesty International.

However, limited information about the company's philanthropic activities is available on Putumayo's official website, and the company does not publish its financial information." http://en.wikipedia.org/wiki/Putumayo_World_Music, accessed 2 August 2011.

18. As the *New York Times* reported, "Storper predicts that sales for the year will approach $13 million, up almost 20 percent from last year . . . [while] according to the Recording Industry Association of America, shipments of music products declined more than 15 percent in the first half of 2003 from the period a year earlier, after drops of more than 10 percent in both 2001 and 2002" (Tanya Mohn, "Private Sector; Stumbling Into a World of Music," *New York Times*, 21 December 2003, www.nytimes.com/2003/12/21/business/private-sector-stumbling-into-a-world-of-music.html?pagewanted=all&src=pm).

19. When Adam Smith first introduced the term "the invisible hand" in his *Theory of Moral Sentiments* (1759/2010), he suggested that the rich will be guided by this invisible hand to distribute wealth in a way that would reflect what would happen if resources were to be distributed equitably.

CONCLUSION

1. http://armenra.com/photo-gallery/.
2. Film audiences are one place where I think distributed subjectivity began to come into being earlier than many other settings. In general I am not making a particularly historical argument, in large part because I am neither an archival researcher nor a historian, but my sense is that distributed subjectivity belongs roughly to the postwar period, to the time that is variously called postmodernity, or late capitalism. Distributed subjectivity seems to me to precede that in a few places—horror films in particular would be one place where I think audition conditions a group subjective experience through, for example, the shared heightening tension that horror film music does so well.
3. *The Economist*, "Data, Data Everywhere," 25 February 2010.
4. This does not, however, make me want to have dinner there. But Olive Garden surely believes that the music helps create a pleasurable atmosphere for the clientele, or they wouldn't be spending money on it. And from the perspective of this book, they are right to do so. If, however, we were to take the whole realm of sensory marketing into account, we would have to consider their demographics, and the relationship of what might be considered a "mainstream" palate to various kinds of "ethnic" foods.
5. http://chunkymove.com.au/Our-Works/Current-Productions/Mortal-Engine.aspx, accessed 24 May 2012.

Works Cited

Abel, Richard, and Rick Altman, eds. 2001. *The Sounds of Early Cinema.* Bloomington: Indiana University Press.
Adorno, Theodor. 1988. *Introduction to the Sociology of Music.* New York and London: Continuum.
Altman, Rick. 1992. "Sound Space." In Altman, ed., *Sound Theory/Sound Practice.* New York: Routledge.
Annie. 1982. Directed by John Huston, music by Charles Strouse. Columbia Pictures and Rastar Pictures.
APA (American Psychiatric Association). 2000. *Diagnostic and Statistical Manual of Mental Disorders, DSM-IV.* Washington, DC: American Psychiatric Association.
Aronowitz, Stanley. 1993. *Roll Over Beethoven: The Return of Cultural Strife.* Hanover, NH: Wesleyan University Press.
Attali, Jacques. 1985. *Noise: The Political Economy of Music.* Minneapolis: University of Minnesota Press.
Attinello, Paul. 2010. "Rock, Television, Paper, Musicals, Scissors: Buffy, The Simpsons, and Parody." In *Sounds of the Slayer: Music and Silence in Buffy and Angel,* edited by Paul Attinello and Vanessa Knights. Farnham, UK: Ashgate.
Avdeeff, Melissa. 2011. "Finding Meaning in the Masses: Issues of Taste, Sociability, and Identity in Digitality." PhD thesis. University of Edinburgh.
Baade, Christina. 2011. *Victory through Harmony: The BBC and Popular Music in World War II.* New York: Oxford University Press.
Barenboim, Daniel. 2006. BBC Reith Lecture Number 2, "The Neglected Sense," 14 April. www.bbc.co.uk/programmes/p00gm37g. Accessed 6 July 2011.
BBC (British Broadcasting Company). 2006. "The Sound of Dubstep" (video feature). 6 April 2006. www.bbc.co.uk/dna/collective/A10695684. Accessed on 27 November 2009.

Beck, Jay, and Tony Grajeda. 2008. *Lowering the Boom: Critical Studies in Film Sound*. Champaign: University of Illinois Press.

Beller, Jonathan. 2006. *The Cinematic Mode of Production: Attention Economy and the Society of the Spectacle*. Hanover, NH: Dartmouth College Press.

Biddle, Ian. 2009. "Visitors, or The Political Ontology of Noise." *Radical Musicology* 4: par. 2. www.radical-musicology.org.uk/2009/Biddle.htm. Accessed 15 November 2010.

Bijsterveld, Karin. 2008. *Mechanical Sound: Technology, Culture, and Public Problems of Noise in the Twentieth Century*. Cambridge, MA: MIT Press.

Billson, Anne. 2005. *Buffy the Vampire Slayer*. London: BFI.

Bloxham, Donald. 2005. *The Great Game of Genocide: Imperialism, Nationalism, and the Destruction of the Ottoman Armenians*. Oxford: Oxford University Press.

Born, Georgina, and David Hesmondhalgh, eds. 2000.*Western Music and Its Others: Difference, Representation, and Appropriation in Music*. Berkeley and Los Angeles: University of California Press.

Bothamley, Jennifer. 1993. *Dictionary of Theories*. London: Gale Research

Bottum, J. 2000. "The Soundtracking of America." *Atlantic Monthly*, March 2000. www.theatlantic.com/issues/2000/03/bottum.htm.

Boundas, Constantin. 2005. "Virtual/Virtualities." In *The Deleuze Dictionary*, edited by Adrian Parr. Edinburgh: Edinburgh University Press.

Brackett, David. 1999. "Music." In *Key Terms in Popular Music and Culture*. Edited by Bruce Horner and Thomas Swiss. London: Blackwell.

Bradby, Barbara. 1990. "Do Talk and Don't Talk: The Division of the Subject in Girl-Group Music." In *On Record: Rock, Pop, and the Written Word*, edited by Simon Frith and Andrew Goodwin. London and New York: Routledge.

Brett, Philip. 2009. "Queer Musical Orientalism." *Echo: A Music-Centered Journal* 9 (1). www.echo.ucla.edu/Volume9-Issue1/brett/brett1.html. Accessed 9 August 2011.

Buffy the Vampire Slayer. 1997–2003. Created by Joss Whedon. Mutant Enemy, Kuzui Enterprises, Sandollar Television, and Twentieth Century Fox Television. Musical episode: "Once More, with Feeling," season six, episode seven, 6 November 2001.

Bull, Michael. 2000. *Sounding Out the City: Personal Stereos and the Management of Everyday Life*. London: Berg.

———. 2007. *Sound Moves: iPod Culture and Urban Experience*. London and New York: Routledge.

Caffentzis, George. 2007. "Crystals and Analytic Engines: Historical and Conceptual Preliminaries to a New Theory of Machines." *ephemera: theory and politics in organization* 7 (1): 24–45.

Castells, Manuel. 1996–98. *The Information Age*. 3 vols. London: Wiley Blackwell.

The Cell. 2000. Directed by Tarsem Singh, music by Howard Shore. New Line Cinema, A Caro-McLeod/Radical Media Production, in association with Katira Productions GmbH & Co. KG.

Charlie's Angels: Full Throttle. 2003. Directed by McG, music by Edward Shearmur. Columbia Pictures Corporation, Flower Films (II), Tall Trees Productions, Wonderland Sound and Vision.

Chicago. 2002. Directed by Rob Marshall, music by Danny Elfman. Miramax Films, Producers Circle Co., Storyline Entertainment, in association with Kalis Productions GmbH & Co. KG.

Chicago Hope. 1994–2000. Created by David E. Kelley. Twentieth Century Fox Television and David E. Kelley Productions. Musical Season 4, Episode 3, "Brain Salad Surgery." 15 October 1997.

Chitty Chitty Bang Bang. 1968. Directed by Ken Hughes, music by Irwin Kostal. A Warfield—D.F.I. Picture.

Chion, Michel. 1994. *Audio-Vision.* Translated by Claudia Gorbman. New York: Columbia University Press.

Chong, Sang Chul, Sabine Kastner, and Anne Treisman. 2004. "Effects of Focused and Distributed Attention on Neural Competition." *Journal of Vision* 4 (8). doi:10.1167/4.8.9.

The Chronicle of Higher Education. 2002. "Researchers Verify the Accuracy of a Protein-Folding Model Based on Distributed Computing." Information Technology Section, 49 (14): A27.

Chu, Maurice, Patrick Cheung, and James Reich. 2004. "Distributed Attention." Proceeding SenSys '04. Proceedings of the 2nd international conference on embedded networked sensor systems, ACM. New York, NY, USA. ISBN:1–58113–879–2. doi:10.1145/1031495.1031556.

Clarke, David. 2007. "Beyond the Global Imaginary: Decoding BBC Radio 3's *Late Junction.*" *Radical Musicology* 2. www.radical-musicology.org.uk/Clarkeref.htm.

Clarke, Eric. 2005. *Ways of Listening.* Oxford and New York: Oxford University Press.

Clough, Patricia Ticineto. 2000. *Autoaffection: Unconscious Thought in the Age of Teletechnology.* Minneapolis: University of Minnesota Press.

———, ed. 2007. *The Affective Turn.* Durham, NC: Duke University Press.

Clough, Patricia Ticineto, Greg Goldberg, Rachel Schiff, Aaron Weeks, and Craig Willse. 2007. "Notes Towards a Theory of Affect-Itself." *ephemera: theory and politics in organization* 7 (1): 60–77.

CNN.com. 2000. "The House of the Future Is Here Today." www.cnn.com/2000/TECH/ptech/01/03/future.homes/. Accessed 31 July 2011.

Connor, Stephen. 2000. *Dumbstruck: A Cultural History of Ventriloquism.* Oxford: Oxford University Press.

Cook, Diane J., and WenZhan Song. 2009. "Ambient Intelligence and Wearable Computing: Sensors on the Body, in the Home, and Beyond." *Journal of Ambient Intelligence & Smart Environments* 1: 1–4. doi:10.3233/AIS-2009–0014.

Cop Rock. 1990. Created by Steven Bochco and William M. Finkelstein. Twentieth Century Fox Television and Steven Bochco Productions.

Corbin, Alain. 1998. *Village Bells: Sound and Meaning in the Nineteenth-Century French Countryside.* Translated by Martin Thom. New York: Columbia University Press.

Crary, Jonathan. 1999. *Suspensions of Perception: Attention, Spectacle, and Modern Culture.* Cambridge, MA: MIT Press.

Cubitt, Sean. 1984. "Maybellene: Meaning and the Listening Subject." In *Popular Music.* Vol. 4, *Performers and Audiences,* pp. 207–24. Cambridge: Cambridge University Press.

Dancer in the Dark. 2000. Directed by Lars von Trier, music by Björk. presented by Zentropa Entertainments, Trust Film Svenska, Film i Väst, Liberator Productions, a coproduction of Pain Unlimited GmbH Filmproduktion, Cinematograph A/S, What Else? B.V., Icelandic Film, Blind Spot Pictures Oy, France 3 Cinéma, Danish Broadcasting Corporation, arte France Cinéma, SVT Drama, Arte, in collaboration with Angel Films, Canal+, FilmFour, Filmek A/S, Constantin Film Produktion, Lantia Cinema & Audiovisivi, TV 1000, Vrijzinnig Protestantse Radio Omroep (VPRO), Westdeutscher Rundfunk (WDR), Yleisradio (YLE), Memfis Film.

Daria. 1997–2001. Created by Glenn Eichler and Susie Lewis. MTV Animation.

Dartnell, Lewis. 2008. "How Online Games Are Solving Uncomputable Problems." *New Scientist,* 5 November 2008 (magazine issue 2681). www.newscientist.com/article/mg20026811.700-how-online-games-are-solving-uncomputable-problems.html. Accessed 11 July 2010.

Davies, Ioan. 1995. *Cultural Studies and Beyond.* London and New York: Routledge.

Dean, Josh. 2008. "Seth MacFarlane's $2 Billion Family Guy Empire." *Fast Company,* online magazine. www.fastcompany.com/magazine130/family-values.html? page = 0%2Co. Accessed 30 May 2011.

de Lauretis, Teresa. 1984. *Alice Doesn't: Feminism, Semiotics, Cinema.* Bloomington: Indiana University Press.

Deleuze, Gilles, and Felix Guattari. 1987. *A Thousand Plateaus: Capitalism and Schizophrenia.* Translated by Brian Massumi. Minneapolis: University of Minnesota Press.

Demers, Joanna. 2010. *Listening through the Noise: The Aesthetics of Experimental Electronic Music.* Oxford: Oxford University Press.

DeNora, Tia. 2000. *Music in Everyday Life.* Cambridge: Cambridge University Press.

Dick, Philip K. 1968/2007. *Do Androids Dream of Electric Sheep?* London: Gollancz Ltd.

The Dick van Dyke Show. 1961–66. Created by Carl Reiner. Calvada Productions, Columbia Broadcasting System.

Dienst, Richard. 1994. *Still Life in Real Time: Theory After Television.* Durham, NC: Duke University Press.

———. 2011. *The Bonds of Debt.* London and Brooklyn: Verso Books.

Doane, Mary Ann. 1985. "Ideology and the Practice of Sound Editing and Mixing." In *Film Sound,* edited by Elisabeth Weis and John Belton. New York: Columbia University Press.

The Drew Carey Show. 1995–2004. Created by Drew Carey and Bruce Helford. Mohawk Productions and Warner Bros. Television. Musical Episode "Time Warp/Shake Your Groove Thing." Season 4, Episode 10, originally aired 18 November 1998.

Eisler, Hanns, and Theodor Adorno. 1947. *Composing for the Films.* New York: Oxford University Press. Reprint Athlone Press, 1994.

Erlmann, Veit. 1993. "The Politics and Aesthetics of Transnational Musics." *World of Music* 35 (2): 3–15.

———. 1996. "The Aesthetics of the Global Imagination: Reflections on World Music in the 1990s." *Public Culture* 8: 467–87.

———, ed. 2004. *Hearing Cultures: Essays on Sound, Listening, and Modernity.* New York: Berg Publishers.

———. 2010. *Reason and Resonance: A History of Modern Aurality.* Cambridge, MA: MIT Press.

Evita. 1996. Directed by Alan Parker, music by Andrew Lloyd Webber. Hollywood Pictures, Cinergi, Dirty Hands, Summit Entertainment.

Fabbri, Franco. 1982. "A Theory of Musical Genres: Two Applications." In *Popular Music Perspectives,* edited by David Horn and Philip Tagg, pp. 52–81. Göteborg and Exeter: IASPM.

Fairley, Jan. 2001. "The 'Local' and the 'Global' in Popular Music." In Frith, Straw, and Street, *The Cambridge Companion to Pop and Rock.*

Falck, Daniel. n.d. "Voyages on the Line." Author's manuscript.

Family Guy. 1999–2012. Created by Seth MacFarlane. Twentieth Century Fox Television, Film Roman Productions, Fuzzy Door Productions, Hands Down Entertainment.

Feld, Steven. 1994a. "Notes on World Beat." In Keil and Feld, *Music Grooves.*

———. 1994b. "From Schizophonia to Schismogenesis: The Discourses of World Music and World Beat." In Keil and Feld, *Music Grooves.*

———. 2000. "A Sweet Lullaby for World Music." *Public Culture* 12 (1)

Fernandez, Maria Elena. 2009. "Chris Colfer's Journey from Small Town to 'Glee.'" *Los Angeles Times,* 8 September, Entertainment section.

Fink, Robert. 2000. "Orchestral Corporate." *Echo: A Music-Centered Journal* 2 (1). www.humnet.ucla.edu/humnet/musicology/echo/Volume2-Issue1/fink/fink-article.html.

Fish, Stanley. 1980. *Is There a Text in This Class?* Cambridge, MA: Harvard University Press.

Florida, Richard. 2002. *The Rise of the Creative Class: And How It's Transforming Work, Leisure, Community and Everyday Life.* New York: Perseus Book Group.

Foucault, Michel. 1979. "What Is an Author?" In *Textual Strategies: Perspectives in Post-Structuralist Criticism,* edited by Josué V. Harari. New York and London: Routledge.

Frasca, Gonzalo. 2003. "Ludologists Love Stories, Too: Notes from a Debate That Never Took Place." www.ludology.org/articles/Frasca_LevelUp2003.pdf.

Frith, Simon. 2001. "Pop Music." In Frith, Straw, and Street, *The Cambridge Companion to Pop and Rock*.

———. 2008. "The Voice as a Musical Instrument." In *Music, Words and Voice: A Reader*. Manchester, UK: Manchester University Press.

Frith, Simon, Will Straw, and John Street, eds. 2001. *The Cambridge Companion to Pop and Rock*. Cambridge: Cambridge University Press.

Fulberg, Paul. 2003. "Using Sonic Branding in the Retail Environment—An Easy and Effective Way to Create Consumer Brand Loyalty While Enhancing the In-Store Experience." *Journal of Consumer Behavior* 3 (2): 193–98.

Galloway, Alexander. 2004. *Protocol: How Control Exists after Decentralization*. Cambridge, MA: MIT Press.

Garofalo, Reebee. 1993. "Whose World, What Beat: The Transnational Music Industry, Identity and Cultural Imperialism." *World of Music* 35 (2): 3–15.

Gay, Peter. 1996. *The Naked Heart*. New York: W. W. Norton.

Gaya, Lalya, Ramia Mazé, and Lars Erik Holmquist. 2003. "Sonic City: The Urban Environment as a Musical Interface." Proceedings of the 2003 Conference on New Interfaces for Musical Expression (NIME-03), Montreal, Canada.

Genette, Gerard. 1972, rep. 1983. *Narrative Discourse: An Essay in Method*. Ithaca, NY: Cornell University Press.

Gibbs, W. Wayt. 2000. "As We May Live." *Scientific American*, 19 November.. www.scientificamerican.com/article.cfm?id=as-we-may-live.

Gifford, Bill. 1995. "They're Playing Our Song," FEED. www.feedmag.com/95.10gifford/95.10gifford1.html. Accessed 16 July 2011.

Gillespie, Nick, and Jesse Walker. 2006. "South Park Libertarians: Trey Parker and Matt Stone on Liberals, Conservatives, Censorship, and Religion." *Reason.com: Free Minds and Free Markets*. http://reason.com/archives/2006/12/05/south-park-libertarians. Accessed 30 May 2011.

Glee. 2009–2012. Created by Ian Brennan, Ryan Murphy, and Brad Falchuck. Brad Falchuck Teley-vision and Ryan Murphy Productions in association with Twentieth Century Fox Television.

Glennie, Evelyn. 1993. "The Hearing Essay." www.evelyn.co.uk/Resources/Essays/Hearing%20Essay.pdf.

Goodman, Steve. 2010. *Sonic Warfare: Sound, Affect, and the Ecology of Fear*. Cambridge, MA: MIT Press.

Gorbman, Claudia. 1987. *Unheard Melodies: Narrative Film Music*. Bloomington and Indianapolis: Indiana University Press.

Gouk, Penelope. 1999. *Music, Science and Natural Magic in Seventeenth-Century England*. New Haven, CT: Yale University Press.

Groden, Michael, Martin Kreiswirth, and Imre Szeman, eds. 1994. *The Johns Hopkins Guide to Literary Theory and Criticism*. Baltimore: Johns Hopkins University Press. http://litguide.press.jhu.edu/. Accessed 16 May 2006.

Guilbault, Jocelyne. 2001. "World Music." In Frith, Straw, and Street, *The Cambridge Companion to Pop and Rock*.
Guys and Dolls. 1955. Directed by Joseph L. Mankiewicz, music by Frank Loesser. The Samuel Goldwyn Company.
Haraway, Donna. 1991. "A Cyborg Manifesto: Science, Technology, and Socialist-Feminism in the Late Twentieth Century." In *Simians, Cyborgs and Women: The Reinvention of Nature*. New York and London: Routledge. First published in *Socialist Review* no. 80, 1985.
Hardt, Michael. 1999. "Affective Labor." *boundary 2* 26 (2): 89–100.
Hardt, Michael, and Antonio Negri. 2000. *Empire*. Cambridge, MA: Harvard University Press.
Hayles, N. Katherine. 2007. "Hyper and Deep Attention: The Generational Divide in Cognitive Modes." *Profession* 2007 13: 187–99.
Hebdige, Dick. 1979. *Subculture: The Meaning of Style*. London: Methuen.
Hegarty, Paul. 2007. *Noise Music: A History*. London: Continuum.
Hemming, Roy, and David Hajdu. 1991. *Discovering Great Singers of Classic Pop: A New Listener's Guide*. New York: Newmarket Press.
Hercules: The Legendary Journeys. 1995–99. Created by Christian Williams. MCA Television, Pacific Renaissance Pictures Ltd., Renaissance Pictures, Studios USA Television, Universal TV. Musical episodes: "Greece is Burning," season 5, episode 15, original air date 22 February 1999; "Men in Pink," season 4, episode 12, original air date 2 February 1998; ". . . And Fancy Free," season 4, episode 8, original air date 17 November 1997.
Hickey, Jim. 2010. "Smell-O-Vision: Have Japanese Found Sweet Smell of Success?" ABC News, 21 October. http://abcnews.go.com/Technology/japanese-claim-smell-vision-advance/story?id=11936387#.T7zSqUVYv_k. Accessed 23 May 2012.
Howard, Keith. 2009. "Live Music vs Audio Tourism: World Music and the Changing Music Industry." Inaugural professorial address, School of Oriental and African Studies, University of London.
Humes, Malcolm. 1995. "What Is Ambient Music?" http://music.hyperreal.org/epsilon/info/humes_notes.html. Accessed 21 July 2012.
Huron, David. 2008. *Sweet Anticipation: Music and the Psychology of Expectation*. Cambridge, MA: MIT Press.
I Love Lucy. 1951–57. Written by Bob Carroll Jr., Madelyn Davis, and Jess Oppenheimer. Desilu Productions.
Ipeirotis, Panagiotis. 2010. "Demographics of Mechanical Turk." New York University, Leonard N. Stern School of Business, Working Paper Series, March 2010.
Iskold, Alex. 2007. "The Attention Economy: An Overview." *ReadWriteWeb*. www.readwriteweb.com/archives/attention_economy_overview.php. Accessed 10/06/11.
Jarman, Freya. 2009. "Notes on Musical Camp." In *The Ashgate Research Companion to Popular Musicology*, edited by Derek Scott. Farham, UK: Ashgate.

Johnson, James. 1995. *Listening in Paris: A Cultural History.* Berkeley: University of California Press.
Kahn, Douglas. 2001. *Noise, Water, Meat: A History of Sound in the Arts.* Cambridge, MA: MIT Press.
Kassabian, Anahid. 2001a. *Hearing Film: Tracking Identifications in Contemporary Hollywood Film Music.* New York and London: Routledge.
———. 2001b. "Ubisub: Ubiquitous Listening and Networked Subjectivity." *Echo: A Music-Centered Journal* 3 (2). www.humnet.ucla.edu/echo/ Volume3-issue2/kassabian/ index.html.
———. 2003. "The Sound of a New Film Form." In *Popular Music and Film,* edited by Ian Inglis. London: Wallflower.
Kaufman, Joanne. 2001. "If You Liked Our Oil Change, Wait 'Til You Hear Our Taste in Music." *Wall Street Journal,* 28 August 2001, p. A12.
Keightley, Keir. n.d. "Reading Capitol/E.M.I.: Musical Tourism and Industrial Globalization in the Record Industry, 1954–63." Author's manuscript.
———. n.d. "Around the World, Musical Tourism and the Globalization of the Record Industry, 1946–66." Author's manuscript.
Keil, Charles, and Steven Feld. 1994. *Music Grooves.* Chicago: University of Chicago Press.
Knights, Vanessa, and Paul Attinello, eds. 2010. *Music, Sound, and Silence in "Buffy the Vampire Slayer."* Farnham, UK: Ashgate.
Koblin, Aaron. 2011. "Artfully Visualizing Our Humanity." www.ted.com/talks/aaron_koblin.html. Accessed 29 April 2012.
Kramer, Lawrence. 1994. *Music As Cultural Practice, 1800–1900.* Berkeley: University of California Press.
———. 1996. *Classical Music and Postmodern Knowledge.* Berkeley: University of California Press.
———. 2000. *After the Lovedeath: Sexual Violence and the Making of Culture.* Berkeley and Los Angeles: University of California Press.
———. 2003. *Franz Schubert: Sexuality, Subjectivity, Song.* Cambridge: Cambridge University Press.
Kricfalusi, John. 2010. "Good Direction VS Turning the Furnace On and Off." http://johnkstuff.blogspot.com/2010/10/good-direction.html. Accessed 30 May 2011.
Lanza, Joseph. 2004. *Elevator Music : A Surreal History of Muzak, Easy-Listening, and Other Moodsong,* rev. ed. Ann Arbor: University of Michigan Press. (New York: Picador USA, 1995.)
Lara Croft: Tomb Raider. 2001. Directed by Simon West, music by Graeme Revell. Paramount Pictures, Mutual Film Company, British Broadcasting Corporation (BBC), Lawrence Gordon Productions, Marubeni Corporation, Eidos Interactive, KFP Produktions GmbH & Co. KG, Tele München Fernseh Produktionsgesellschaft (TMG), Toho-Towa.
The Larry Sanders Show. 1992–98. Created by Dennis Klein and Garry Shandling. Brillstein-Grey Entertainment, Columbia Pictures Television, Home Box Office (HBO), Partners with Boundaries.

Lastra, James. 2000. *Sound Technology and the American Cinema: Perception, Representation, Modernity*. New York: Columbia University Press.
Lee, David, Amanda Henderson, and David Shum. 2004. "The Effect of Music on Preprocedure Anxiety in Hong Kong Chinese Day Patients." *Journal of Clinical Nursing* 13 (3): 297–303.
Lee, Haesung, and Joonhee Kwon. 2010. "Combining Context-Awareness with Wearable Computing for Emotion-based Contents Service." *International Journal of Advanced Science and Technology* 22 (September): 13-24.
Le Sang d'un Poète. 1932. Directed by Jean Cocteau, music by Georges Auric. Vicomte de Noailles.
Lipsitz, George. 1994. *Dangerous Crossroads: Popular Music, Postmodernism, and the Poetics of Place*. New York: Verso.
Ludlow, Peter, and Mark Wallace. 2009. *The Second Life Herald: The Virtual Tabloid That Witnessed the Dawn of the Metaverse*. Cambridge, MA: MIT Press.
Lunenfeld, Peter. 2011a. *The Secret War Between Downloading and Uploading: Tales of the Computer as Culture Machine*. Cambridge, MA: MIT Press.
———. 2011b. "How Computers Can Cure Cultural Diabetes." *New Scientist*, 5 July 2011.
Lyotard, Jean-Francois. 1984. *The Postmodern Condition: A Report on Knowledge*. Minneapolis: University of Minnesota Press.
Maasø, Arnt. 2000. "This Goes to Eleven: 'High' and 'Low' Sound in Television." Author's manuscript.
MacDonald, Scott. 1998. "Arthur Peleshian." In *A Critical Cinema 3: Interviews with Independent Filmmakers*, pp. 93–103. Berkeley and Los Angeles: University of California Press.
Malcolm in the Middle. 2000–2006. Created by Linwood Boomer. Satin City Productions, Regency Television, and Fox Television Studios.
Marks, Laura U. 2002. *Touch: Sensuous Theory and Multisensory Media*. Minneapolis: University of Minnesota Press.
Mary Poppins. 1964. Directed by Robert Stevenson, music by Irwin Kostal. Walt DisneyProductions.
Massumi, Brian. 2002. *Parables for the Virtual: Movement, Affect, Sensation*. Durham, NC: Duke University Press.
The Matrix. 1999. Directed by Andy Wachowski and Lana Wachowski, music by Don Davis, music supervisor Jason Bentley. Warner Bros. Pictures, Groucho II Film Partnership, Silver Pictures.
McCarthy, Anna. 2000. *Ambient Television: Visual Culture and Public Space*. Durham, NC: Duke University Press.
McClary, Susan. 1986. "A Musical Dialectic from the Enlightenment: Mozart's Piano Concerto in G Major, K. 453, Movement 2." *Cultural Critique* 4: 129–70.
———. 1991. *Feminine Endings: Music, Gender and Sexuality*. Minneapolis: University of Minnesota Press.

McCracken, Allison. 2001. "Real Men Don't Sing Ballads: The Radio Crooner in Hollywood, 1929–1933." In *Soundtrack Available: Essays on Film and Popular Music*, edited by Pamela Wojcik and Arthur Knight. Durham, NC: Duke University Press.

Meier, Leslie. 2011. "Promotional Ubiquitous Musics: Recording Artists, Brands, and "Rendering Authenticity." *Popular Music and Society* 34 (4): 399-415.

Men in Black 3 IMAX 3D. 2012. Directed by Barry Sonnenfeld, music by Danny Elfman. Amblin Entertainment, Hemisphere Media Capital, Imagenation Abu Dhabi FZ, Media Magik Entertainment, Parkes/MacDonald Productions.

Meyer, Moe. 1994. *The Politics and Poetics of Camp*. London: Psychology Press.

Milliman, Ronald E. 1982. "Using Background Music to Affect the Behavior of Supermarket Shoppers." *Journal of Marketing* 46 (3): 86–91.

Mirror, Mirror: The Untold Adventures of Snow White. 2012. Directed by Tarsem Singh, music by Alan Menken. Relativity Media, Yuk Films, Goldmann Pictures, Rat Entertainment, Misha Films, Citizen Snow Film Productions.

Modleski, Tania. 1986. *Studies in Entertainment: Critical Approaches to Mass Culture*. Bloomington: Indiana University Press.

Moulin Rouge! 2001. Directed by Baz Luhrmann, music by Craig Armstrong. Twentieth Century Fox Film Corporation, Bazmark Films, Angel Studios.

Murray, Janet. 2005. "The Last Word on Ludology v Narratology in Game Studies." Preface to keynote at DiGRA 2005, http://lcc.gatech.edu/~murray/digra05/lastword.pdf.

Nichanian, Marc. 2002. *Writers of Disaster: The National Revolution*. London: Taderon Press.

Nielsen, Michael A. 2002. "Rules for a Complex Quantum World." *Scientific American*, 15 October, 66–75.

North, Adrian C., David J. Hargreaves, and Jennifer McKendrick. 1999. "The Influence of In-Store Music on Wine Selections." *Journal of Applied Psychology* 84 (2): 271–76.

Northmore, Sarah. 2004. "Hear, New York: Sounding the Space." *NY Arts*, September/October. www.nyartsmagazine.com/september-october-2004/hear-new-york-sounding-the-space-by-sarah-northmore.

Oakes, Steve. 2003. "Musical Tempo and Waiting Perceptions." *Psychology and Marketing* 20 (8): 685–705.

Open University. 2006. "Reith 2006: In The Beginning Was Sound." www.open2.net/reith2006/. Accessed 6 July 2011.

O'Sullivan, Tim, John Hartley, Danny Saunders, Martin Montgomery, and John Fiske, eds. 1994. *Key Concepts in Communication and Cultural Studies*. 2nd ed. London and New York: Routledge.

Oz. 1997–2003. Created by Tom Fontana. The Levinson/Fontana Company and Rysher Entertainment. Musical episode season 5, episode 6, original air date 10 February 2002.

Palahniuk, Chuck. 2002. *Lullaby*. New York: Anchor Books.

Parks, Lisa, and Elana Levine, eds. 2003. *Red Noise: "Buffy the Vampire Slayer" and Critical Television Studies*. Durham, NC: Duke University Press.

Parks Associates. 2003. "Listening to Music Tops the List of Most Important Home Media Activities; Consumers Find More Value in Listening to Music Than in Watching TV or Using the PC." *Business Wire*. 15 July.

Parr, Adrian, ed. 2005. *The Deleuze Dictionary*. Edinburgh: Edinburgh University Press.

Passler, Jann. 2000. "Race, Orientalism, and Distinction in the Wake of the Yellow Peril." In Born and Hesmondhalgh, *Western Music and Its Others*.

Pentland, A. 2000. "It's Alive!" *IBM Systems Journal* 39 (3/4): 821–22.

Pi. 1998. Directed by Darren Aronofsky, music by Clint Mansell. Harvest Filmworks, Truth and Soul Pictures, Plantain Films, Protozoa Pictures.

Picard, R. W. 2000. "Toward Computers That Recognize and Respond to User Emotion." *IBM Systems Journal* 39 (3/4): 705–19.

Picker, John M. 2003. *Victorian Soundscapes*. New York: Oxford University Press.

Postman, Neil. 2000. *Building a Bridge to the 18th Century: How the Past Can Improve Our Future*. New York: Random House.

Powers, Devon. 2010. "Strange Powers: The Branded Sensorium and the Intrigue of Musical Sound." In *Blowing Up the Brand: Critical Perspectives on Promotional Culture*, edited by Melissa Aronczyk and Devon Powers. New York: Peter Lang.

Putumayo. 2003. *Putumayo World Music: 10th Anniversary Collection, 1993–2003*. New York: Putumayo World Music.

Rath, Richard Cullen. 2005. *How Early America Sounded*. Ithaca, NY, and London: Cornell University Press.

Ree, Jonathan. 1999. *I See a Voice: A History of Deafness, Language, and the Senses*. New York: Metropolitan Books.

Rogers, Holly. 2013. *Sounding the Gallery: Video and the Rise of Art Music*. New York and Oxford: Oxford University Press.

Roles, Joy. 2010. "Forming Soundmarks: A Critical Evaluation of the Sonic Brand within the Contemporary Mediascape." PhD thesis. University of East London.

Run Lola Run. 1998. Directed by Tom Twyker, music by Reinhold Heil, Johnny Klimek, and Tom Twyker. X-Filme Creative Pool, Westdeutscher Rundfunk (WDR), Arte.

Sadie, Stanley, and John Tyrell, eds. 2001. *The New Grove Dictionary of Music and Musicians*. New York: Macmillan.

Schafer, Own. n.d. "The Sound of Muzak." *Tokyo Classified Rant 'n' Rave*. http://archive.metropolis.co.jp/tokyorantsravesarchive299/265/tokyorantsravesinc.htm. Accessed 16 July 2011.

Schafer, R. Murray. 1993. *The Soundscape*. Rochester, VT: Inner Traditions Intl.

Schwarz, David. 1997. *Listening Subjects: Music, Psychoanalysis, Culture*. Durham, NC: Duke University Press.

———. 2006. *Listening Awry: Music and Alterity in German Culture*. Minneapolis: University of Minnesota Press.

Scrubs. 2001–2010. Created by Bill Lawrence. Doozer, Towers Productions, ABC Studios (2007–2010), Touchstone Television (2001–2007). "My Musical" season 6, episode 6, originally aired 18 January 2007.

Sedgwick, Eve Kosofsky. 1985. *Between Men: English Literature and Male Homosocial Desire*. New York: Columbia University Press.

Shaviro, Steven. 2010. *Post Cinematic Affect*. Ropley, UK: O Books.

———. 2012. "Post-Continuity." Text of SCMS talk, on blog *The Pinocchio Theory*. http://www.shaviro.com/Blog/?p = 1034. Accessed 12 May 2012.

Simon, Bryant. 2009. *Everything but the Coffee: Learning about America from Starbucks*. Berkeley and Los Angeles: University of California Press.

Simon, Herbert. 1971. "Designing Organizations for an Information-Rich World." In *Computers, Communications, and the Public Interest*, edited by Martin Greenberger. Baltimore, MD: Johns Hopkins University Press.

The Simpsons. 1989–2012. Created by Matt Groening. Gracie Films and Twentieth Century Fox Television. Numerous musical episodes.

The Singing Detective. 1986. Created by Dennis Potter. British Broadcasting Company (BBC) and Australian Broadcasting Company (ABC).

A Single Man. 2009. Directed by Tom Ford, music Abel Korzeniowski. Fade to Black Productions, Depth of Field, Artina Films.

Smith, Adam. 1759/2010. *Theory of Moral Sentiments*. London: Penguin Classics.

Smith, Mark M. 2001. *Listening to Nineteenth-Century America*. Chapel Hill: University of North Carolina Press.

Some Like It Hot. 1959. Directed by Billy Wilder, music by Adolph Deutsch. Ashton Productions and the Mirisch Corporation.

The Sound of Music. 1965. Directed by Robert Wise, music by Richard Rodgers and Irwin Kostal. Robert Wise Productions and Argyle Enterprises.

South, James B., ed. 2003. *"Buffy the Vampire Slayer" and Philosophy: Fear and Trembling in Sunnydale*. Chicago and LaSalle, IL: Open Court.

Spivak, Gayatri Chakravorty. 1999. *A Critique of Postcolonial Reason: Towards a History of the Vanishing Present*. Cambridge, MA: Harvard University Press.

Stagoll, Cliff. 2005. "Plane." In Parr, *The Deleuze Dictionary*.

Stein, Alexander. 2000. "On Listening in Music and Psychoanalysis." *Journal for the Psychoanalysis of Culture and Society* 5 (1): 139–44.

Stephenson, Neal. 1992. *Snowcrash*. New York: Bantam Spectra.

Stevenson, Gregory. 2004. *Televised Morality: The Case of "Buffy the Vampire Slayer."* Lanham, MD: Hamilton Books.
Sterne, Jonathan. 1997. "Sounds Like the Mall of America: Programmed Music and the Architectonics of Commercial Space." *Ethnomusicology* 41 (1): 22–50.
———. 2003. *The Audible Past: Cultural Origins of Sound Reproduction.* Durham, NC: Duke University Press.
———. Forthcoming. "The Non-Aggressive Musical Deterrent." In *Ubiquitous Musics*, edited by Marta García Quiñones, Anahid Kassabian, and Elena Boschi. Farnham, UK: Ashgate.
Stilwell, Robynn J. 2003. "It May Look Like a Living Room . . . : The Musical Number and the Sitcom." *Echo: A Music-Centered Journal* 5 (1). www.echo.ucla.edu/Volume5-issue1/stilwell/stilwell.pdf.
Stockfelt, Ola. 1997. "Adequate Modes of Listening." In *Keeping Score: Music, Disciplinarity, Culture*, edited by David Schwarz, Anahid Kassabian, and Lawrence Siegel. Charlottesville: University Press of Virginia.
A Streetcar Named Desire. 1951. Directed by Elia Kazan, music by Alex North. Charles K. Feldman Group and Warner Bros. Pictures.
Subotnik, Rose Rosengard. 1991. *Developing Variations: Style and Ideology in Western Music.* Minneapolis: University of Minnesota Press.
Sucker Punch. 2011. Directed by Zack Snyder, music by Tyler Bates and Marius De Vries. Warner Bros. Pictures, Legendary Pictures, Cruel & Unusual Films, Lennox House Films.
Talachian, Reza. n.d. *A Brief Critical History of Iranian Feature Film (1896–1975).* www.lib.washington.edu/neareast/cinemaofiran/intro.html. Accessed 16 May 2006.
Tamaoki, Mihoko. n.d. Unpublished manuscript.
Tauber, Daveena, n.d. "What I Did on My Summer Vacation; or, the Politics of Postmodern Tourism." *Passionfruit: A Women's Travel Journal.* www.passionfruit.com/postmodern.htm. (No longer archived on this site.)
Taylor, Timothy D. 1997. *Global Pop: World Music, World Markets.* New York: Routledge.
———. 2002. "Music and the Rise of Radio in 1920s America." *Historical Journal of Film, Radio and Television.* 22 (4): 425–43.
Terranova, Tiziana. 2000. "Free Labor: Producing Culture for the Digital Economy." *Social Text* 18 (2): 33–58.
Thompson, Emily. 2002. *The Soundscape of Modernity: Architectural Acoustics and the Culture of Listening in America, 1900–1933.* Cambridge, MA: MIT Press.
Thorburn, Sandy. 2004. "Insights and Outlooks: Getting Serious with Series Television Musicals." *Discourses in Music* 5 (1). www.discourses.ca/v5n1io.html.
Thornton, Sarah (1996) *Club Cultures: Music, Media and Subcultural Capital.* Hanover, NH: Wesleyan University Press.

Thrift, Nigel. 2004. "Intensities of Feeling: Towards a Spatial Politics of Affect." *Geografiska Annaler* 86 B (1): 57–78. http://onlinelibrary.wiley.com/doi/10.1111/j.0435-3684.2004.00154.x/pdf.

Tomlinson, Gary. 1994. *Music in Renaissance Magic: Toward a Historiography of Others*. Chicago: University of Chicago Press.

Two Pints of Lager and a Packet of Crisps. 2001–2012. Created by Susan Nickson. British Broadcasting Corporation (BBC). Musical Episode "The Aftermath, Part 1," season 8, episode 9, original air date 15 December 2009.

Venn, Couze. 1997. "Beyond Enlightenment: After the Subject of Foucault, Who Comes?" *Theory, Culture, and Society* 14 (3): 1–28.

Walser, Robert. 1993. *Running with the Devil: Power, Gender, and Madness in Heavy Metal Music*. Hanover and London: Wesleyan University Press (University Press of New England).

Webster's New Twentieth-Century Dictionary. 1983. 2nd ed., unabridged. New York: Prentice Hall.

Weiser, Mark. 1991. "The Computer for the Twenty-First Century." *Scientific American* 265, no. 3 (September): 94–104. www.ubiq.com/hypertext/weiser/SciAmDraft3.html.

Westcott, Kathryn. 2006. "Barenboim Hits Out at 'Sound of Muzak.'" *BBC News*, 7 April. http://news.bbc.co.uk/1/hi/entertainment/4883612.stm. Accessed 6 July 2011.

Wilcox, Rhonda. 2005. *Why Buffy Matters: The Art of "Buffy the Vampire Slayer."* London: I. B. Tauris.

Wilcox, Rhonda V., and David Lavery, eds. 2002. *Fighting the Forces: What's at Stake in "Buffy the Vampire Slayer"?* Lanham, MD: Rowman and Littlefield.Williams, Raymond. 1976. *Keywords: A Vocabulary of Culture and Society*. London and New York: Oxford University Press.

Xena: Warrior Princess. 1995–2001. Created by John Schulian and Robert G. Tapert. MCA Television, Renaissance Pictures Studios, USA Television, Universal TV. Musical episodes "Lyre, Lyre Hearts on Fire," season 5, episode 10, original air date 17 January 2000; "The Bitter Suite," season 3, episode 12, original air date 2 February 1998.

X-Play. 2003–2012. Created by Guy Branum. G4 Media and TechTV Inc.

Index

Adorno, Theodor, xxii–xxiii, 6, 8, 58, 69
advertising, xviii, 6, 68, 113
affect, xi, xiii–xiv, xxiv–xxv, xxvi–xxx, 18, 20–23, 29, 31–32, 35, 38, 41, 48–50, 82–83, 90–92, 94, 99, 108, 111–114, 116–117, 121n, 124n, 131n
Altman, Rick, 39–40, 67
Attali, Jaques, xxiv, 17, 33–34
attention, xviii–xxii, xxiv, xxx, 7, 8, 10, 16, 18, 33, 38, 42, 49–53, 56–58, 60–62, 66–70, 72, 77, 81–82, 84, 93, 98, 102, 105, 109–116
Avdeeff, Melissa, 10

Baade, Christina, 9
Balassanian, Sonia, 24–25, 28–29, 112
Barenboim, Daniel, xviii, 109, 127–128n
Bastajian, Tina, 24–25, 30, 112, 123n
Beck, Jay, xiv, 119
Beller, Jonathan, xix, 65, 68, 70–72
Biddle, Ian, 33
Bijsterveld, Karin, xiv
Bottum, J., 3
Boundas, Constantine, xxix
Brackett, David, 33–34

Cage, John, 5, 34
Castells, Manuel, xxiv
Chion, Michel, 34, 39–40

Clarke, David, 96–98, 106–108
Clough, Patricia, 51, 68, 107, 131–132n
Crary, Jonathan, xix
Crosby, Bing, xx, 62

Davenport, Thomas, 67
Dean, Josh, 61–62
Deleuze, Gilles, xxvii, xxix, 132n
Deleuze, Gilles and Félix Guattari, xvi–xvii, xxiv, 31, 93, 109–110, 120n, 132n
Dienst, Richard, 67–68, 70, 132n
distributed subjectivity, xi, xiv, xviii, xxiii–xxviii, xxx–xxxi, 19–21, 23, 32–33, 40–41, 49–50, 72, 82–83, 85, 89, 92–94, 103–116, 120n, 122n, 125n, 131n, 133n
Doane, MaryAnn, 29, 38, 41

Edgar, Jacob, 89, 104
Eno, Brian, 5, 15, 17, 122n
Erlmann, Veit, xiv, 94–95, 99, 132n
ethnomusicology, xiii, 7, 19, 77, 89, 98–99

Fairley, Jan, 96, 102–103
Falck, Daniel, 34
Feld, Steven, 94–96
feminism, xxii, 25, 27, 40, 46, 73–74, 82, 93, 107, 111, 124–125n, 130n

150 / Index

film music, xiv, xvi, xviii, xx, xxii, xxx, 4, 21–31, 34–44, 48–50, 54–56, 60, 62–63, 78, 113, 116n, 121–125n, 127n, 133n
Foucault, Michel, 6, 120n
Frasca, Gonzalo, 35–36
Freud, Sigmund, xxi, 120n
Frith, Simon, xx, 104–105
Fulberg, Paul, 69

Gabriel, Peter, xix–xx, 30, 85
galleries, 24, 123n
Galloway, Alexander, 71, 93, 132n
Garofalo, Reebee, 96
gender, xxiii, 23–24, 43, 46–47, 74–75, 81, 125n
Genette, Gérard, 40
Gibbs, W. Wayt, 2
Gifford, Bill, 3, 5, 8–9
Glennie, Evelyn, xv–xvi
Godard, Jean-Luc, 25, 28
Goldhaber, Michael, 67
Goodman, Steve, xviii, 71, 84
Grajeda, Tony, xiv

haptics, xvi–xvii
Hakobyan, Diana, 23–25, 27, 112
Haraway, Donna, xxiv, 93, 125n, 132n
Hargreaves, David, 69
Harvey, David, 107
Hayles, N. Katherine, xix, xxi, 49, 53
Howard, Keith, 98
Humes, Malcolm, 5

identification, xvii, xxvii, xxix, 29–30, 42, 48–49
identity, 18, 21–23, 28, 31–32, 73, 78, 82, 88, 95, 109–112, 114–115
Iskold, Alex, 67

Jameson, Fredric, 94, 107
Jarman, Freya, 65

Keightley, Keir, 98–99, 102
Koblin, Aaron, xxvi
Kode 9, xv

Lanza, Joseph, xii, 3, 5, 51, 84
Lastra, James, xiv
Lee, Haesung and Kwon, Joonhee, 11–12
Lee, David, Amanda Henderson, and David Shum, 69
Lomax, Alan, 97, 132n
Lunenfeld, Peter, 71–72, 128n
Lyotard, Jean-Francois, 35
listening, xi–xii, xiv–xv, xviii, xix–xxiv, xxx–xxxi, 3–11, 13, 16, 18–23, 31, 39, 49, 51, 58, 60–61, 65, 68–70, 72–73, 75–76, 82–83, 85, 89, 92–93, 95, 99–101, 103, 105–106, 108–117, 120n, 127n, 132n

Makeba, Miriam, 5, 87
Marks, Laura, xvi–xviii
Marx, Karl, 40, 70, 94, 97, 107
Massumi, Brian, xvi–xviii, xxvii, xxix, 31, 82
McCarthy, Anna, 51
McClary, Susan, xiii, xxiii, 46, 124n
McCracken, Allison, xx
McKendrick, Jennifer, 69
media studies, viii, xi, xvi, 19, 50, 69, 110, 115
Meier, Leslie, xviii, 84
Merriam-Webster's Dictionary of English Usage, 7
Meyer, Moe, 59–60
Milliman, Ronald E., 69
Modleski, Tania, 67
Moten, Fred, xiii
Morris, Meaghan, 107
Murray, Janet, 36
musicology, xiii, 116, 120, 125
Muzak, xii, xxiv, 3–6, 8, 9, 34, 68, 84–85

narrative, narratology, xvii, xxii–xxiii, 23–25, 29, 35–40, 42–43, 46, 48–50, 107, 120n, 124–125n
national anthem, xxviii, 20
nationalism, xxvii, 21, 32, 75, 77, 123n
Nice, Joe, xv

Nielsen, Michael, 103–104
North, Adrian C., 69

Oakes, Steve, 69
Oldfield, Paul, 102–103

Palahniuk, Chuck, 52–53, 69
Paradjanov, Sergei, 23, 25–26
Pelechian, Artavazd, 23, 25, 28, 123n
Pentland, Sandy, 2
Picard, Rosalind W., 2
Picker, John M., xiv
Powers, Devon, xviii, 69, 84
popular music studies, ix, xiii, 7, 19, 92, 116
Prendergast, Mark, 5

Rath, Richard Cullen, xiii
Reynolds, Simon, 102–103
Rogers, Holly, 22, 123n
Roles, Joy, xviii

Sablon, Jean, xx
Satie, Erik, 5
Schafer, Own, 4, 19
Scholes, Robert, 46
Schrödinger's cat, 102–103
Schwarz, David, xix–xx
senses, xi, xiii–xvi, xix, xxi, xxx, 8, 35, 39, 43, 68, 71–72, 108, 111–113, 115, 120n
Shaviro, Steven, 50
Silverman, Kaja, 29, 111
Singh, Tarsem, 34, 50
Simon, Bryant, 90–91
Simon, Herbert, xviii, 65–67, 86, 88, 90–91, 99, 131n

Smith, Mark, xiv
Silverman, Kaja, 29, 111
Sinatra, Frank, xx, 63, 85, 89, 126n
sound art, xiv
Sterne, Jonathan, xiii, 1, 3
soundscape, xxi, 3, 15, 17, 20, 41, 48
sound studies, viii, xiii, xxiii, 33, 111
Squier, General George Owen, 5, 18
Stagoll, Cliff, xxvii
Stockfelt, Ola, xx–xxi, 3–4, 7
Storper, Dan, 86–89, 94, 100–101, 104, 133n

Tauber, Daveena, 101
Tamaoki, Mihoko, 6
Tchaikovsky, Pyotr Ilyich, xxiii
Thompson, Emily, xiv
Thrift, Nigel, 91
Tuncboyaciyan, Arto, 76–77, 79–81

ubiquitous, xi–xii, xiv–xv, xviii–xix, xxiii–xxx, 1–2, 4, 9–12, 18, 20, 22–23, 31, 51, 69–70, 84, 92, 100, 105, 108–109, 111–114, 116, 120n-121n, 127n

Venn, Couze, xxiv
video art, xvi, xxx, 20–32, 35, 42, 112, 115, 123n
video game studies, xxi, xxv–xxvi, 13, 35–36, 42–43, 115, 127n

Ward, Steve, 9
Weiser, Mark, xii, 2, 4, 18
Williams, Raymond, 67
Wurtzel, Steve, xiv